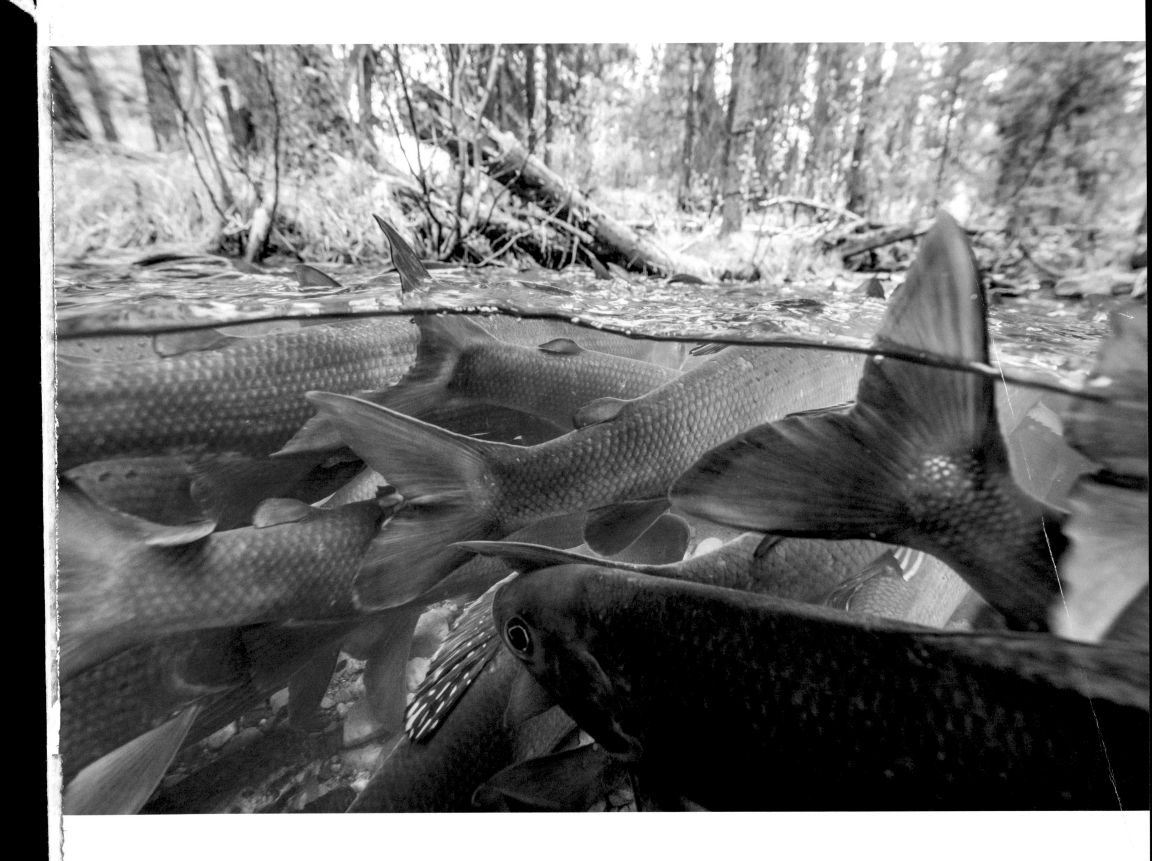

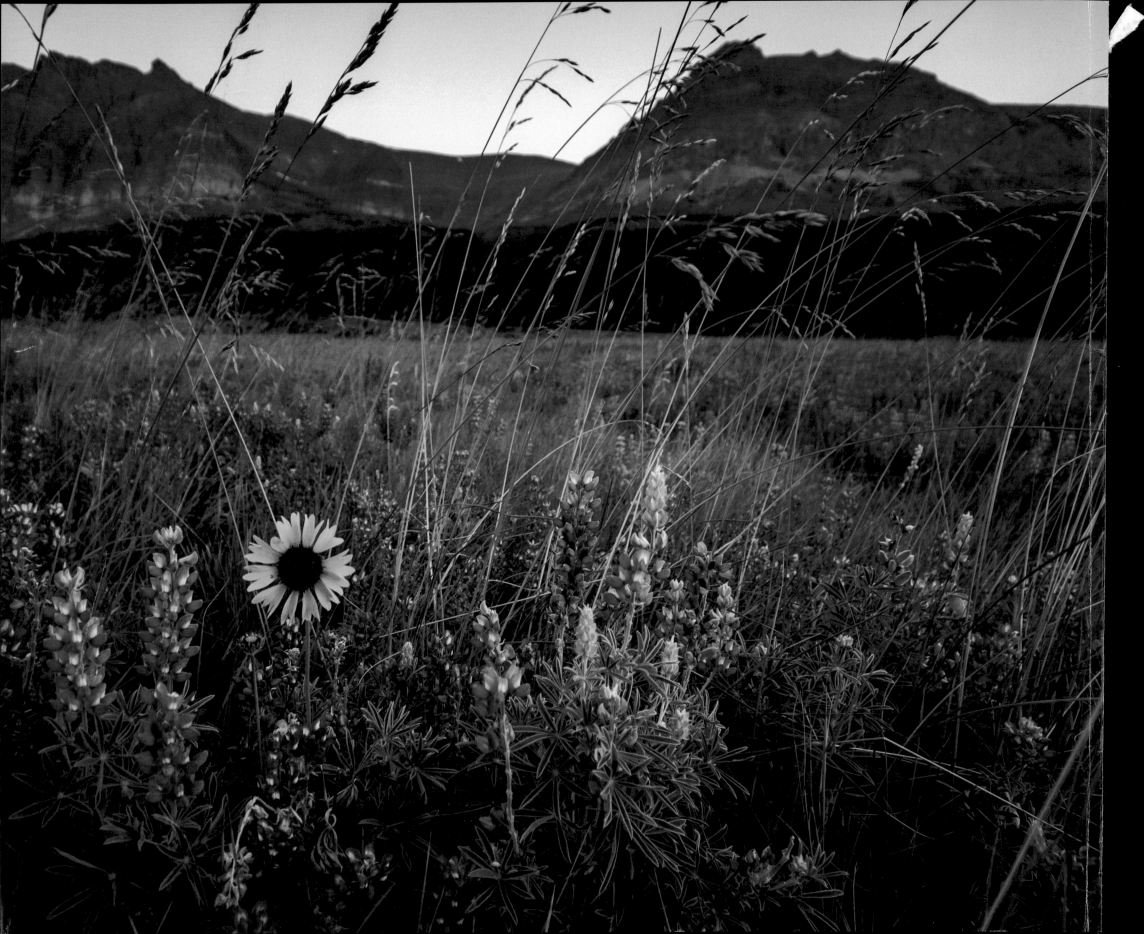

CROWN OF THE CONTINENT

The Wildest Rockies

STEVEN GNAM

DOUGLAS H. CHADWICK | MICHAEL JAMISON | DYLAN BOYLE | KARSTEN HEUER

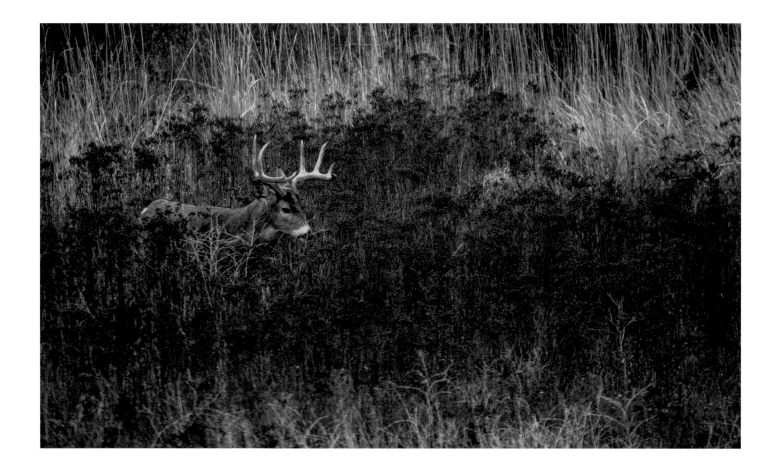

Guard, protect, and cherish your land,
for there is no afterlife for a place
that started out as Heaven.

—C. M. Russell

Contents

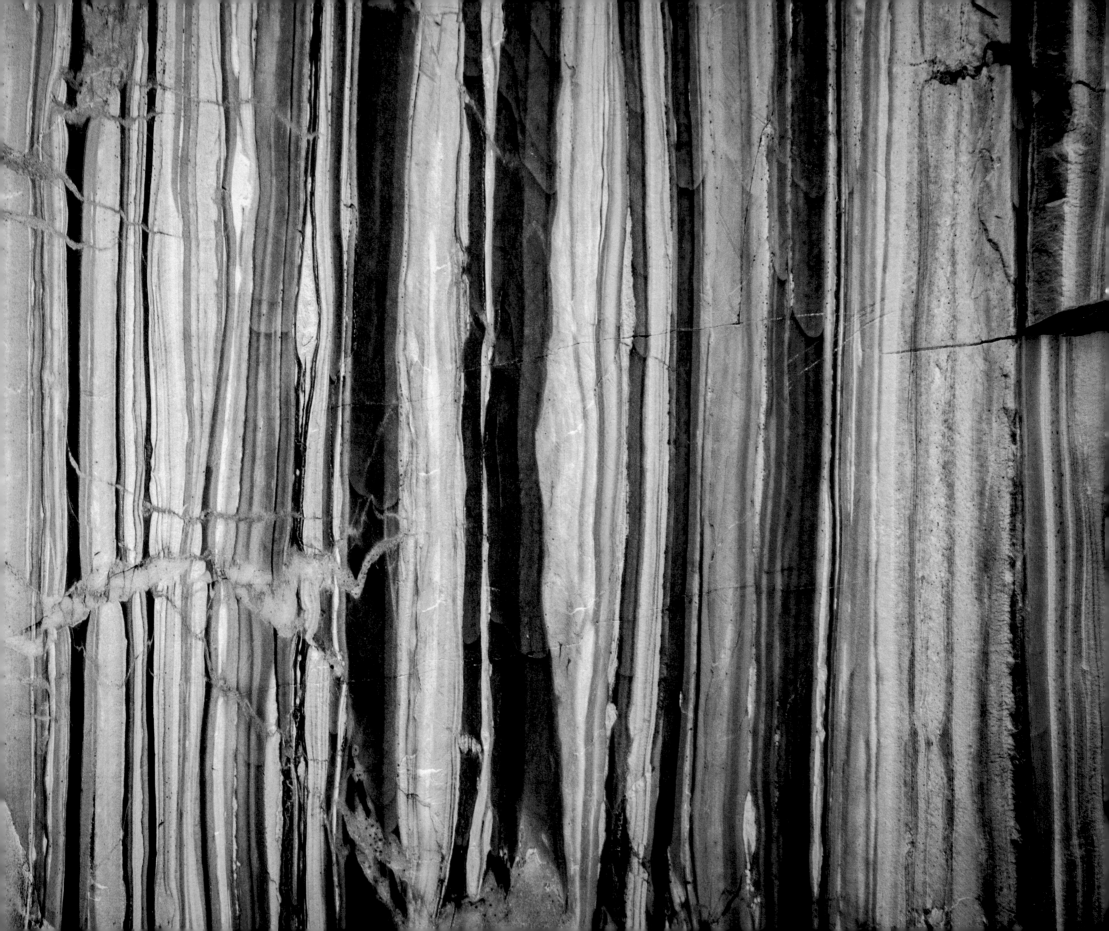

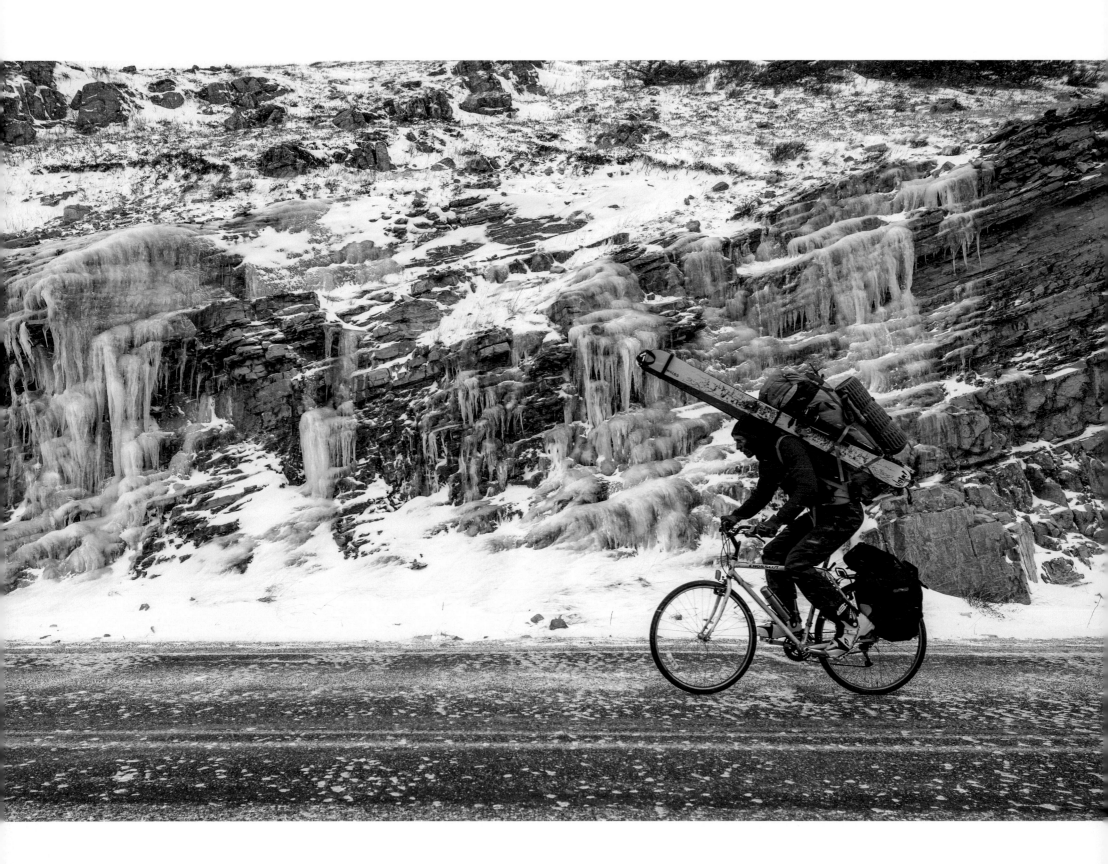

Growing Up with Wild Connections

Steven Gnam

My roots in the Crown of the Continent go as deep as my first wobbly steps on Earth. My folks came to the heart of the Crown with hope for a better life for themselves and their children. A handful of photos of the Bob Marshall Wilderness in a 1985 issue of *National Geographic* sparked their migration. They packed up their old white station wagon and two infants to leave behind the city and its traffic, crime, and air pollution, and to embrace a new life of fresh air and fresh starts, settling in the rural northwestern corner of Montana.

My early years were full of huckleberry-stained hands, clothes sooty from picking morel mushrooms in forest fire burns, and the lingering smell of trout that clung to me after family fishing trips. In middle school I rode my bike beyond the edge of town to explore the woods and creeks flowing out of the Whitefish Range. I wandered looking for animals, fishing, and trying to live off the land in

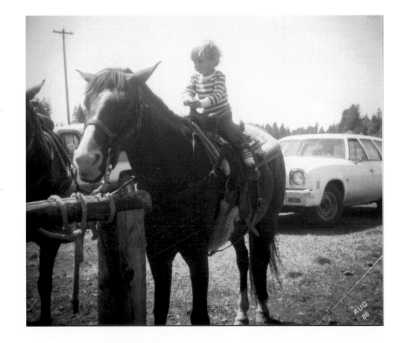

Steven Gnam on horseback just outside Waterton–Glacier International Peace Park

OPPOSITE *Steven Gnam en route for a weeklong trip into the mountains to photograph wildlife and landscapes in midwinter*

poorly constructed shelters that barely kept my skinny frame from hypothermia. I learned about plants and made tea from birch, mint, and spruce; I collected saskatoons, rose hips, and cattails for food. My awareness of humanity's connection to the land grew in those creek bottoms and deep forests.

I still remember pressing my seven-year-old nose against the cold glass of my parent's station wagon window, enchanted by the snowy peaks of the mountain ranges that form the Crown of the Continent. I tried to imagine what it was like up there, guessing that people couldn't visit that rugged country. I didn't know then that I would arrange my schedule in high school and college so I could spend as many days as possible in the Crown's mountains. I laugh now, looking back at those trips. I often went alone and always inadequately prepared—camping for days with plastic bread bags inside of sneakers for snow boots, layers of heavy cotton-flannel shirts, and a leaky one-man tent.

Those early forays into the mountains provided the first inspiration for the images in this book.

The Crown of the Continent—the expanse of the Rocky Mountains stretching roughly from Missoula, Montana, to Banff, Alberta—is unique in the world. From the convergence of the climates of the Pacific Northwest, Rocky Mountains, Arctic, and northern Great Plains springs up a colorful spectrum of plants and animals. In the Crown, the full suite of creatures that lived

here alongside the region's earliest human inhabitants still make their home in these mountains and valleys. Nowhere else on this continent, and very few places in the world, is such wildness intact alongside modern society.

People live here to be close to the land; the land in return is what provides people's living, as residents host visitors, harvest sustainable forest products, and care for the wilderness. The land also shapes the culture of the Crown's communities. Climbing a peak, encountering a bear, and picking huckleberries all strengthen the bonds between place, self, and community, forming stories and memories. Experiencing strong, graceful creatures and intact landscapes rubs off a bit and enriches the beholder.

The blessings of the land are not just for its residents. Every year millions of people from around the world visit the Crown to escape the bustle of cities and to experience nature in its wildest form—to catch a glimpse of a grizzly bear or a wolverine, to hike in solitude, or to float a pristine river. These visitors come to experience something they can't at home: the earth and its communities, whole and healthy.

The Crown of the Continent remains intact because a handful of people saw its natural resources and its beauty as something that should stay untouched for generations. In defiant acts of self-restraint, they chose to forgo the short-term rewards of using the land as however they saw fit and instead laid the groundwork for the long-term rewards we enjoy now: wide-open space, abundant wildlife, clean water. But these early visionaries who left a network of wildlands couldn't anticipate the scale of growth and development that would come. Nor could they foresee that the protected islands of parks and wilderness would not be big enough by themselves for viable populations of wolverines and grizzlies, wolves, harlequin ducks, and eagles, in the long run. These creatures need more than island preserves—they need corridors and routes from Yellowstone all the way north to the Canadian Yukon. These connected lands offer space for wildlife to travel and mix with others of their kind, to roam in search of food, and to migrate in response to the changes that climate and time bring.

I've witnessed the need for the Crown of the Continent to be connected to the lands surrounding it. The wild critters have shown me that this land is intricately connected to distant ocean coastlines, adjacent prairie ecosystems, and the Rockies north and south across state and international boundaries. Since I was

a kid, I've been enthralled with the colorful harlequin ducks that visit the Crown every spring. When I moved away for a few years, I continued to find them along Puget Sound near the Pacific coast, where the waters from the Crown gather and reach the ocean. A population of these painted ducks spends a chunk of their life in the roiling surf of the Pacific Ocean, weathering winter storms from Alaska to Oregon. Every spring, pairs fly back across western North America to the crest of the Rockies, right to the heart of the Crown. They choose equally turbulent waters, this time the clearest and coolest streams, near which to nest and rear their young before flying back to the ocean.

Like the harlequin, wolverines move without recognizing our maps and political boundaries. Growing up exploring the mountains of the Crown, I often saw wolverine tracks crossing high alpine basins, traveling straight through avalanche chutes and cliff bands. Nowadays, I continue to cross paths with these rare creatures while I'm out backcountry skiing. Around the Crown, wolverines travel across provinces and international borders, in and out of protected areas. They need large tracts of mountainous terrain to find enough food to survive. They also need snow, deep snow that lasts well into late spring so that females can dig dens to house their newborn kits.

The harlequin and the wolverine show us that the Crown of the Continent needs to remain connected to other wildlands and that what we do with our human lives affects the wild—the land and wildlife—out there. Harlequins need clean water, on the Pacific coast and in the Crown, to keep up their age-old migration. Wolverines need space—lots of it. As the snowpack shrinks due to climate change and mountainous areas are fragmented by human activities, wolverine country gets smaller.

If we know what to look for, the natural world tells us how we're doing, much better than we can tell ourselves. Just as the canary in a coal mine—if miners listened, that bird could keep them alive— told us about the air quality of the deep; harlequins tell us about the health of our oceans and trout streams; a wolverine's presence tells us whether our mountain ecosystems are intact. All the creatures of the Crown tell us that these wild refuges must be connected to one another to sustain the human and animal communities that live here.

During the last few years, I've worked with folks from the far corners of the Crown of the Continent, from southeast British Columbia to southwest Alberta to northwest Montana, to ensure

Harlequin ducks from the Crown of the Continent spend winters along the Pacific coast. During early spring they migrate back to streams throughout the Crown, where they nest on the ground or occasionally in tree cavities and on cliffsides.

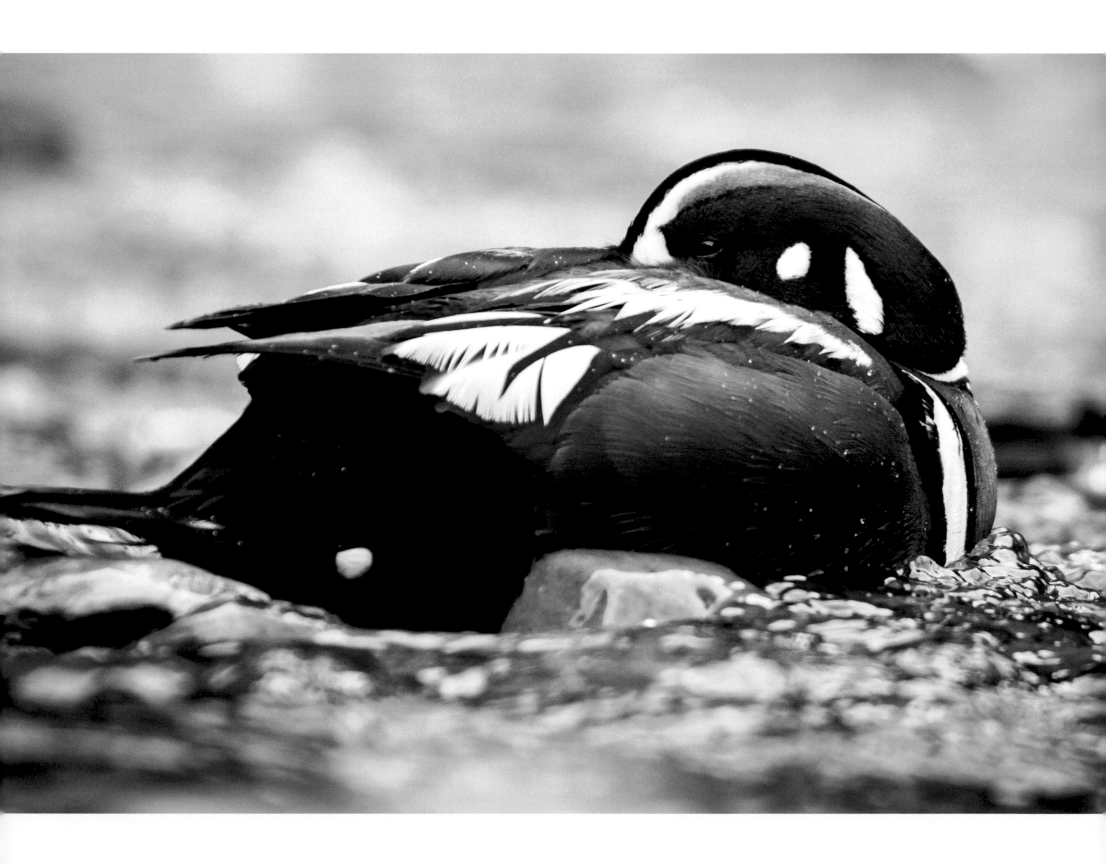

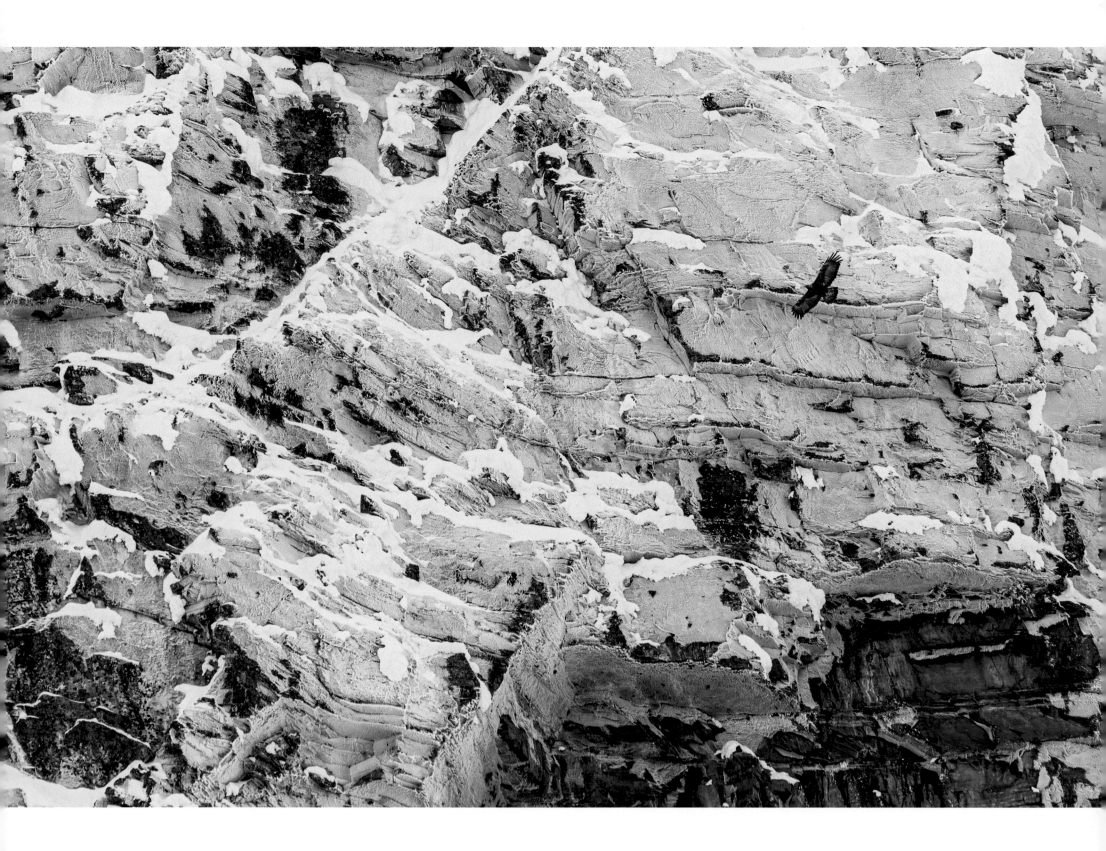

this place remains a viable homeland for human communities and wild creatures. Over cups of coffee and miles of trail, we talked about the need to amplify the voice of the land and its animals. Eventually this project was born so that we could share the treasure of the Crown and invite others to join us in this work. And so I find myself in the most pleasant of company—a cross section of some of the most down-to-earth and hospitable souls of the Crown.

DOUG CHADWICK, a seasoned biologist, writes about connections, how the soil, water, bugs, and bears are woven together into the fiber of our lives. I've known Doug since my childhood; he took me on my first backpacking trip and let his son Russell and me bring all forms of the animal and plant kingdom into the Chadwick home. We brought meadow voles into the kitchen like a house cat proud of its catch; we came home covered head to toe in the rich clay soil we'd found in the nearby creek bed. Doug, who writes about wildlife around the world for *National Geographic,* shares in these pages his passion for the place where he has raised his family and that he has called home for decades.

MICHAEL JAMISON intimately knows the people, places, and issues of the Crown, working as a reporter for *The Missoulian* for fifteen years before joining the National Parks Conservation Association as the Crown of the Continent Initiative program manager. Michael weaves together the natural and cultural landscape, describing how our thoughts, beliefs, and values are inseparable from the environment around us. He and I have shared days in the backcountry exploring the headwaters of the transboundary Flathead River, which threads along the world's first international peace park, Waterton-Glacier. His work and writing bring together the lives of people who are working for common ground to protect and celebrate this place.

DYLAN BOYLE opens the door for readers to explore the Crown for themselves. With the Crown of Continent Geotourism Council, Dylan works to preserve the Crown's geographic character, encourage sustainable businesses, support community well-being, advance landscape stewardship, and provide outstanding visitor experiences. Dylan and I decided to have our initial "business meeting" while fly-fishing in Glacier National Park. We planned for a day of fishing at a subalpine lake, but a couple of grizzly bears changed our plans . . . so we instead spent the afternoon fly-fishing for westslope cutthroat trout from a stream on our way back home. By the end of the day, Dylan was on board with this project and we'd begun a tradition I hope to keep with him over the years.

And, finally, **KARSTEN HEUER** ties it all together in his epilogue—who better to wrap it up than the man who trekked the entire 2200 miles (3542 kilometers) from Yellowstone to Yukon, including the 250-mile (402-kilometer) spine of the Crown of the Continent? Karsten has seen the whole region from the ground, moving through it just as the water and wildlife do, and knows intimately the importance of corridors for wild things to roam free. As president of the Yellowstone to Yukon Conservation Initiative, he works with communities, governments, and organizations to connect people to the land and connect fragmented land together.

In the back of this book, there is information for getting involved and supporting the work of people who are preserving the Crown of the Continent as a global treasure. We hope you will join us.

Golden eagle soaring along ice-coated cliffs

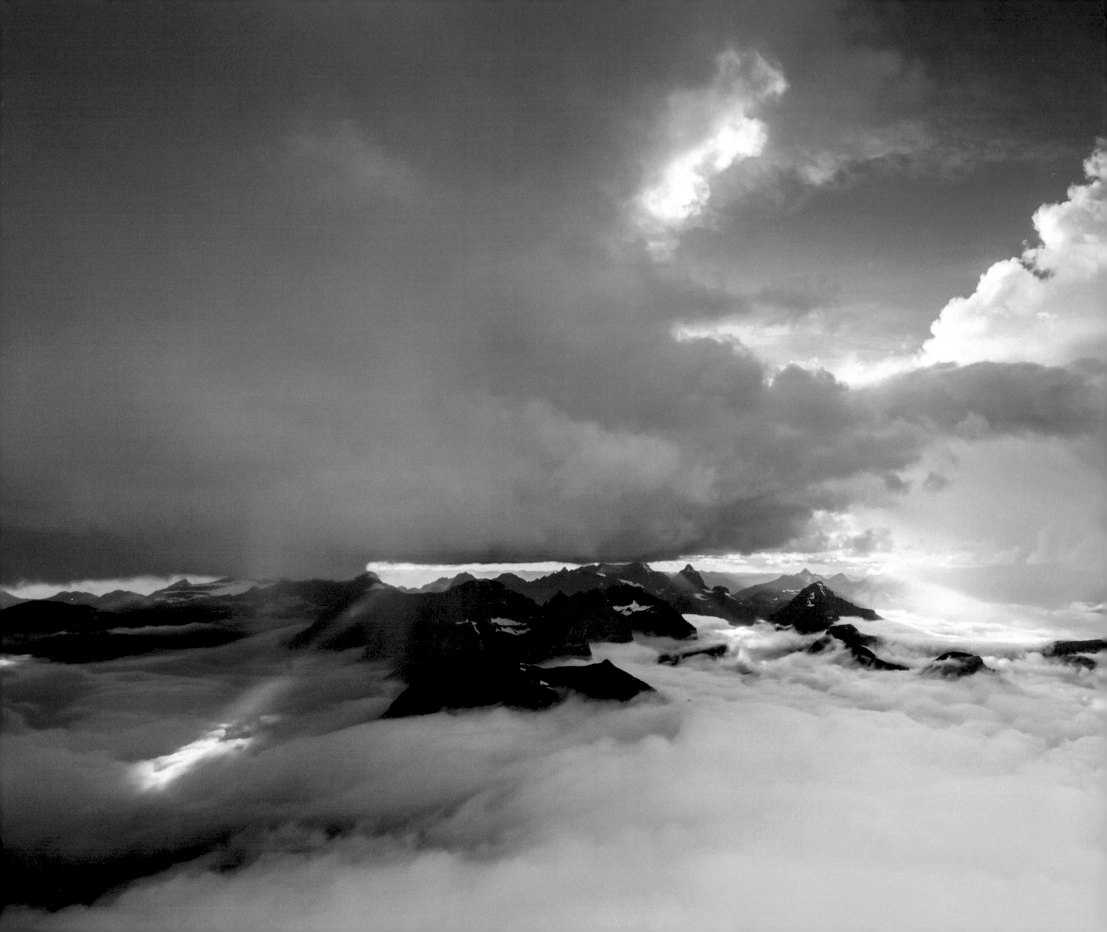

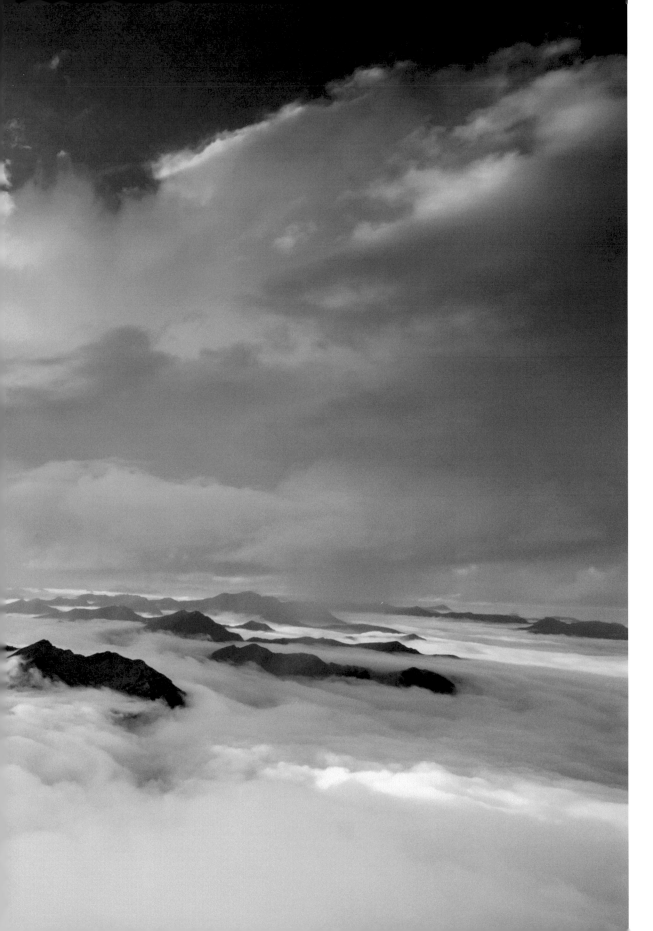

"At the onset of this project I wanted to take people into the far reaches of the Crown, up into the mountains, down under the clear waters, deep into its forests. I also wanted to share the views you could see on foot, the views you see with a little sweat and persistence. None of the images in this book were shot from airplanes, and all the wildlife photographed is wild."

—Steven Gnam

The Crown of the Continent Ecosystem

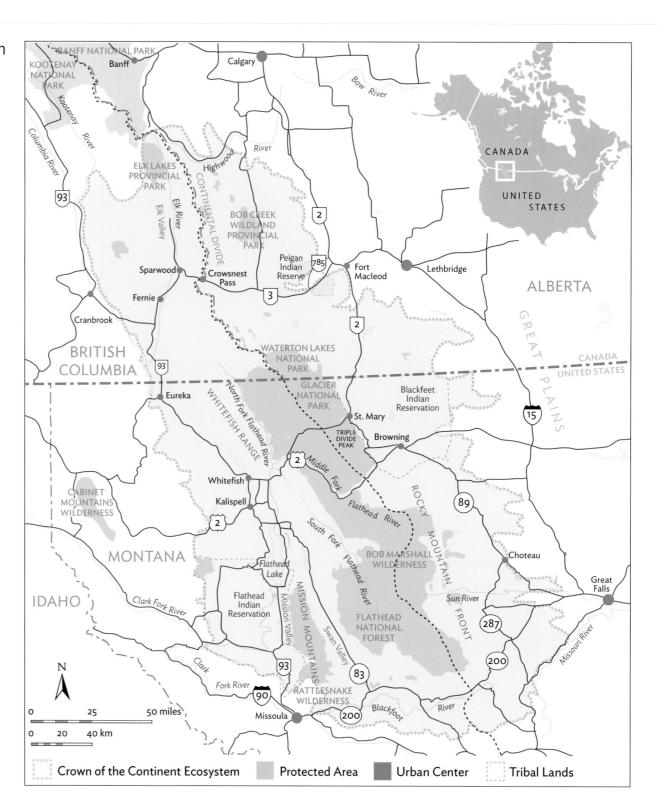

One of the wildest and most biologically diverse ecosystems in the world is located where Alberta, British Columbia, and Montana converge, stretching along the Continental Divide of the Rocky Mountains. Naturalist George Bird Grinnell named the transboundary region the "Crown of the Continent" in the early 1890s. He recognized the region's geographical importance as the headwaters of the continent, where clean water flows to the Pacific Ocean, Gulf of Mexico, and Hudson Bay. For the Blackfoot Indians, the rugged peaks of the Rocky Mountains were the "backbone of the world."

Bounded by the Rocky Mountain Trench on the west and the prairie foothills to the east of the Rocky Mountains, the Crown extends from the Bob Marshall Wilderness Complex in Montana north to the Highwood River in Alberta and the Elk Valley in British Columbia. The landscape of this 18-million-acre (7.3-million-hectare) ecosystem contains majestic high peaks, dense conifer forests, aspen glades, native grasslands, and clean-flowing, sparkling rivers and streams. The Crown is home to more than 65 species of mammals, 260 species of birds, and more than 1400 species of native plants.

The Crown claims some of the most well-known and treasured national, state, and provincial parks and forest and tribal reserves. Among them are Waterton-Glacier International Peace Park (the first transboundary park in the world—and a UNESCO World Heritage Site), the Bob Marshall Wilderness Complex, and the first tribal wilderness formed in the United States, the Mission Mountains Tribal Wilderness.

While these magnificent parks receive international acclaim, it is the areas between and connecting them that are at risk and require dedicated stewardship. Roads and other human development, such as rural residential sprawl, fences, and natural resource extraction, are encroaching upon safe passages and havens between the parks. Vulnerable species—grizzly bears, wolverines, mountain goats, bighorn sheep, numerous native bird species, and trout—are forced to move across the landscape to forage and find conditions favorable to migration and reproduction.

Many groups, including ranchers, fishermen, members of First Nations tribes, businesses, the outdoor industry, community leaders, and conservation groups, recognize that that it is their common ground to work together to ensure that the Crown will continue to be healthy for future generations. While some long-running success stories are cause to celebrate, there is still much to do to adopt conservation strategies and practices that preserve and restore critical wildlife corridors in the most vulnerable sections of the Crown.

In the following pages, explore the Crown—the wildest part of the Rockies, where these spectacular mountains truly come to life—through the lens of Steven Gnam and the thoughtful essays of writers who live and work in the region and deeply care about the Crown and its future. Their combined images and words provide a glimpse of what Lewis and Clark encountered on their expedition in the early 1800s and where, today, the landscape, natural flora and fauna, and the people who rely on the region are undeniably connected.

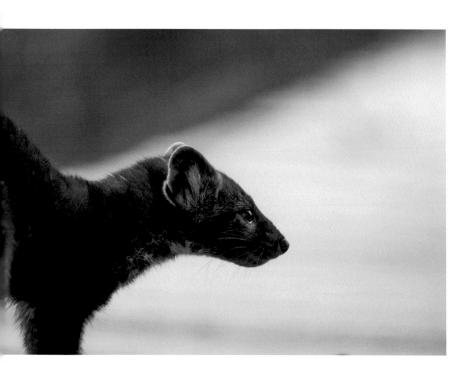

Pine martens live year-round in the Crown of the Continent without hibernating.

RIGHT *Looking north across the US-Canada border at Akamina Ridge in Waterton Lakes National Park*

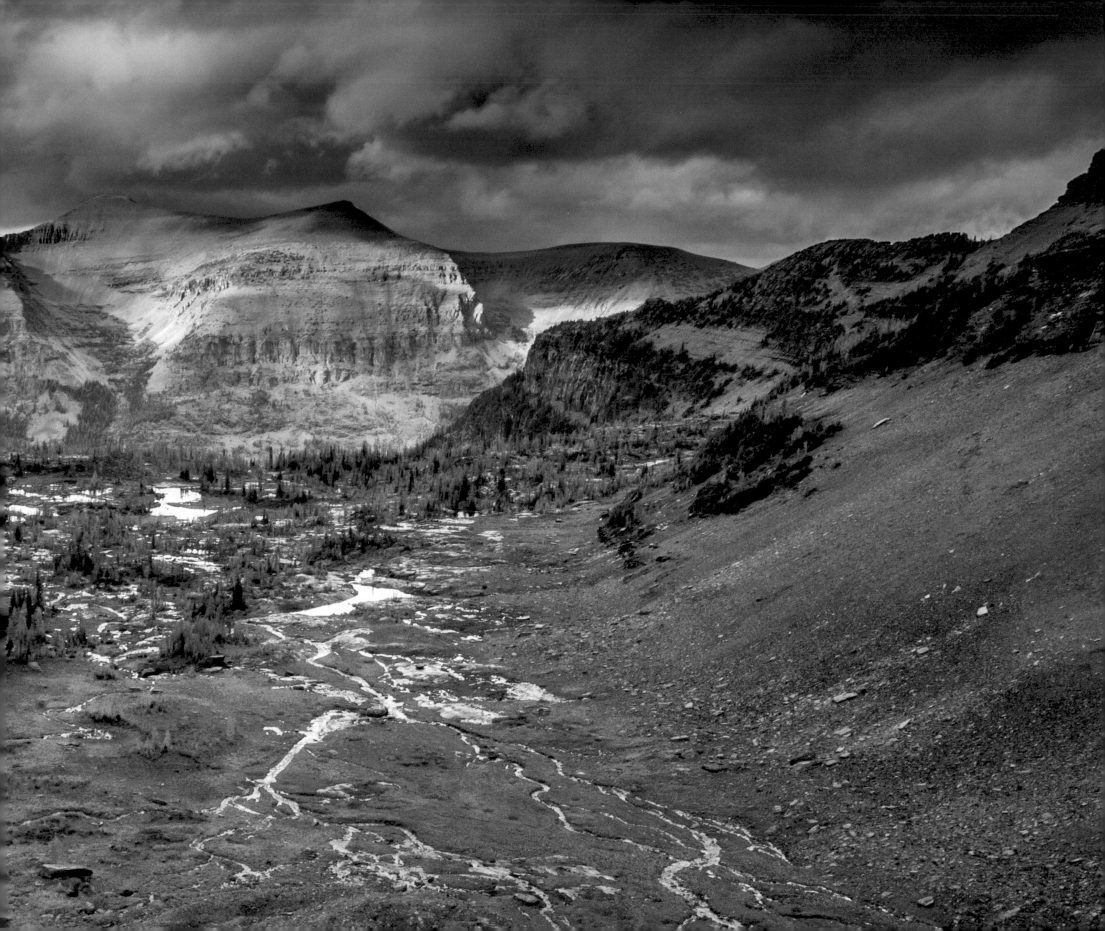

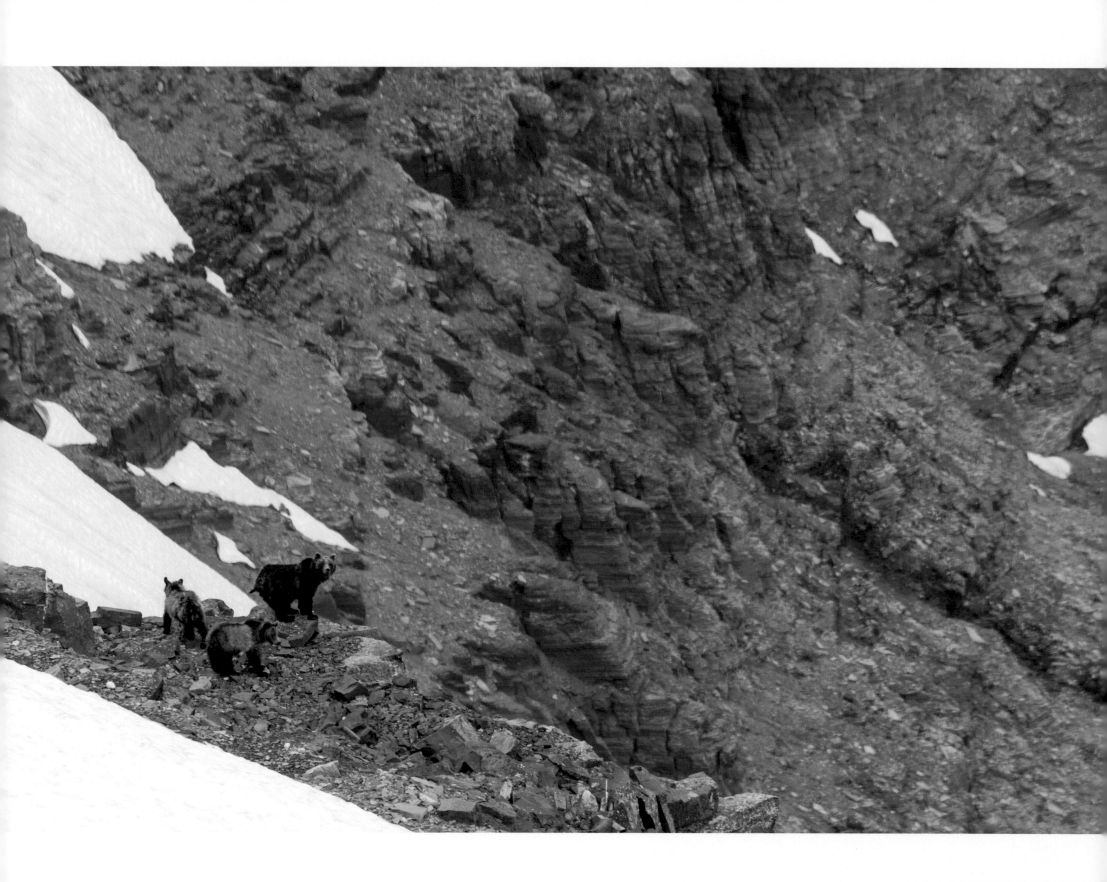

Where the Rockies Come Alive

Douglas H. Chadwick

In the mostly dark, flash-freezing vastness of space, a planet that is leafed with life—eyed with it, blooming, squirming, splashing, crying out, and soaring with it—is beyond rare. Ours may be the only such sphere in existence. However you define miracles, our home is an ongoing one 24,860 miles (40,008 kilometers) around.

Amid daily worries and chores, it's easy for us to lose sight of the dimensions of wonder we're part of. But I know a place that will remind you. People call it the Crown of the Continent.

A grizzly mother and two offspring explore above the tree line.

The Crown of the Continent is where the Rocky Mountains sweep along peaked and powerful and unbroken for 250 miles (402 kilometers) between western Montana's Blackfoot River drainage and Elk Lakes Provincial Park in British Columbia, taking in 18 million of the loveliest acres (7.3 million hectares) on the blue-green globe. Their crest is the Continental Divide. The centerpiece is Waterton-Glacier International Peace Park, a union of Canada's Waterton Lakes National Park and America's Glacier National Park. Declared in 1932, it was the first transboundary park in the world, symbolizing a recognition of the way natural systems reach across political borders, as can shared values and hopes.

Within the peace park, Triple Divide Peak rises like a fountainhead for North America. Snowmelt from its summit cascades west to the Pacific, southeast to the Atlantic's subtropical Gulf of Mexico, and northeast across Canada to Hudson Bay to the Arctic Ocean.

In a reverse of that outpouring, flora and fauna from the deep-forested Pacific Northwest, Great Plains grasslands, southern climes, and northern boreal zone all converge upon the continent's Crown. Then they stack up in niches from sheltered valley floors less than 3000 feet (914 meters) above sea level to crags nearly two miles (more than 3200 meters) tall. Lake-flecked, cliff-faced, cloud-snagging, meadow-enfolding, the place overflows with life. Ecologists define an area's biological diversity—biodiversity for

short—as its total array of species plus all the genetic variation, biochemical processes and behaviors, and ecological interactions associated with those life-forms. The Crown is a nexus of biodiversity for the continent and a storehouse of it for the world.

Counting groups such as lichens and mosses, at least 1400 plant species pattern the Crown, forming the most varied array of vegetation in Canada. The animals include a splashy spectrum of aquatic creatures in streams and rivers so jewel-bright and translucent they are used as a world standard for water quality. Golden eagles, pale prairie falcons, red-tailed hawks, mountain bluebirds, and pink flocks of pine grosbeaks animate the air.

Between the swimmers and flyers, the single most diverse collection of carnivores in North America walks alongside a full suite of the other furred forms present since at least the end of the last Ice Age. Together, from least weasels weighing just ounces (a few hundred grams) to wolf packs, from antelope and mule deer to mountain lions and the densest population of wolverines in the lower forty-eight states, they radiate grace and strength and sometimes a touch of danger, but most of all never-tamed majesty—another reason people think of this region as the Crown of the Continent.

Right now I'm high in the middle of it, keeping an eye on three grizzlies climbing toward a pass. Mother bear muscles steadily

upslope as two cubs of the year scramble in spurts behind. Bunched on an avalanche chute painted over with wildflowers, a band of bighorn sheep is watching the grizzly family just as intently as I am. Below, elk stride through clearings in the forest of subalpine fir. A pair of hoary marmots exchange whiskery sniffs on a boulder not far from where I set down my pack.

I can make out sunlit patches of tawny prairie on the far eastern horizon. To the west, a flotilla of moist-bellied clouds is sailing my way over darkly forested slopes. The wind driving them arrives first, louder by the minute. Before long, it's crashing over my ridgeline perch like a breaking wave. Whenever I move my head, the rush of air past my ears takes on a new tone. I'm as attuned to its storm trumpetings as I was to the whispers and trills of rivulets from melting snow patches before the sky changed.

Out here, up here, I feel intensely connected to everything within eyeshot and earshot, drawn outward toward the curvature of the earth—made humble and huge all at once. Made whole. The scale of the terrain is so colossal, and the energies of the weather and waterfalls and wild residents seem so strong, and all my senses are firing so fiercely, I think that if I sit still any longer I might start vibrating. When an eagle flashes past, one of the marmots issues a sharp warning whistle. It breaks the spell but only freshens my awareness of exactly how lucky I am to be alive and in this place.

In addition to reminding us of the wonder we're part of, the Crown of the Continent offers perhaps the best hope on earth of keeping a mountain ecosystem with a rich diversity of landscapes and life complete and fully functioning for generations to come. At the same time, it stands as a model for conservation efforts elsewhere around the globe. It might even be the region that folks a century from now point to and say, "Look: This is where humankind figured out how to pursue progress without overwhelming the natural resources we rely upon. Without diminishing the natural splendors that inspire us. Without fraying the fabric of life that ultimately sustains our own. This is where they finally got it right."

Wildlife Stronghold

The Crown of North America stands as one of the most intact ecosystems in the Lower 48 and on the continent as a whole. Worldwide, there are fewer than two dozen (by some measures only a dozen) regions left where no species has gone extinct in recent centuries. The Crown is one of those. Unlike other global wildlife strongholds, it is located not at some remote corner of the planet but within the temperate zone of two busy, industrialized, First World countries, comparatively easy for anyone to reach.

That might sound surprising, considering the pressures present-day development typically places on an environment. But the two modern democracies joined by this segment of the Rockies are the first nations that systematically began building a legacy of conservation. Their efforts proved particularly foresighted in the Crown, and people on both sides of the Canadian–US border continue to find ways to strengthen this ecosystem while accommodating a growing human population and its activities.

I'm part of that populace, having lived in the Crown for decades. Hiking its contours with my wife and growing children made the place home in the truest sense—the landscape to which our hearts belong. The same is true of this book's co-author, Michael Jamison, and his family.

Photographer Steven Gnam, reared here, was drawn to natural history from early childhood. He found summer jobs maintaining trails in the backcountry. For a while, he was also a mountain-climbing instructor and guide. Each year, Steven found himself devoting more and more time to photographing the region. Still in his twenties, he now spends every day he can exploring the Crown on foot or skis or sometimes submerged with a snorkel, capturing images and helping to conserve the part of the world he has come to know so intimately and care for so deeply. If a picture is worth a thousand words, you have in your hands a Gnam encyclopedia. What makes it so extraordinary is that it feels like a single poem, straight from the heart and as light as a flame.

One of the main reasons there is so much for us all to celebrate in this place revolves around the concept of public domain—US federal and state lands, along with Canadian federal and provincial lands. Making up more than half the region, these tracts are owned not by private individuals, corporations, or a privileged class of any kind but by every Canadian or every American citizen. Through their voices and, ultimately, their votes, the people as a whole will be the ones to decide what happens to the waterways, the trout casting shadows on the stream beds, the winter-colored mountain goats, graceful swans, old-growth cedar-hemlock forests, sagebrush flats with prickly pear cactus blossoms, tailed frogs, gangly moose,

Bighorn sheep rams during the fall rutting season

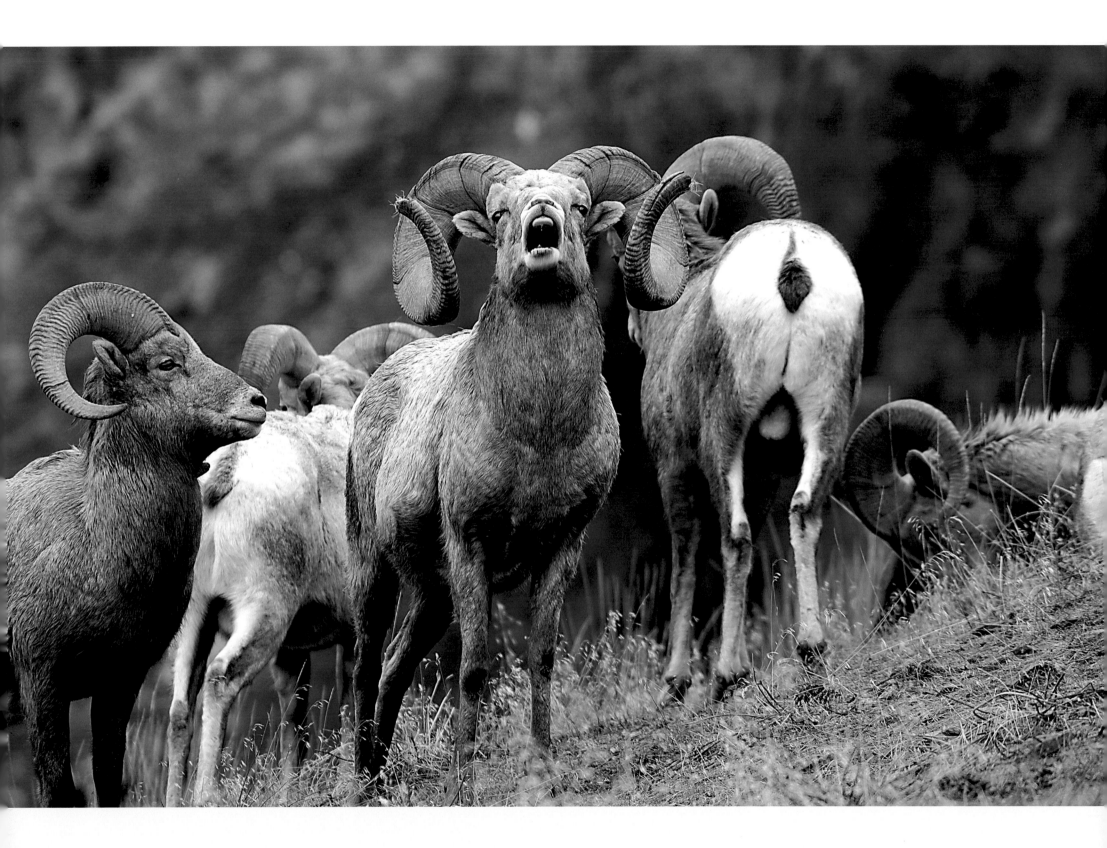

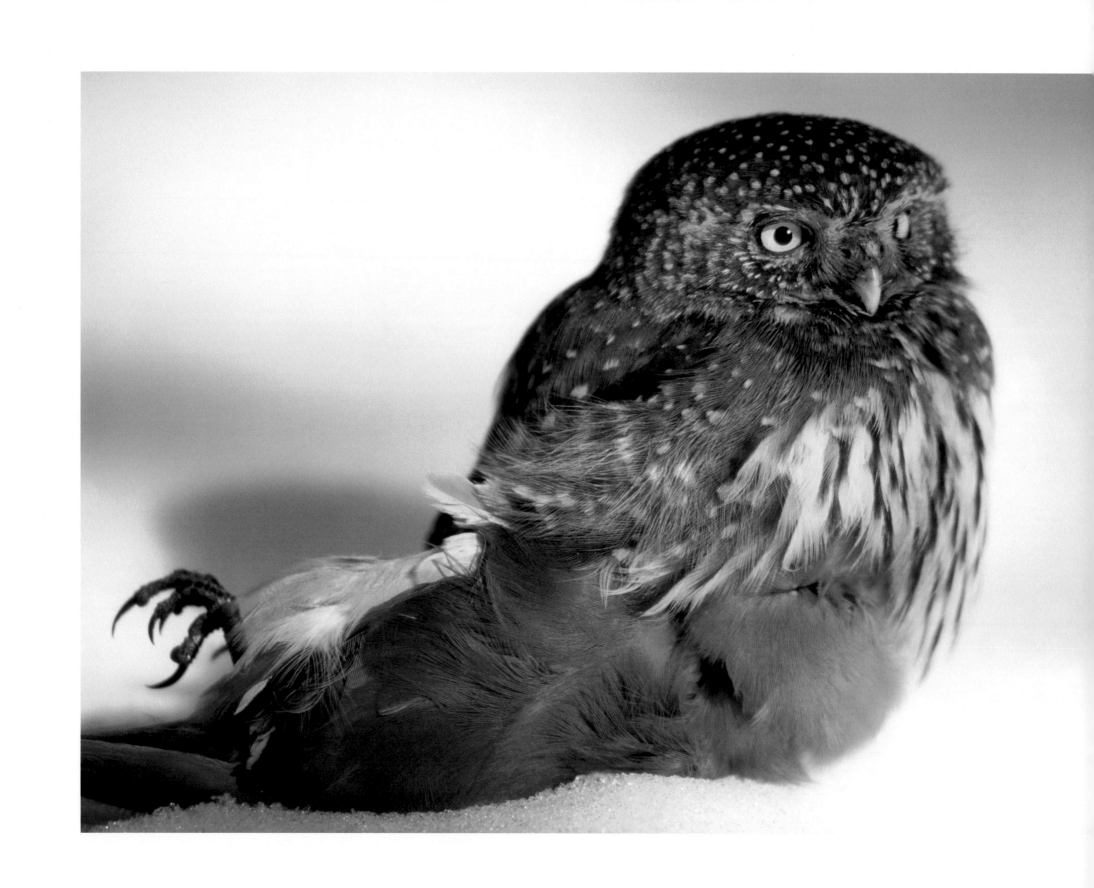

and lynx scanning the wooded slopes for the silhouette of a snowshoe hare.

Although the bonds I've forged with the Crown are mighty strong, I don't think I'm overemphasizing the global significance of this ecosystem. The United Nations designated each of the national parks at the Crown's core, Waterton Lakes and Glacier, an international biosphere reserve in 1976, and in 1995 it declared Waterton-Glacier International Peace Park a world heritage site. By any name, the coupled parks have served for decades now as a stimulus for the creation of international joint reserves on other continents. Like the mountains and the wildlife that roams them, the idea embodied here transcends the old boundaries that humans set for themselves.

I travel to report on wildlife hot spots around the world. More often than not, I end up in politically volatile regions where human numbers are skyrocketing while human opportunities—and human rights—decline along with the condition of the environment. Of the planet's inhabitants still blessed with elbow room, Canadians and Americans rank among the best-educated and most affluent. Being the owner-operators of stable representative governments leaves them all the more able to shape their own destiny and, thus, all the more free.

Given the spectacular countrysides and wildlife communities that residents of the Crown enjoy, nearly everybody here wants to conserve them. Oh, we argue plenty over exactly how to go about it, but rarely over the goals: Pure water. Sweet air. Sustainable methods of making a living for ourselves and for those who come after us. Open spaces that give physical meaning to our freedoms. Wild beauty close at hand. When all's said and done, the quality of our lives can't be separated from the quality of the living systems around us.

Preserving the Backbone of the World

A more detailed look at the people of the Crown has to begin with the original nations of the region. Long before Europeans came probing what to them was a frontier, Salish, Kootenai, and Pend Oreille Indians were at home among this region's western mountainsides and valleys, occasionally traveling east across the Great Divide. Meanwhile Blackfeet (Pikuni), Piegan, and Blood Indians claimed most of the eastern slopes and the open prairies beyond. These people are all still in the Crown, still here in

Mistakis—a Blackfeet name meaning "Backbone of the World"—living on self-governing reservations. Considered sovereign territories, tribal lands make up about one-sixth of the region. Native American traditions include an abiding spiritual relationship with other creatures, which further explains why all the native animal inhabitants are still here too.

These days, Native Americans comprise roughly 10 percent of a human population totaling about 160,000 in the Crown. It is a mix of ranchers, downtown business owners, farmers, educators, loggers, medical workers, outdoor guides, electronic technology specialists . . . a cross section of souls sharing the mountains' embrace. A great many more folks pass through this area each year. As a prime example, Montana's 1500-square-mile (3885-square-kilometer) Glacier National Park, located close to the center of the Crown, hosts two million visitors annually. The entire state, though a hundred times larger, has barely a million residents.

Waterton Lakes National Park was established back in 1895. Glacier was made a national park in 1910, thanks in good part to the influence of George Bird Grinnell, the prominent naturalist and writer who coined the name "Crown of the Continent" to define the region. The east side of the Divide, where the walls of the high country drop abruptly onto the plains amid bursts of winds and wild iris, is known as the Rocky Mountain Front. Roughly 40 miles (64 kilometers) south of Glacier, 200,000 acres (80,937 hectares) of federal land along the Front were set aside in 1913 as the Sun River Game Preserve to protect elk depleted by commercial hunting. It helped, but many of the herds' winter pastures lay at lower elevations on privately owned ranchland. The state of Montana later purchased several of those properties and, with additional ground from the federal Bureau of Land Management, created the Sun River Game Range. The elk began to prosper once more.

Large blocks of public domain in both the Canadian and US portions of the Crown had already been set aside as forest preserves early in the twentieth century. Several tracts of US national forest along the Sun River and nearby in the South Fork of the Flathead River drainage were designated as primitive areas. In 1940 they were merged into a Forest Service wilderness. Then that was enlarged under the 1964 Wilderness Act and officially renamed the Bob Marshall Wilderness, better known to locals nowadays as "the Bob." And all this was only a start.

A northern pygmy owl holds a freshly caught bohemian waxwing. Northern pygmy owls often hunt prey larger than themselves and can carry up to three times their own weight.

Lands immediately south of the Bob became the Scapegoat Wilderness in 1972. Four years later, the three main branches of the Flathead River draining the Crown's west side were added to the US National Wild and Scenic Rivers system. Two years after that, a big chunk of national forest joining the Bob to Glacier National Park on the north was declared the Great Bear Wilderness. Across the border, meanwhile, British Columbia and Alberta were setting aside provincial parks, heritage areas, and other locales to conserve natural resources and prized spots for backcountry recreation.

The Confederated Salish and Kootenai Tribes set aside the Mission Mountains Wilderness Area on their reservation during 1982. Situated roughly 30 miles (48 kilometers) west of the Bob, this was the first tribal wilderness area ever established in the United States. Moreover, it adjoins a federal wilderness designated in the Mission Mountains seven years before. The Salish and Kootenai have also won admiration for a top-notch wildlife management and native fishery program.

Beginning in the 1990s, US federal and state transportation departments proposed widening US Highway 93, the main traffic artery through this reservation. In response, the tribes forced the agencies to undertake what was described as the most extensive wildlife-sensitive highway design effort in the United States to date. The result, more than a decade later, was forty-one crossings built for the native animals, together with 16 miles (26 kilometers) of special fencing to steer them toward those passageways. Most are extra-large culverts beneath the asphalt, but one is a stout bridge arching high above—an overpass for the four-legged, planted with natural vegetation. The goal is not only to benefit animals within the Crown but also to promote wildlife connectivity between this region and others, such as the Selway-Bitterroot ecosystem stretching from Montana well into Idaho.

Automatic cameras have since documented virtually every kind of wild pedestrian—from painted turtles and otters to cougars, black bears, and grizzlies—using the crossings. I saw a bobcat emerge from one culvert after I'd pulled over for a closer look at ruddy ducks and great blue herons wading in a nearby pond. The new arrival was interested in bird watching too, bobcat style. At least eighteen more safe underpasses are planned as highway rebuilding proceeds on the Salish-Kootenai Flathead Reservation.

Across the Continental Divide to the east, the Blackfeet Indians reintroduced bison to some ranchlands on their reservation. I tagged along with biologists working in the area who were studying swift foxes, a species eliminated across most of their continental prairie range by trapping and poisoning. These slender, cat-sized canines are most active after dark. As a thunderstorm bore down from the northeast, I borrowed one of the scientists' night vision binoculars to watch two juveniles, called kits, approach a colony of ground squirrels. Though they might have been hunting, they had temporarily forgotten about their prey. Instead, relying on reflexes that looked fast as the lightning flashes in the distance, the youngsters made a game of racing as close as they dared around a burly, whirling badger that had been digging into the squirrels' burrows. The foxes owed their presence, just as I owe that memory, to the tribal wildlife department, which had recently partnered with the nonprofit conservation group Defenders of Wildlife to reintroduce swift foxes to the region.

A World-Class Mountain Ecosystem

A pattern becomes clear: the Crown of the Continent hasn't stayed as intact as it is merely because of tough topography and sheer luck. Sure, the steep tilt of the Rockies, coupled with harsh, snowbound winters, discouraged settlement in the higher elevations; this length of the Continental Divide still has only two roads running through it from east to west that are open year-round. But it was the foresight of earlier conservation leaders and tribal elders, combined with support from local communities and political representatives, that stitched into place a remarkable quilt of protected sites even as more houses and human activities spread through the sheltered valleys and partway up the slopes. The reserves were drawn large enough and close enough together to keep the ecosystem operating much as it always had.

The proof is in the grizzlies. The great silver-tipped bears have individual home ranges of as many as several hundred square miles (nearly a thousand square kilometers) and an omnivorous diet that takes them from bottomlands to summits over the course of a year. Where there is enough space, food, and safety for these megamammals to flourish, the needs of most other members of the natural community are going to be covered as well—which is why ecologists refer to *Ursus arctos horribilis* as an umbrella species.

In 1975, after decades of losing habitat and being relentlessly persecuted and heavily sport hunted, grizzlies south of Canada declined to the point that they were declared threatened. Given full protection under the US Endangered Species Act, they began

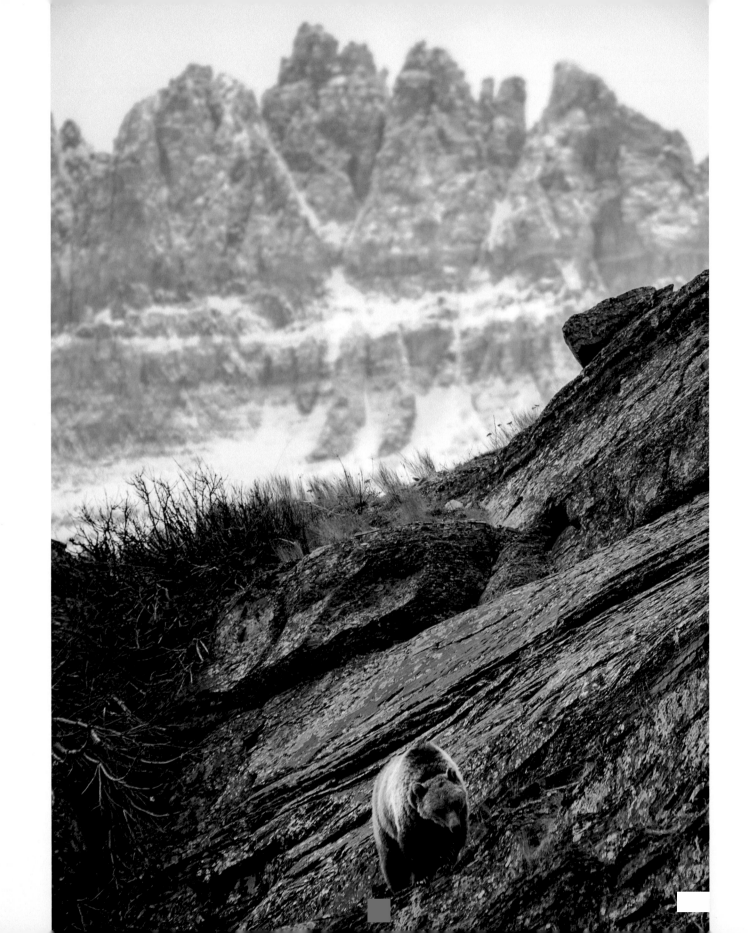

Grizzly bear on a ridgeline in Glacier
National Park just before denning

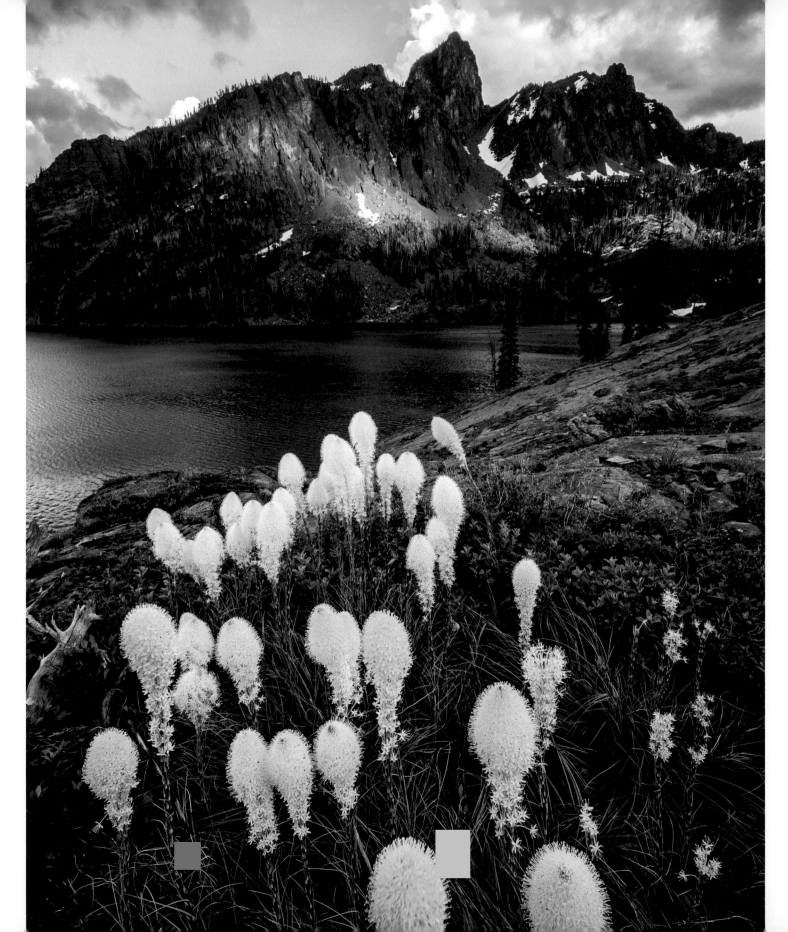

Beargrass blooming in an alpine basin above the Swan Valley

to recover. More tellingly, they continued to increase over the following decades at the same time the human populace was roughly doubling in the American side of the Crown. Grizzly bears don't lie: that level of success for a potent, wide-ranging carnivore that weighs hundreds of pounds and isn't convinced that humans are superior life-forms couldn't happen without lots of high-quality, undisturbed habitats and solid connections between them. Today, the grizzlies in this region constitute both the single largest population in the Lower 48 and the densest population in Canada outside of the salmon-rich Pacific Northwest coast. That tells you a great deal about how the Crown's other wild residents are doing.

Yet if you were to ask people from Canada and the United States where to find outstanding wildlife in the Rockies, many in Canada would likely choose the Banff National Park area, while the Americans would reply: Yellowstone National Park. Each of these parks is, to be sure, a tremendously popular destination renowned for big fauna. However, since neither place has both extensive prairie grasslands and lush lowland forests to go with its spectacular mountain settings, neither can quite match the breadth of the Crown's wildlife array. Travel east on the Rocky Mountain Front, and you could find a griz kicking up dust as it rambles past one of the lizards popularly called horned toads. Follow the headwaters of the Columbia River downslope going west in the Crown, and you might glimpse an elk stepping over long-toed salamanders in the moist shade of lichen-draped 400-year-old spruce.

The lowest elevation in the region is just 2523 feet (769 meters) above sea level. That's at the bottom of Montana's Flathead Lake, the largest body of freshwater in the Crown—and, for that matter, in the western United States. It is 371 feet (113 meters) deep. There is no shortage of local tales about the superserpent Flathead Lake Monster swimming down there. Call me a natural-history nerd if you want, but I'm more intrigued by the little aquatic beasts that the director of the Flathead Lake Biological Station, Jack Stanford, found in valleys where the lake's tributaries run. He told me that when he drilled down into the old glacial gravels that fill the rivers' floodplains, stone-fly larvae came welling up in samples of groundwater from a depth of 250 feet (76 meters).

Stone flies in general like lots of dissolved oxygen. Cold, clear flows hold more of that than warmer water can. Not surprisingly, then, these insects do exceptionally well in the Crown, though hardly anyone expected to find some so far underground. Several

thousand feet (a thousand meters or more) higher, larvae of *Lednia tumana,* the recently discovered and extremely rare meltwater lednian stone fly, inhabit the coldest, freshest water of all: pools within a few yards (meters) of melting alpine glaciers.

It turns out that between its peaks and the gravels underlying its valleys, the Crown supports nearly ninety different stone-fly species, the highest number yet recorded for any region. This assemblage nourishes hungry westslope cutthroat trout and bull trout—both increasingly rare outside the Crown and hard-pressed by warming temperatures and invasive species even inside—whitefish, harlequin ducks, and a very real but nonetheless magical songbird, the ouzel. Also known as the dipper, it constantly bounces up and down as if dancing to some lifelong inner beat, hides its nests behind waterfalls, hunts the stone flies and other aquatic insects by walking totally submerged along stream bottoms, and keeps at it all winter, wading under the ice in subzero temperatures, singing bright notes into the frozen air as soon as it surfaces.

A high level of biodiversity gives an ecosystem more elements with which to restore itself after being disrupted. That in turn makes the ecosystem more resilient, quicker to recover, and, thus, better able to adapt to shifting conditions over the long run. A defining characteristic of the Crown is not only that it retains all its native plants and animals but that there are so many kinds to begin with, from white-winged ptarmigan near the summits to subterranean stone flies, mountaintop lichens to bog orchids.

Conservationists focus on ways to shore up survival of the Crown's exceptional biodiversity, both for each creature's own sake and because keeping every role in every local wildlife community, each strand in each web of nutrients, improves the odds of this world-class mountain ecosystem coping with whatever stresses and strains the passing years may bring.

Connecting Wildlands, Wildlife, and People

With human numbers having swarmed beyond the seven billion mark and still climbing fast, the story of life on earth has become one of nature going to pieces right before our eyes. New cropland, livestock pastures, clusters of housing, highways; new oil and gas drilling complexes and pipelines and new roads bulldozed in to fuel the growth; more swaths of clear-cut logging, more dams, more contaminants in the air, land, and water... the list of activities that unravel ecosystems expands by the hour.

As once-continuous wildlife ranges shrink and become cut off from one another, the remnants begin to resemble archipelagos. Like island inhabitants, the wild residents end up with nowhere else to go if conditions change. And sooner or later, conditions will change, if not as a result of direct human disturbance then from disease epidemics, insect outbreaks, drought, wildfire, flooding, invasions by exotic species, or similar sudden impacts. Confined populations are also especially vulnerable to gradual shifts in climate that alter the makeup of the habitats they rely upon.

Over the long run, with no neighboring groups to replenish their numbers and freshen the gene pool, separated populations are increasingly at risk from the negative effects of inbreeding as well. Inevitably, such isolated areas begin to lose species, sometimes in a chain reaction among organisms highly dependent upon one another. Ninety percent of known extinctions since the year 1500 have been on oceanic islands. The similarity to situations developing on the continents today is underscored by the fact that half of the extinctions recorded over the last two decades were in mainland areas.

Pretty gloomy stuff, right? It doesn't have to be. We know the antidote to the fragmentation of ecosystems and impoverishment of the natural realm: more and better connectivity—between protected wildlands, between wildlife communities, and, in the largest sense, between people and this living planet.

Corridors, linkage zones, habitat bridges—the names we choose for the kinds of paths that can connect core wildlife areas aren't important. What matters is that those wildways don't necessarily have to be large or made into reserves themselves to be effective. They don't even have to avoid places claimed by people, not as long as we get better at using rural lands in ways that keep these wildlife "highways" available to other species, if only to pass through safely now and then.

I've seen examples all over the Crown of wildlife-friendly ranching operations. I can point to any number of sites where timber cutting is done selectively, then followed by closures of the new logging roads so that the disturbance to resident or migrating animals is short lived. The issue with making connections isn't that they are hard to put into place. The chief problem is that too many people and institutions still don't grasp the crucial importance of connectivity to begin with, especially for the smallest reserves, most vulnerable to becoming isolated.

On the whole, modern societies have stuck to a style of conservation put into practice more than a century ago, many decades before the general public had ever heard the word *ecosystem*—and even longer before our understanding of ecosystems was revolutionized by advanced studies of genetics, population dynamics, and the complexities of biological diversity. The old strategy for saving nature, if it can be called that, has simply been to focus on one area or one particular species at a time and mount a heartfelt campaign to protect it. Maps of Canada and the United States highlight the results in dark green. The many patches add up to a wonderful collection of parks and preserves built largely around scenic spectacles and charismatic wildlife. It is an achievement to be proud of. But it is only a start. That's all it *can* be until those areas are connected.

Recalling the definition of biological diversity—the total array of species . . . *plus all the processes and interactions associated with them*—it's plain that the part about processes and interactions, the part that gets at the dynamics of ecosystems, hasn't received much attention. As battles over setting aside prime wildlands were won, conservationists thought they were banking a natural heritage that would hold up no matter what happened to the remaining countrysides. They didn't realize that without connections—without the flux and flow of creatures and genes, pollinators and seed-producers, predators and prey across larger landscapes—even the largest individual reserves weren't big enough to last all on their own.

Besides, nearly everybody assumed that there would always be some undisturbed lands in between protected sites for animals to range through. People couldn't envision the extent to which mechanized development would eventually penetrate the most rugged and remote expanses. They had no measurements to reveal the accelerating pace of climate change. Glacier National Park, which is rapidly losing its last glaciers, has become an internationally recognized natural laboratory for climate change studies. And the data gathered there show global warming to be advancing even more rapidly in high mountain ecosystems than in the much-publicized polar areas, making connectivity for movement all the more important if wildlife is to adjust.

Look at the region around you, wherever you happen to be. How built up was it a century ago compared to today? How many people were there in Canada and the United States then? (About 105 million, a third of the current total in the United States alone.) How many paved roads and cars? (Only a smattering; mass

Ripple on a wetland in the Mission Valley

production of automobiles was just getting underway.) How many all-terrain vehicles and snowmobiles and helicopters carried folks through the nearest mountains? (None.)

Realistically, what do you suppose your region will look like a hundred years from now? I'm not sure we can picture that any better than conservationists in the early 1900s could picture our present era. But it's virtually certain that, along with a markedly warmer atmosphere, there will be millions upon millions of additional people, more dwellings, more machinery, and an order of magnitude more activities. Where? My guess would be, practically everywhere a plan hasn't been put in place to conserve as many of the parts *and* the processes of nature as possible through a network of connections. The Montana side of the Crown alone holds 1.3 million acres (520,000 hectares) of roadless habitat—areas that still effectively function as wildlands but lack special protection. Will decisions about the fate of this stockpile of natural resources be made from a five-year perspective or a centuries-long view?

The challenge before us now is to round out the reserves that have already been created, add others in strategic locations, and web them all together with corridors. Then, and only then, can we honestly proclaim that we are saving nature.

Everyone talks about leaving a legacy for future generations. So far, we have left our descendants an assortment of areas destined to become ecological islands if we don't link them together. It's time to congratulate ourselves on what has been accomplished, admit that it's only a first stage, not a solution, and get to work on the next and most crucial phase of conservation: building connections. And keep connecting. In every way possible.

There is no reason on earth to wait another minute. If you're looking for an example of how to begin, you have but to turn toward the Crown of the Continent.

Wild Corridors

The Crown of the Continent has so many things in its favor, I scarcely know where to start to describe them. The reserves within it are closely aligned with one another and in some cases situated side by side. This is one place where plenty of pristine or only lightly disturbed habitats still exist between officially protected areas, serving as wildlife corridors. They need only be managed so that they remain effective. Conservationists here have been working overtime to guarantee that they will be. The sidebar to the right tells this story.

When we stand back to take in a wide view of this region, we're looking, on the whole, at a long-running success story, and I'm grateful for every opportunity to pass it on. The tale leads farther than you might expect. As a regional ecosystem, the Crown is large enough, is intact enough, and has enough internal connections to sustain its marvelous biodiversity over time. Meanwhile, it serves as the critical transboundary link in the much greater Rocky Mountain ecoregion that conservationists call Y2Y—Yellowstone to Yukon. This, biologists point out, is the sort of span that natural processes require to continue operating on a continental scale.

The proof is in the bald and golden eagles that arrive to nest in the Crown each spring, traveling from Mexico, the US Southwest, and the Great Basin sagebrush country of eastern Oregon, Utah, and Nevada. As many as 10,000 more eagles arrive about the same time and hurl on through the region like a fleet of corsairs en route to Canada and Alaska, riding the winds that wash up against the Divide. It is one of North America's grandest migrations. Come autumn, these birds retrace their route, once again skimming the Crown's spires and surfing its gusts for weeks on end.

Wolverines and wolves were eliminated from the American West early in the twentieth century. Decades later, some followed the Crown of the Continent south from regions farther north in Canada to recolonize parts of Montana, Idaho, and Wyoming. They offer toothier proof of the full scope of wildlife traveling up and down the Rockies. So does the female wolf that loped from Glacier National Park 500 miles (805 kilometers) north nearly to Dawson Creek, British Columbia, at the start of the Alaska Highway. As does the male lynx captured in 2003 near Kamloops, British Columbia, and shipped to Colorado as part of a program to reintroduce the species there. He returned 1200 miles (1930 kilometers) by foot, slipping north along the Continental Divide, passing through the Crown, and padding on from there to the Rocky Mountain Forest Reserve near Nordegg, Alberta.

Just link nature to more nature, and it'll hold up fine. Better than fine—it'll be just about perfect. The proof is all over the Crown. You can see it in the images you'll meet on the pages of this book. Better yet, you can visit this place, walk its paths, let your feet and your senses show you the wonder we're part of. Somewhere along one of the trails, an indispensable truth is waiting to reveal itself: connecting nature, saving nature, and saving ourselves are one and the same thing.

Douglas H. Chadwick

WILD SUCCESS: INNOVATIVE CONSERVATION INITIATIVES

While the United States' Glacier National Park includes roughly the same amount of acreage both east and west of the Continental Divide, Canada's Waterton Lakes National Park is located solely on the east side, in Alberta. The other side of the Divide belongs to the province of British Columbia. That area, directly west of Waterton Lakes, holds the relatively pristine headwaters of the North Fork Flathead River. Which is precisely where several companies recently put forth proposals for gold mining, open-pit coal mining, and a massive road-building and drilling effort to extract coal-bed methane. In addition, this development was slated for the narrowest and therefore the most vulnerable section of the entire 2000-mile (3219-kilometer) Yellowstone-to-Yukon length of wildlands running north-south along the continent's spine.

If carried out, the projects promised to convert one of Canada's foremost natural areas into a heavy-industry zone, imperiling neighboring Waterton-Glacier International Peace Park, a world heritage site. Besides that, any effluents flowing farther south would empty into Flathead Lake, the recreational hub whose exceptionally clear waters are ringed with homes, thriving town sites, and state parks. Under pressure from scientists, Montana's former governor Brian Schweitzer, the state's two senators, Flathead Lake shoreline residents, and citizens on both sides of the border, British Columbia's Premier Gordon Campbell issued a mining moratorium in the headwaters early in 2010. Both the British Columbian and Canadian governments are currently considering a proposal to declare at least a portion of that upper Flathead watershed a national wilderness park adjoining the international peace park.

The year 2010 also marked the final stage of the Montana Legacy Project to conserve 310,000 acres (125,453 hectares), most of them around the southern and western ends of the Bob Marshall Wilderness Complex. Plum Creek, a giant timber company restructured as a real estate investment trust, had owned the properties, which included key wetlands and wildlife corridors between the Bob and the Mission Mountains. Two nonprofit organizations, the Nature Conservancy and the Trust for Public Lands, joined forces to buy those holdings and make them public domain, open for general recreation but permanently protected from fragmentation by development.

Along the eastern boundary of Waterton Lakes National Park, the Nature Conservancy of Canada (a separate organization despite the similarity of its name to the US group's) partnered with ranch owners to preserve more than 29,000 acres (11,736 hectares) where the foothills and prairie come together. They did this by arranging conservation easements, which compensate landholders for giving up certain development options. Ranchers who joined the project agreed not to allow commercial subdivision or other large-scale habitat conversion on their properties.

As for livestock raising, the owners' traditional practices continued unchanged. Consequently, so did the open qualities and diversity of vegetation that make it possible for ranching to co-exist indefinitely with hoofed, winged, and burrowing wildlife in this mix of grasslands and aspen groves now known as the Waterton Park Front.

Other organizations have negotiated conservation easements here and there throughout the Crown, north and south of the international boundary. As a result, there are that many more chances for wild and human communities to thrive together, each upholding the quality of life for the other.

But isn't there a serious issue of jobs versus the environment in all this? Ecology versus the economy?

The answer isn't complicated. It's just: no. The diversity of life and a diversity of opportunities and incomes go hand in hand throughout the region.

Many families depend upon natural-resource-based industries. True, some of those enterprises do have a substantial impact on the environment. This is a big place, though. It can take a punch. But people don't want it to take too many, because that would risk knocking out the Crown's primary economic engine: the environment itself. As a group, businesses connected to general tourism, hunting, fishing, boating, skiing, hiking, wildlife watching, guiding, and other forms of recreation generate the most revenue here. During 2011 visitors spent $110 million US within a 30-mile (48-kilometer) radius of Glacier National Park alone.

Taking care of nature is just good business. How could it be otherwise, when every one of us arrives in this world fully invested with life?

—Douglas H. Chadwick

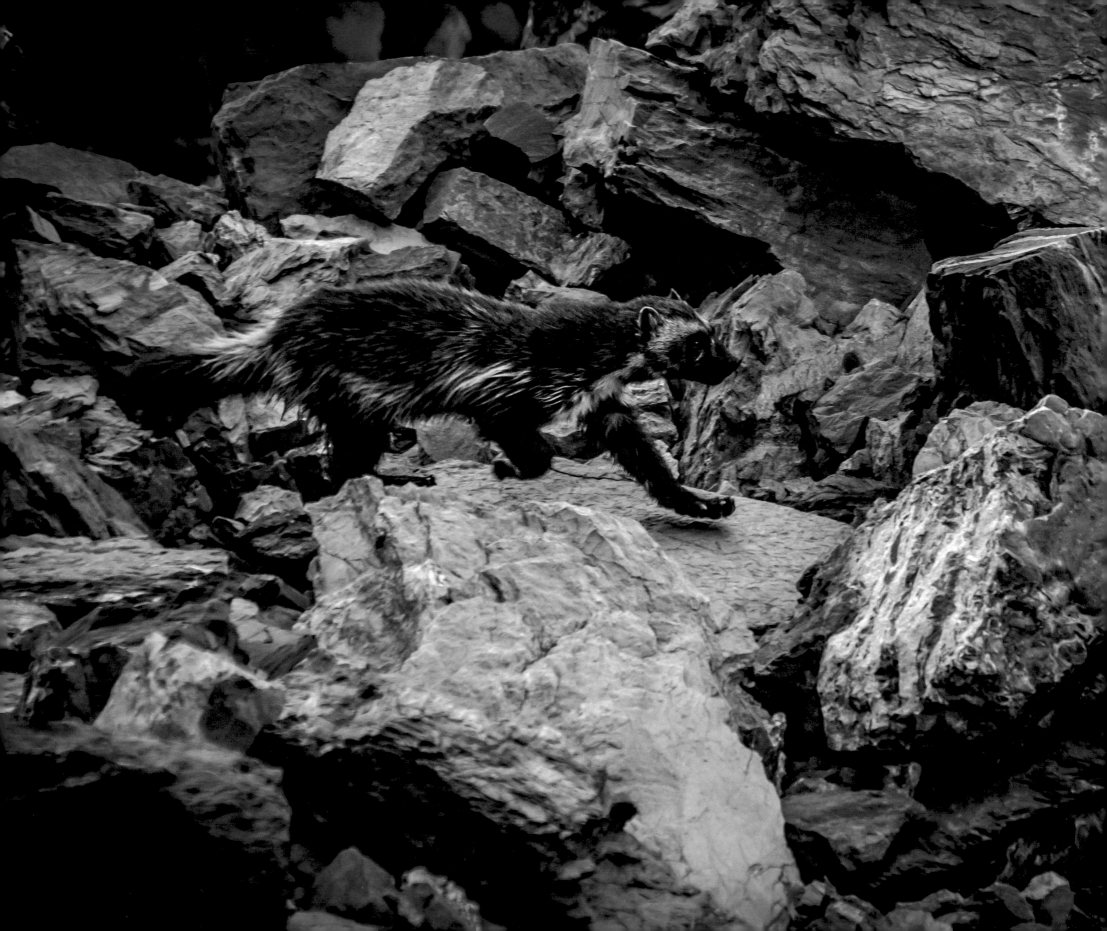

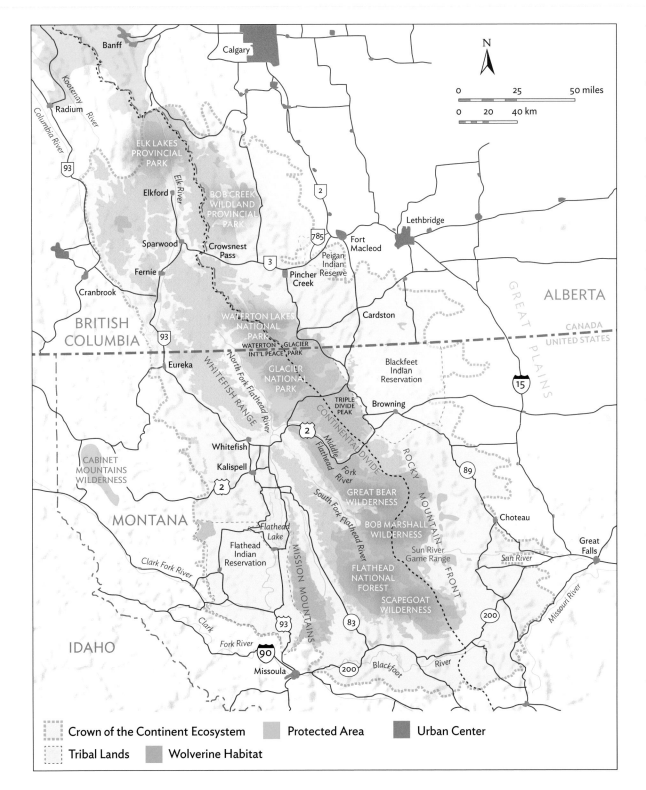

Wolverine Habitat in the Crown

This map shows the areas of suitable habitat for wolverines across the Crown of the Continent. It is based upon a peer-reviewed model developed by wolverine researchers using data on snow cover during spring, which is a critical element in the ecology and distribution of wolverines around the world. About 89 percent of wolverine telemetry locations in summer and 81 percent of locations in winter from eight study areas in North America occurred within areas projected by the model.

Wolverines, one of the most elusive creatures on the planet, occur throughout the higher country of the Crown. The average adult female's home range varies from 110 to 156 square miles (280 to 400 square kilometers). In comparison, the average home range of a female grizzly bear varies from 50 to 300 square miles (125 to 768 square kilometers), depending upon the habitat productivity.

Because they have very low reproductive rates, wolverines cannot sustain high mortality rates, and they are sensitive to human disturbance in their denning areas. Considering projected climate change, wolverines appear to be susceptible to reduction in suitable snowy habitat.

The wolverine was proposed for federal listing as a "threatened" species under the Endangered Species Act on February 4, 2013, by the US Fish and Wildlife Service. In Canada, the western population of wolverines (including those in British Columbia) was assessed by the Committee on the Status of Endangered Wildlife in Canada as a "species of special concern" in 2003 but has not been listed under the Species at Risk Act.

Map based on the work of J. P. Copeland, K. S. McKelvey, K. B. Aubry, A. Landa, J. Persson, R. M. Inman, J. Krebs, E. Lofroth, H. Golden, J. R. Squires, A. Magoun, M. K. Schwartz, J. Wilmot, C. L. Copeland, R. E. Yates, I. Kojola, and R. May, "The Bioclimatic Envelope of the Wolverine (Gulo gulo): Do Climatic Constraints Limit Its Geographic Distribution? Canadian Journal of Zoology 88 (2010): 233–246.

Triple Divide Peak in the Crown of the Continent

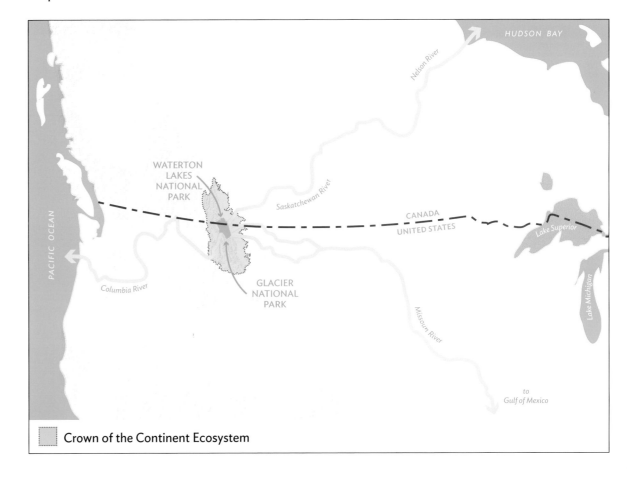

Crown of the Continent Ecosystem

This image of Triple Divide Peak was captured from the trail leading up to Triple Divide Pass, looking toward the west, and facing the side of the mountain that drains to the Gulf of Mexico. The peak can be viewed from the Going-to-the-Sun Road on the east side of Glacier National Park.

ONE SOURCE, THREE OCEANS

Triple Divide Peak, located in Glacier National Park, at 8020 feet (2446 meters), is a fairly rare hydrologic feature—a source of water flowing to three oceans. Rainwater flows from here to the Gulf of Mexico (via the Missouri and Mississippi Rivers), Pacific Ocean (via the Columbia River), and the Arctic Ocean (via the Saskatchewan River to Hudson Bay). Other triple divides are found in Jasper National Park in Alberta, Canada, and in Siberia, Russia.

Map based on the work of C. Muhlfeld and R. Hauer

A bighorn sheep on the Rocky Mountain Front stands between white-bark pines sculpted by the strong prevailing wind.

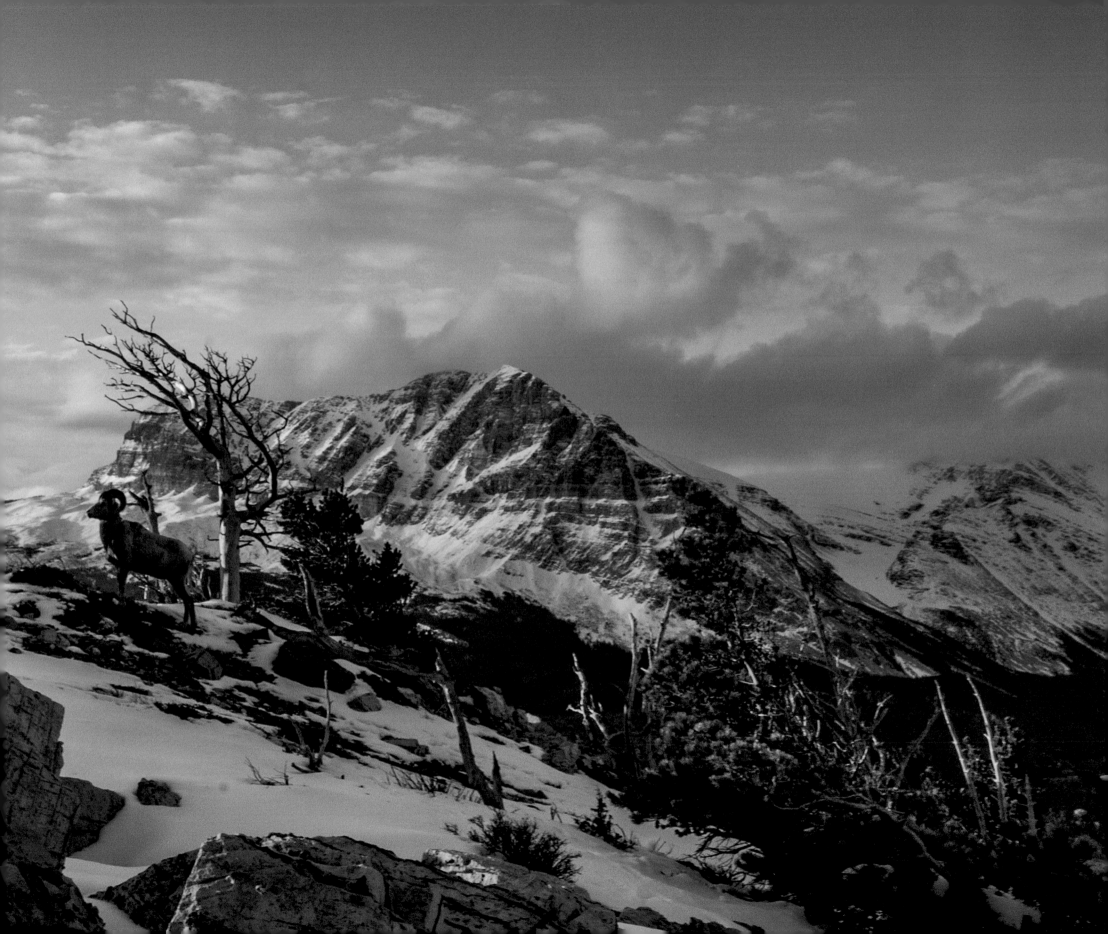

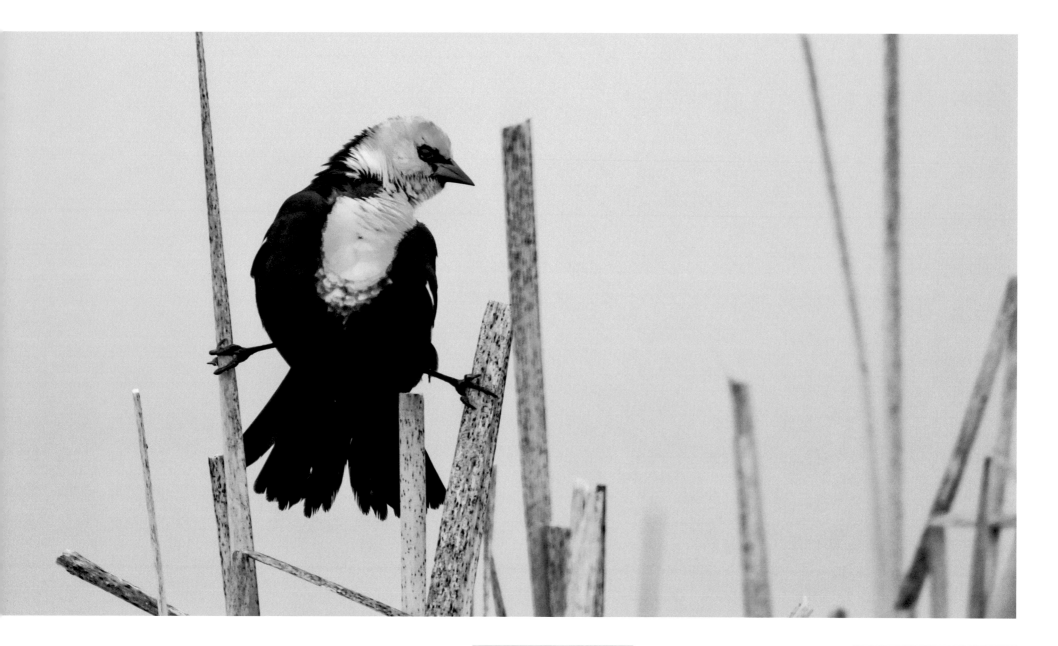

A yellow-headed blackbird perches on cattails in a wetland adjacent to a river. Previously an agricultural area, land in the Flathead Valley has been developed for housing. Some wetland areas near these developments have been protected for wildlife habitat.

OPPOSITE Sunrise illuminates arrowleaf balsamroot along the Rocky Mountain Front. The large roots of these plants were a seasonal food source for Native Americans in the region.

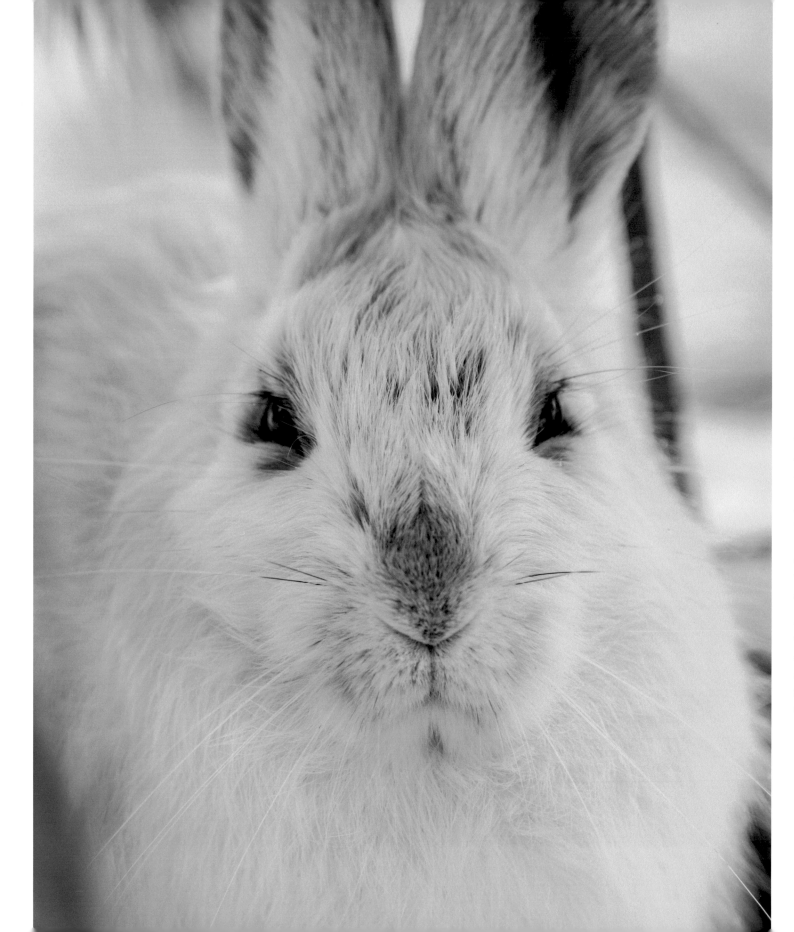

Snowshoe hares change coats from brown to white in the autumn and back to brown in the spring. The shortened days trigger hormones that produce hair without pigment. When the snow cover varies, hares are often left standing out against their surroundings, making them more vunerable to predators.

OPPOSITE The first dusting of snow in the North Fork of the Flathead River, where some wildlife adapts to the changing color of the landscape

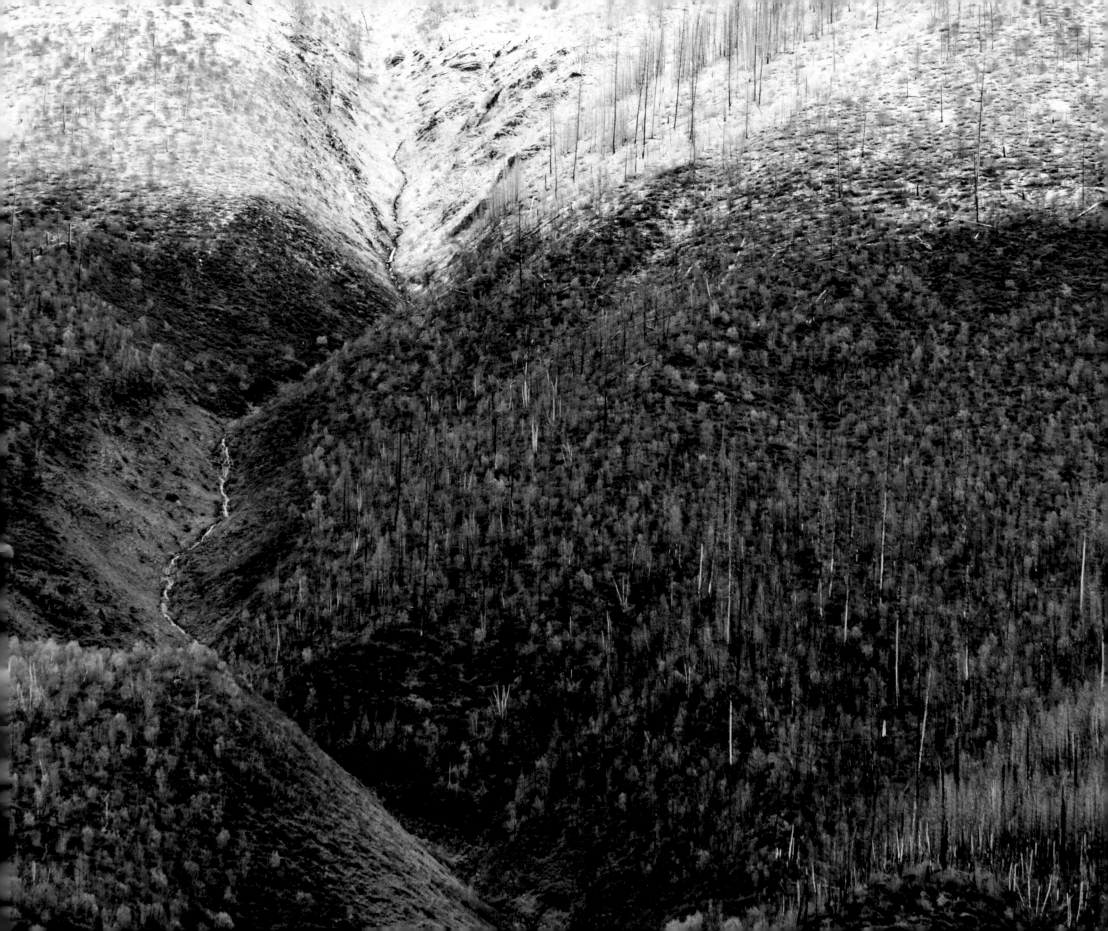

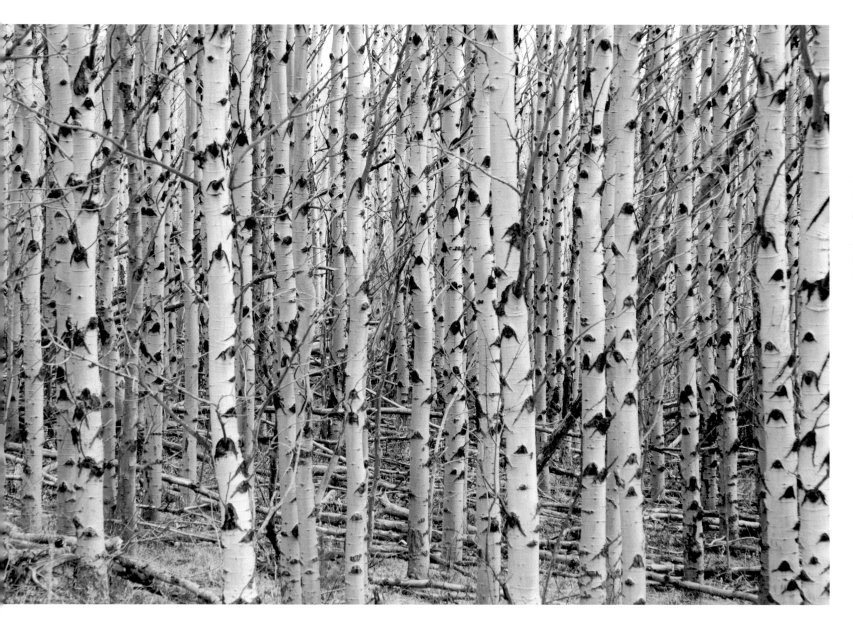

Clusters of aspen trees grow in stands with a shared root system.

OPPOSITE *Snow geese migrate together to nest in the Arctic.*

ASPEN CLONES

Oftentimes when you see a grove of aspen trees, the most wide-spread tree in North America, you are looking at a clone, a group of genetically identical trunks growing from the same root mass. Aspen clones are one of the largest organisms in the world by mass. One way to tell if a stand of aspen is genetically similar is to note if the branches come out of the trunks at the same angle. The other way, aside from genetic testing, is to notice if all the trees change leaf color at the same time in the fall. An aspen clone can cover more than a hundred acres and transfer nutrients from one area to another. This allows aspens to deal with a harsh climate and to send up new growth after part of the clone is affected by fire, drought, or avalanches.

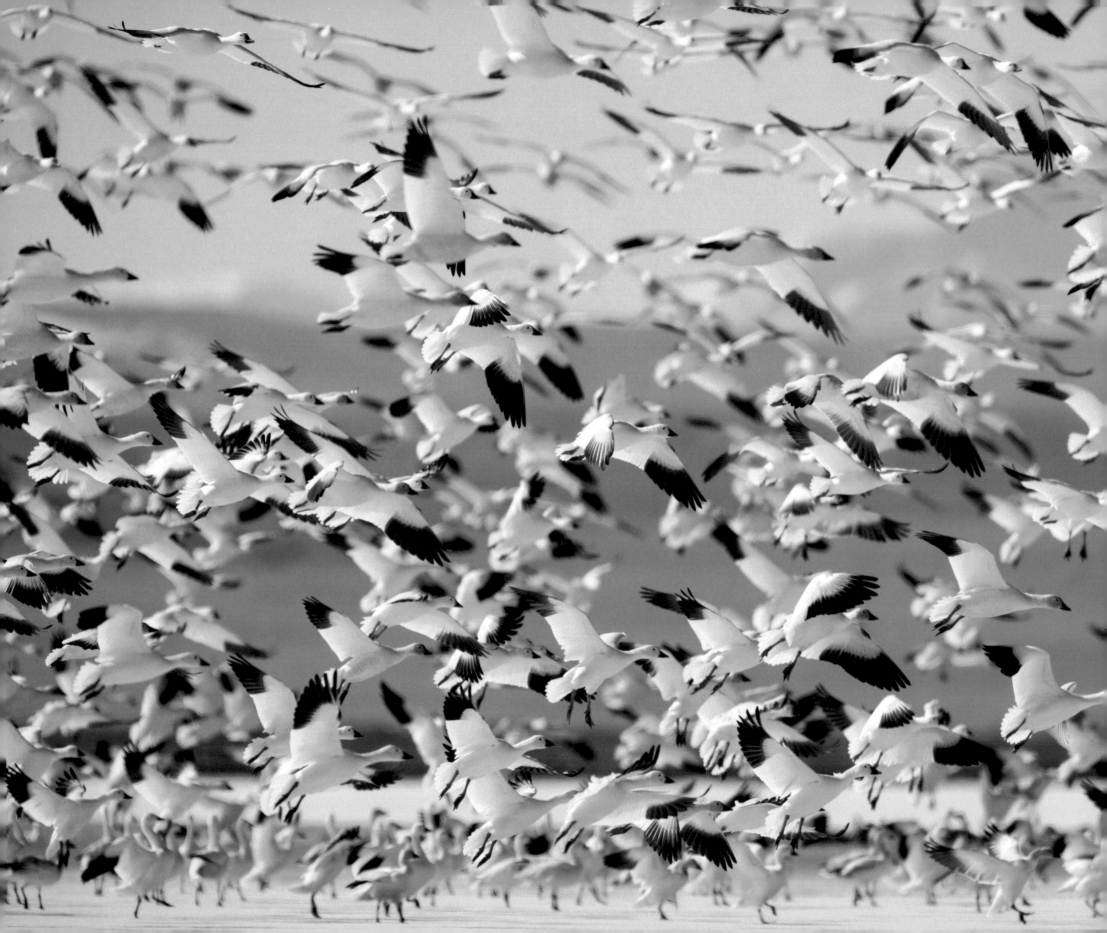

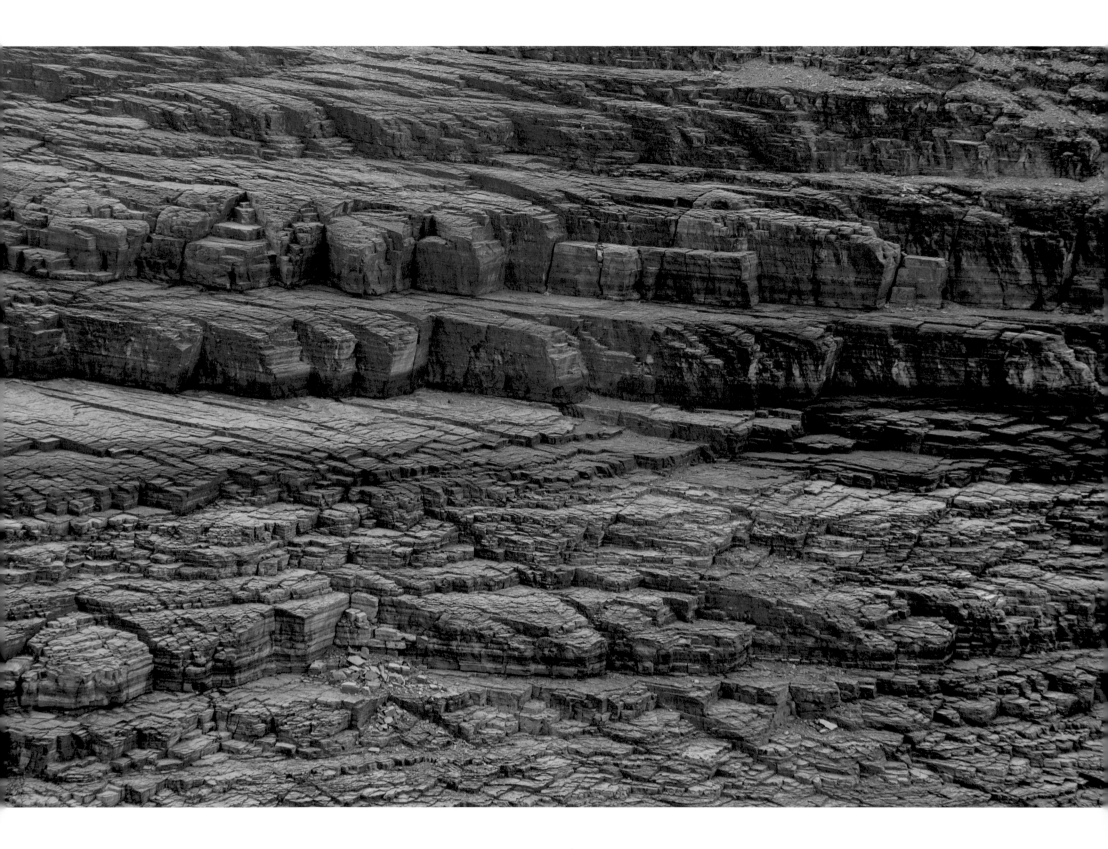

OPPOSITE *A stair-stepped terrace effect caused by the weathering of brightly colored beds of billion-year-old Precambrian red and green argillite*

Precambrian dolomite common to Glacier Park and nearby areas. This unique pattern is called molar tooth structure, the lines often resembling the pattern recognized by early geologists from the surface of the molar teeth of wooly mammoths.

BELOW LEFT *Interbedded green argillite and dolomite*

BELOW CENTER *Dolomite with a cross-cutting calcite vein*

BELOW RIGHT *A Precambrian stromatolite resembling a large "cabbage head." Stromatolites are fossilized blue-green algae found commonly in Precambrian formations of Glacier National Park and Waterton Lakes National Park.*

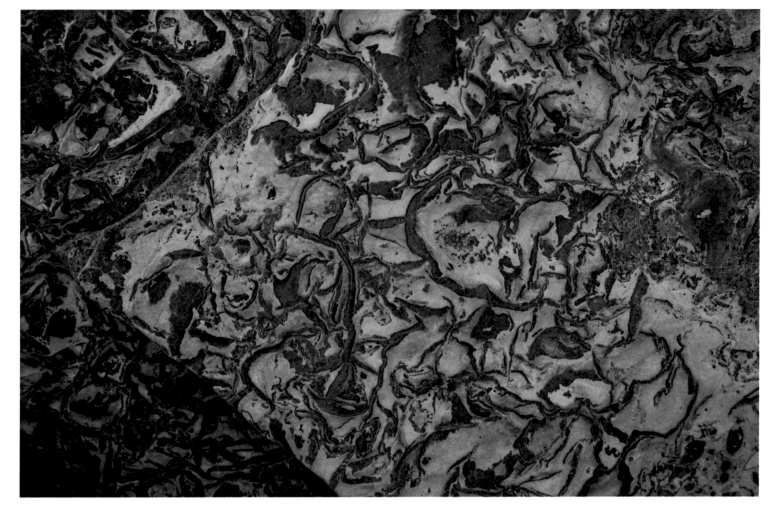

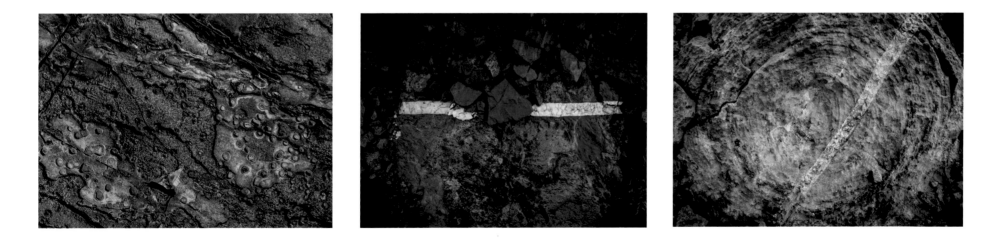

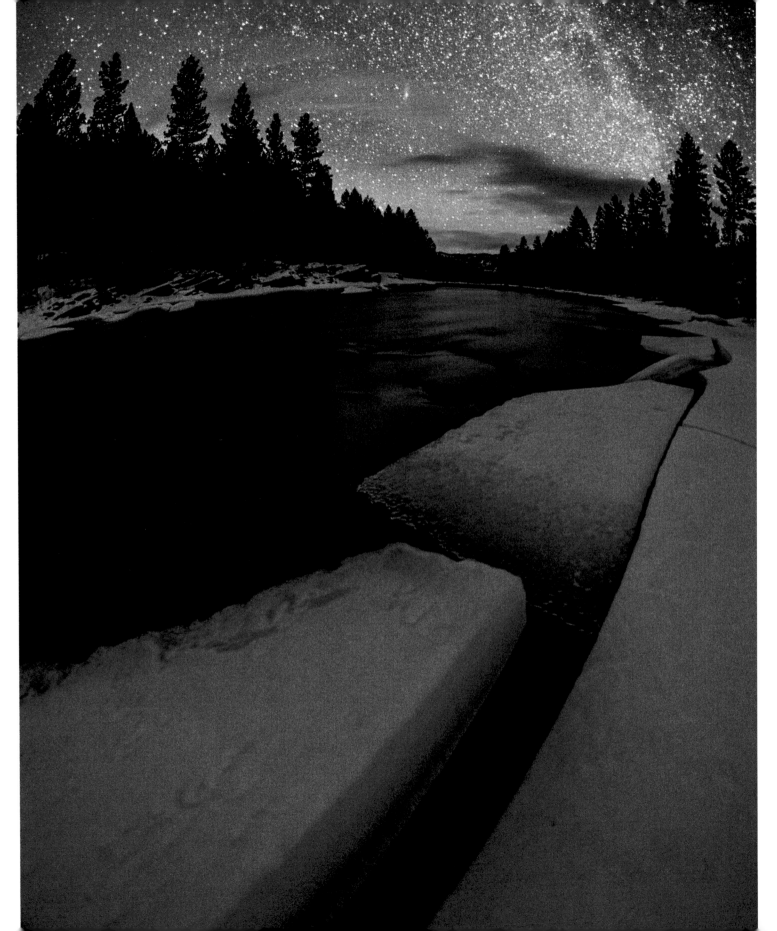

Dark skies free from light pollution are increasingly rare, but necessary for many animals and insects that depend on the natural light of the stars and moon at night. Efforts are being made to reduce light pollution in the Crown, from simple steps like turning off unneeded floodlights at night to large-scale measures to retrofit street lamps with fixtures that turn light down to the ground and away from the night sky.

OPPOSITE Tundra swans silhouetted against a rising full moon during their annual migration to the Arctic

FOLLOWING PAGE, LEFT Multicolored lichen grow on the bottom of a rock overhang in the transboundary Flathead region. Signs of early human habitation— fire scars and fragments of rock tools—can be found in shallow caves in the Crown.

FOLLOWING PAGE, RIGHT Green argillite of the Precambrian "Belt" Sea, found in the high alpine Swan Range. The lines are joint sets formed by mechanical weathering of the rock.

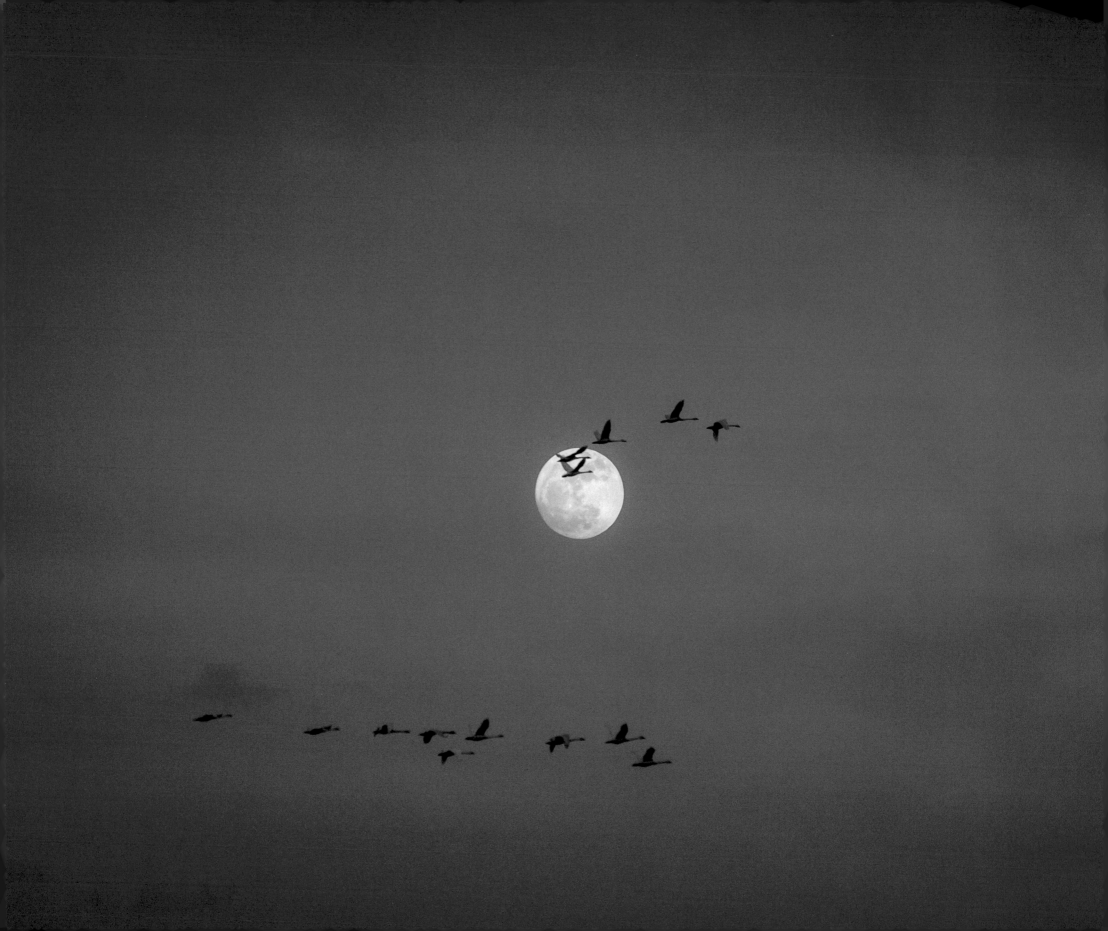

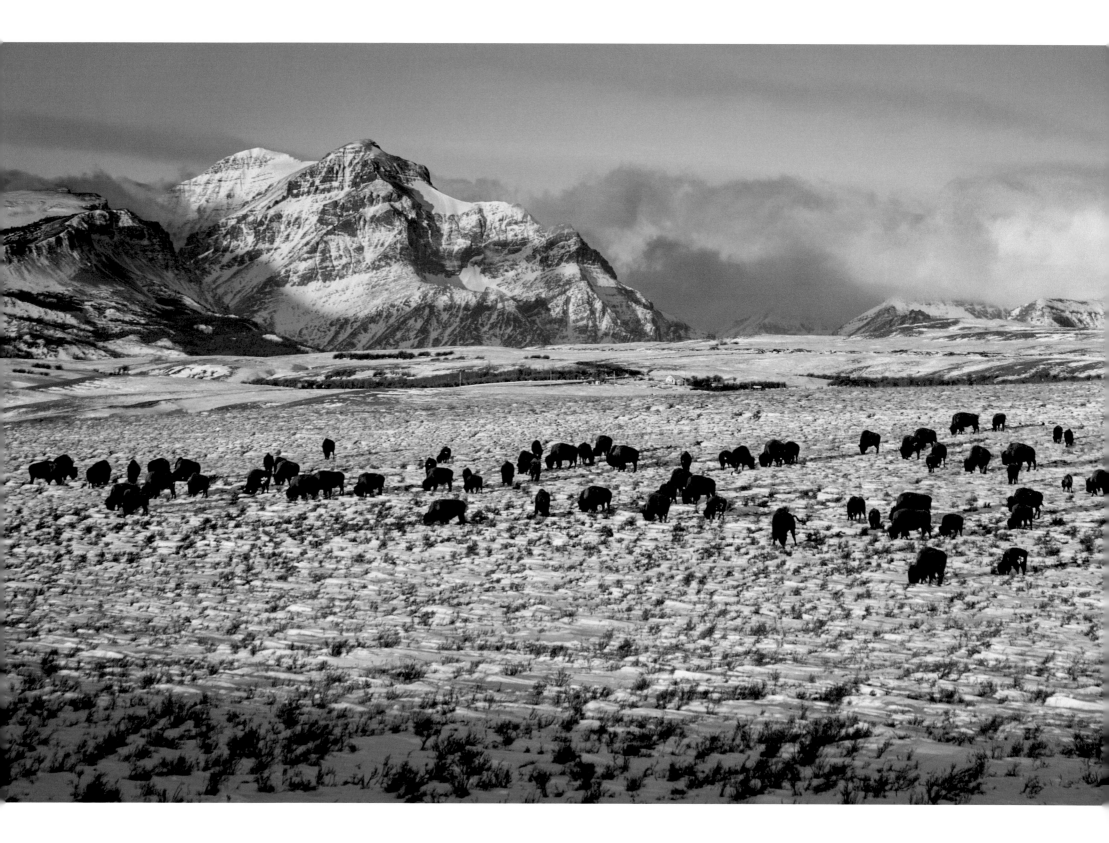

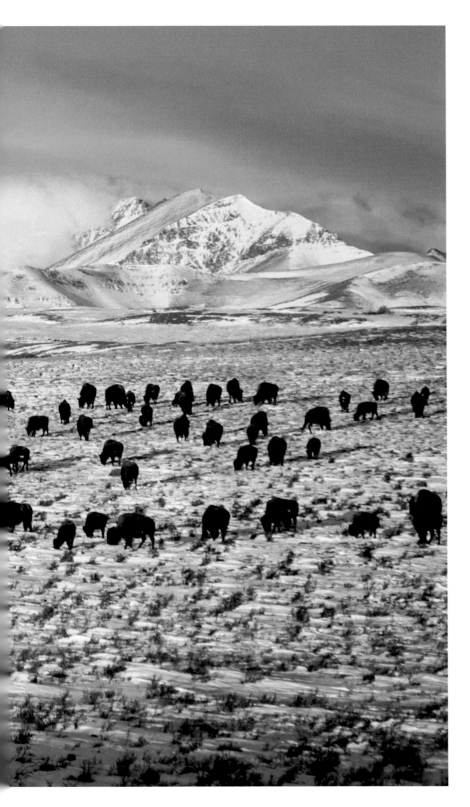

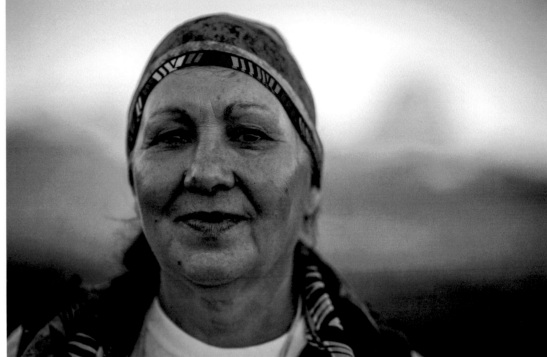

LEFT *On tribal lands, the Blackfoot Nation manages a herd of bison that sometimes numbers in the hundreds. There are increasing efforts to restore bison populations across the Great Plains and along the eastern edge of the Crown.*

The Blackfoot woman pictured above is an herbalist and one of the few people who still practice traditional methods. When oil and gas exploration increased on the Rocky Mountain Front, she—along with other women of the Blackfoot tribe—organized an 80-mile (129-kilometer) walk from Chief Mountain to Heart Butte to raise public awareness about the effects of fracking (hydraulic fracturing) on clean water sources.

Meltwater pool atop the Salamander Glacier in Glacier National Park

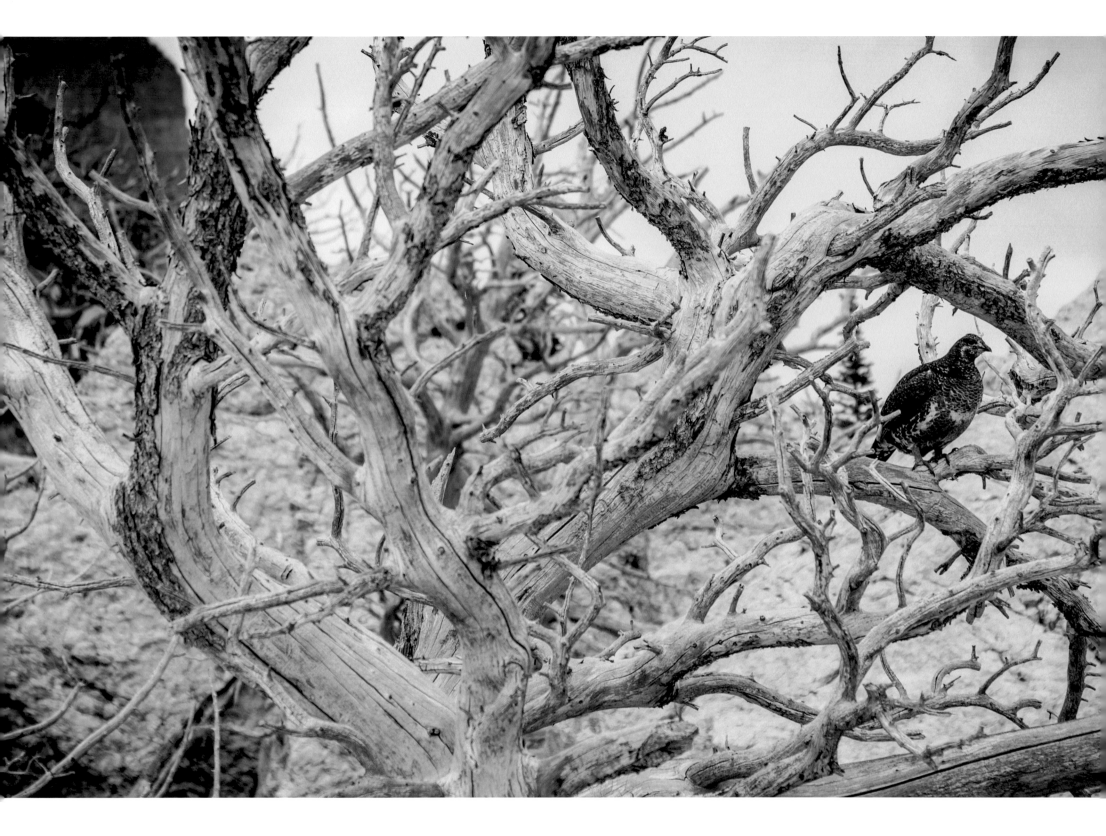

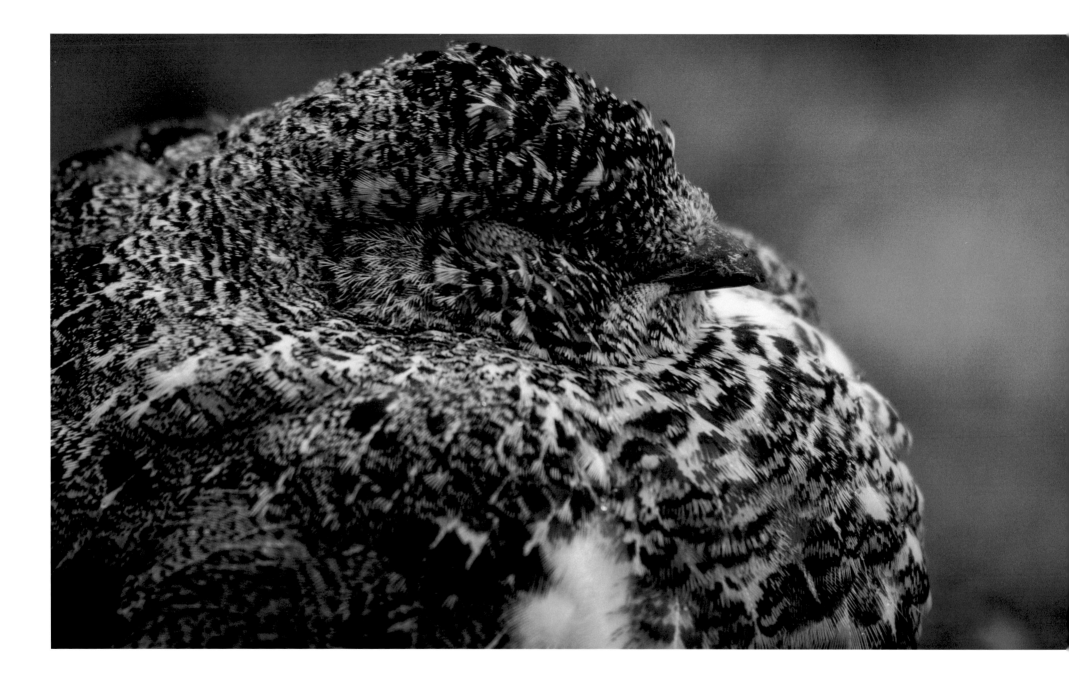

OPPOSITE *Grouse among white-bark pine skeletons*

White-tailed ptarmigan

Native fish species such as west-slope cutthroat trout, bull trout, and Arctic grayling are a world-class attraction for anglers, but are very vulnerable to warming of waters due to climate change.

OPPOSITE *A fly fisherman on McDonald Creek in Glacier National Park*

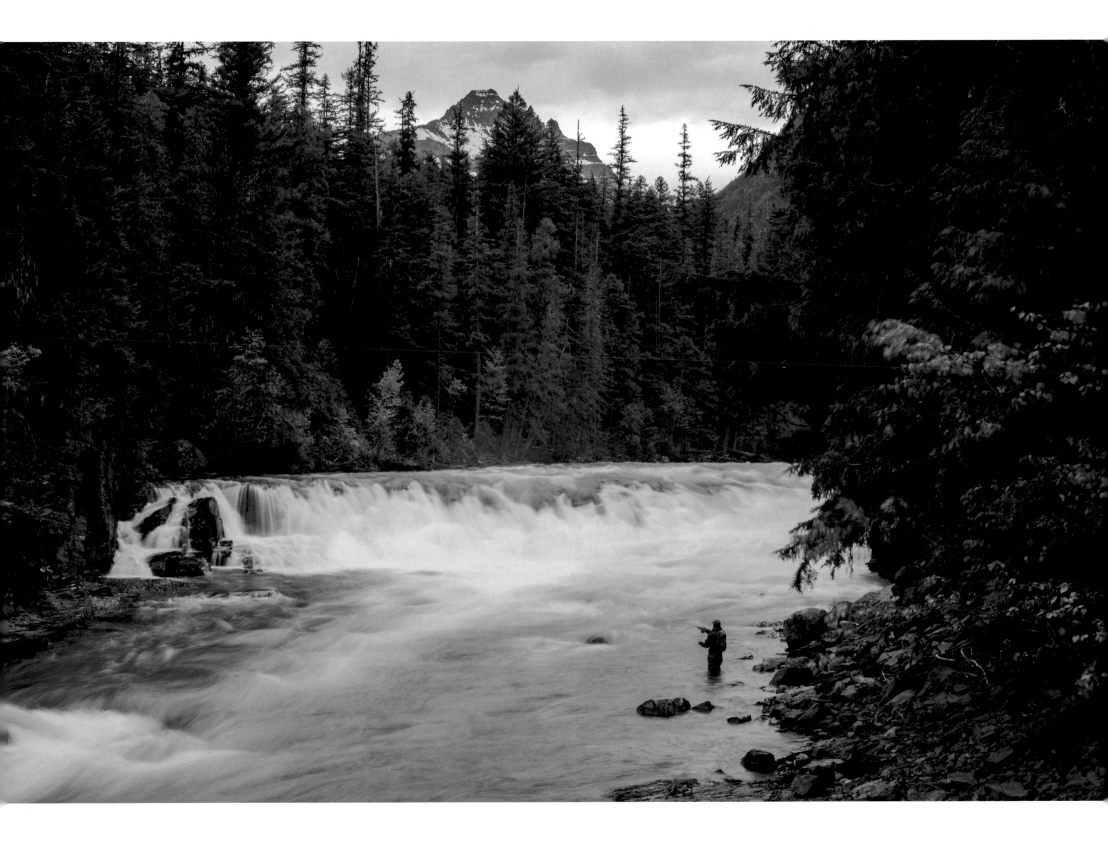

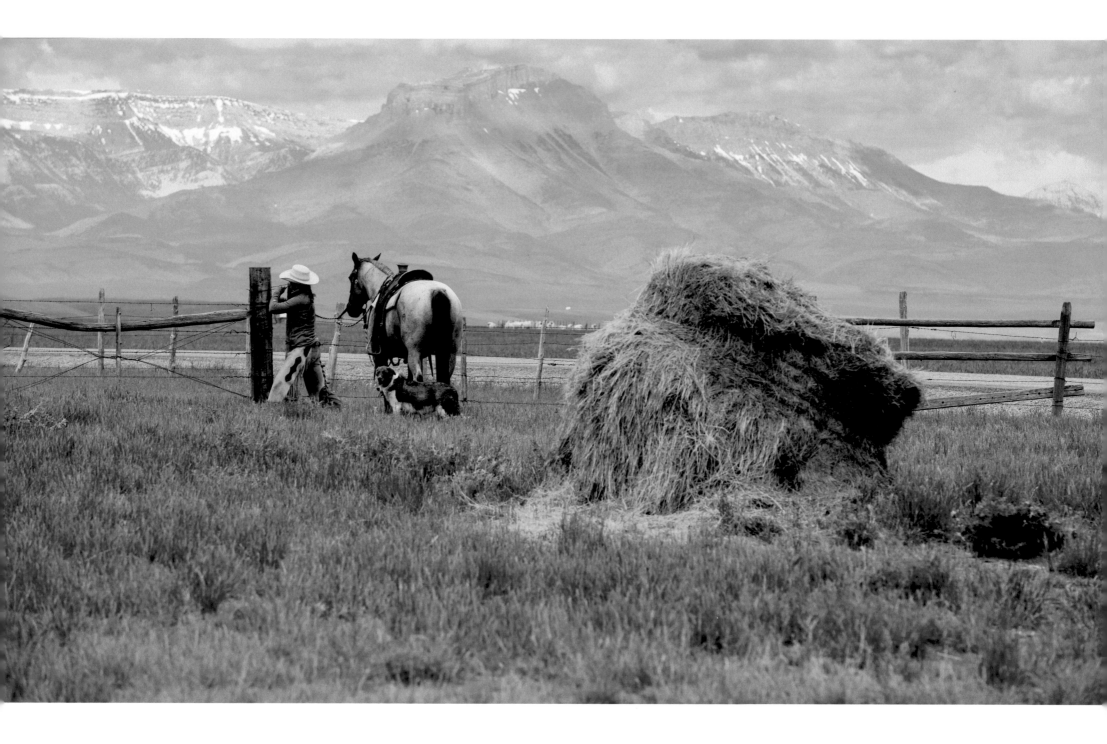

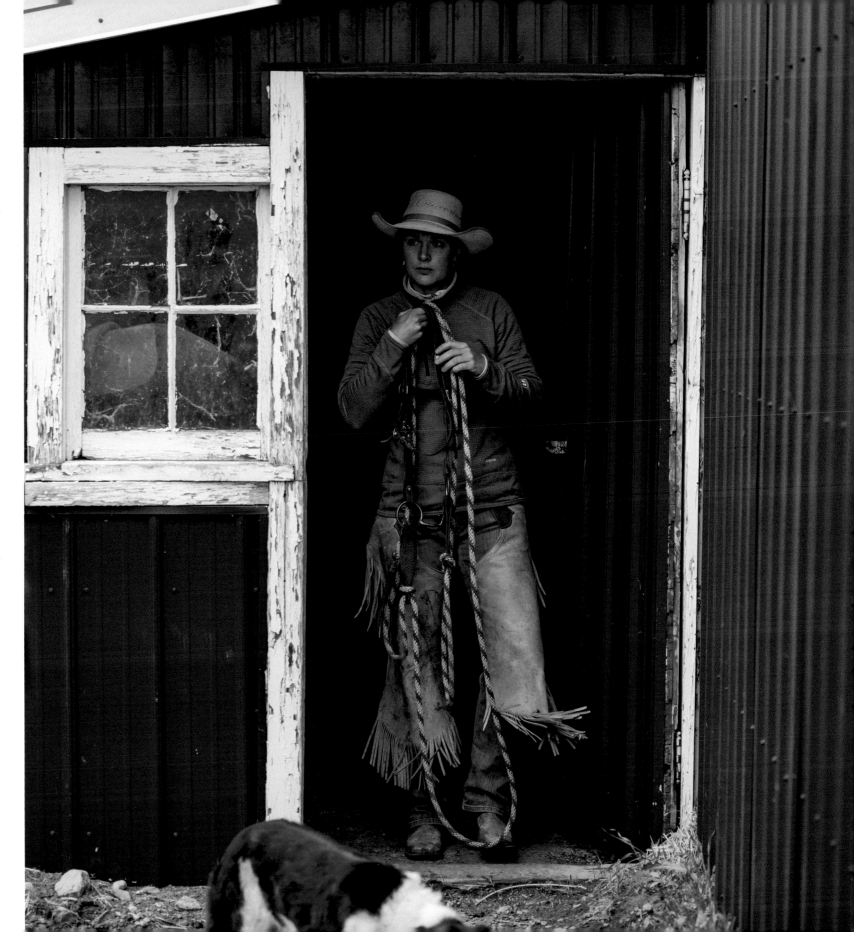

Megan Lee lives and works on her family's ranch outside of Choteau, Montana. She says, "It's the land that sustains us, in so many ways. Sure, we could make an easier living somewhere else. But that would mean living somewhere else."

FOLLOWING PAGE, LEFT
The effects of pine beetles in a forest outside of Choteau along the Rocky Mountain Front

FOLLOWING PAGE, RIGHT
Snags of lodgepole pines stand above a carpet of seedlings that sprang from seeds released during a fire.

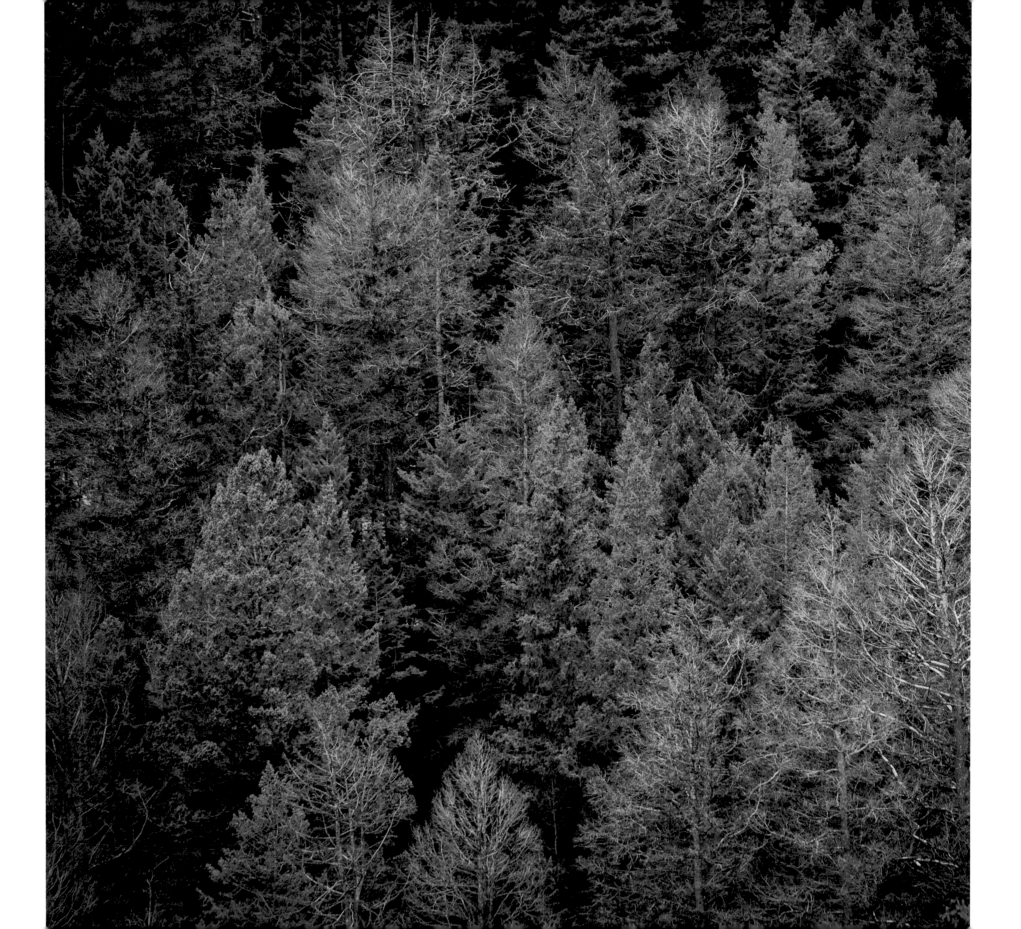

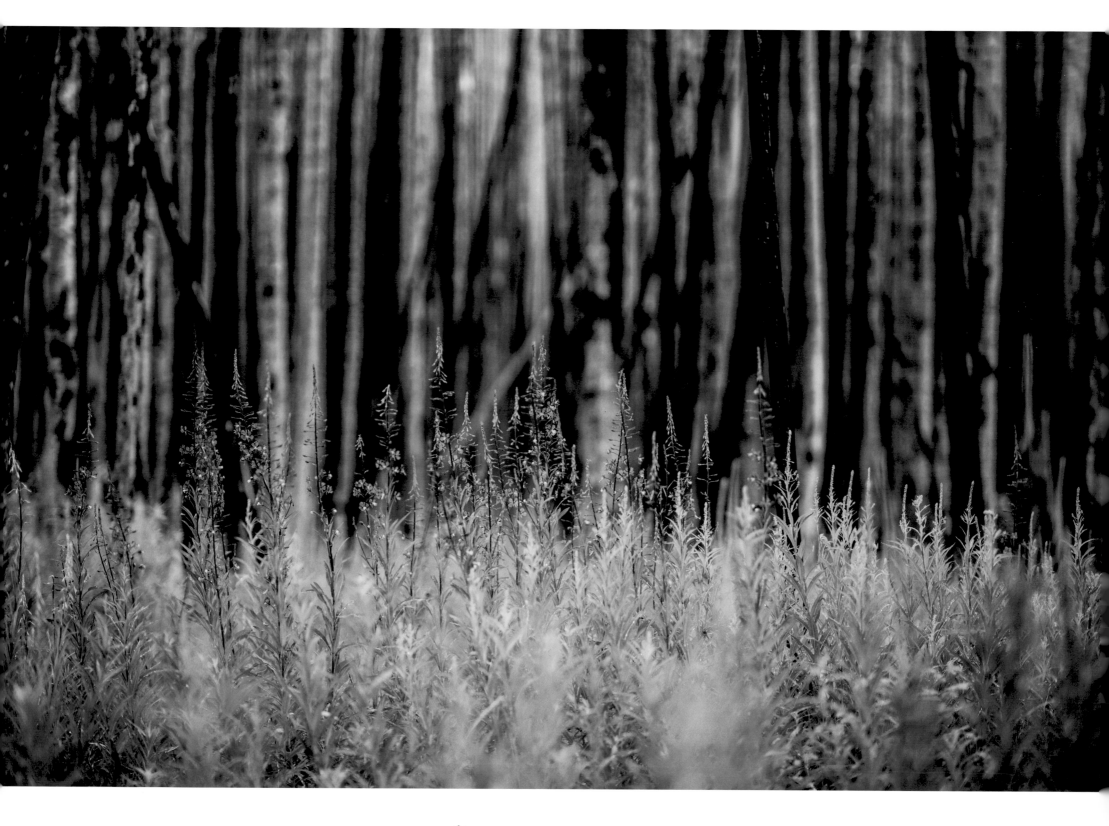

A PLACE FOR WILDFIRES

Decades of aggressive suppression of lower-elevation wildfires from the 1920s or 1930s to the 1990s has changed the ecology of forests around the Crown. When natural forest fires are allowed to burn every few years, they clear smaller trees, shrubs, and grasses from the forest floor, reducing the fuel load as well as the risk of large, catastrophic fires. Many plants have adapted to withstand fire and even rely on it as part of their life cycle. Natural forest fires tend to burn in a mosaic pattern, leaving pockets of forest unburned across a landscape. This mosaic provides unique habitat niches and allows for variety among species. Fire, which helps recycle nutrients, was used by Native Americans for centuries before Europeans came to North America, as a way to clear land and provide habitat for animals and wild plants they harvested.

After sixty to seventy years of fire suppression in the Crown, many forests are unnaturally thick with "fuel ladder" trees and shrubs that grow up into the forest canopy. When a fire comes through an area thick with low-growing vegetation, it burns hotter and reaches the crowns of tall trees, killing everything in the forest and leaving a barren landscape quite different from that left by natural fire burn patterns.

Natural forest fires also help keep disease and insect outbreaks in check. An increase in large-scale mountain pine beetle outbreaks across the West is due in part to forest conditions resulting from fire suppression and climate change. Pine beetles spread in dense, uniform stands of forest. Once a forest has succumbed to an infestation, large tracts of dead trees make perfect fuel for catastrophic fires.

In the past, beetle numbers have been controlled during the winter during cold spells of -30°F (-34°C) for a few days, temperatures at which beetle larvae die off. These kinds of cold temperature have been less common in the past decades.

OPPOSITE *Fireweed is an herbaceous perennial that rapidly colonizes burned-over areas.*

FOLLOWING PAGES *Western larches show fall color beneath a fresh dusting of snow on the Whitefish Range. Forests rebuild in years following fires, as new trees grow amid burned remains.*

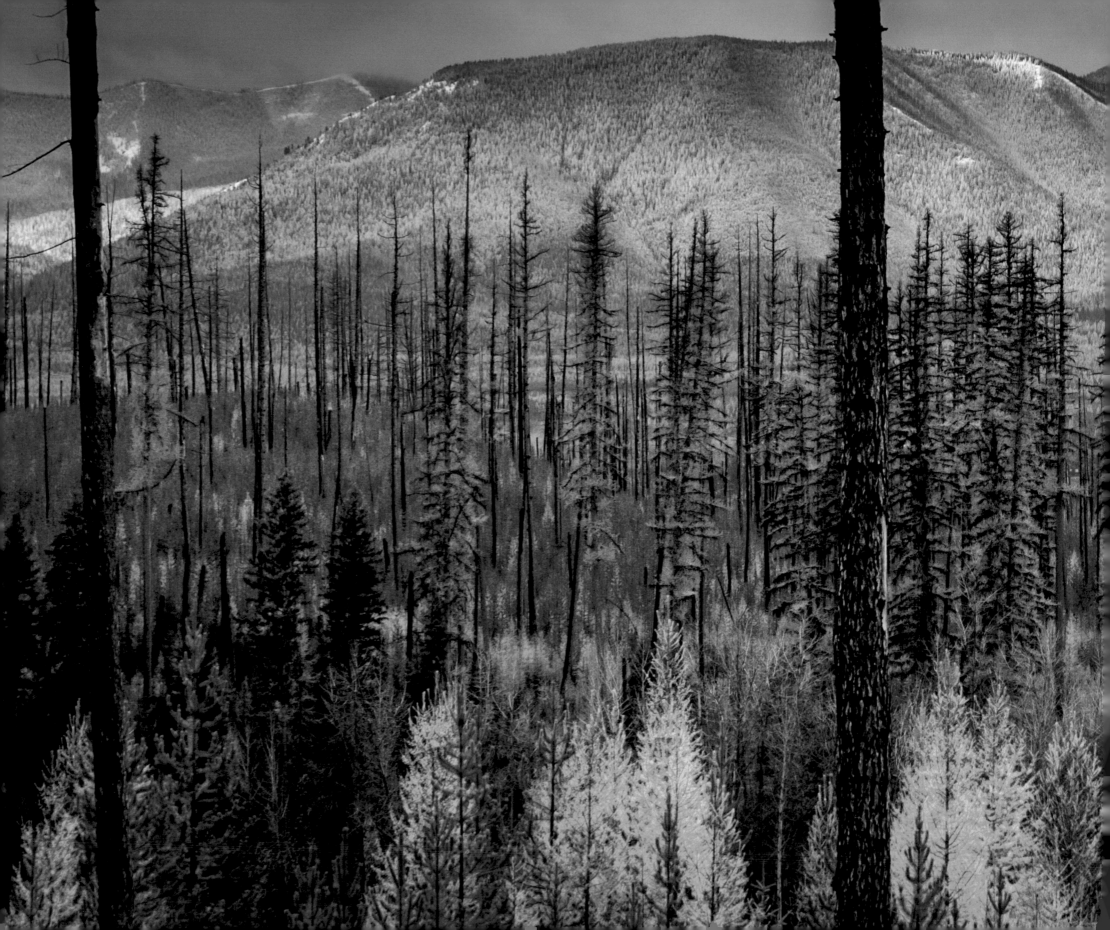

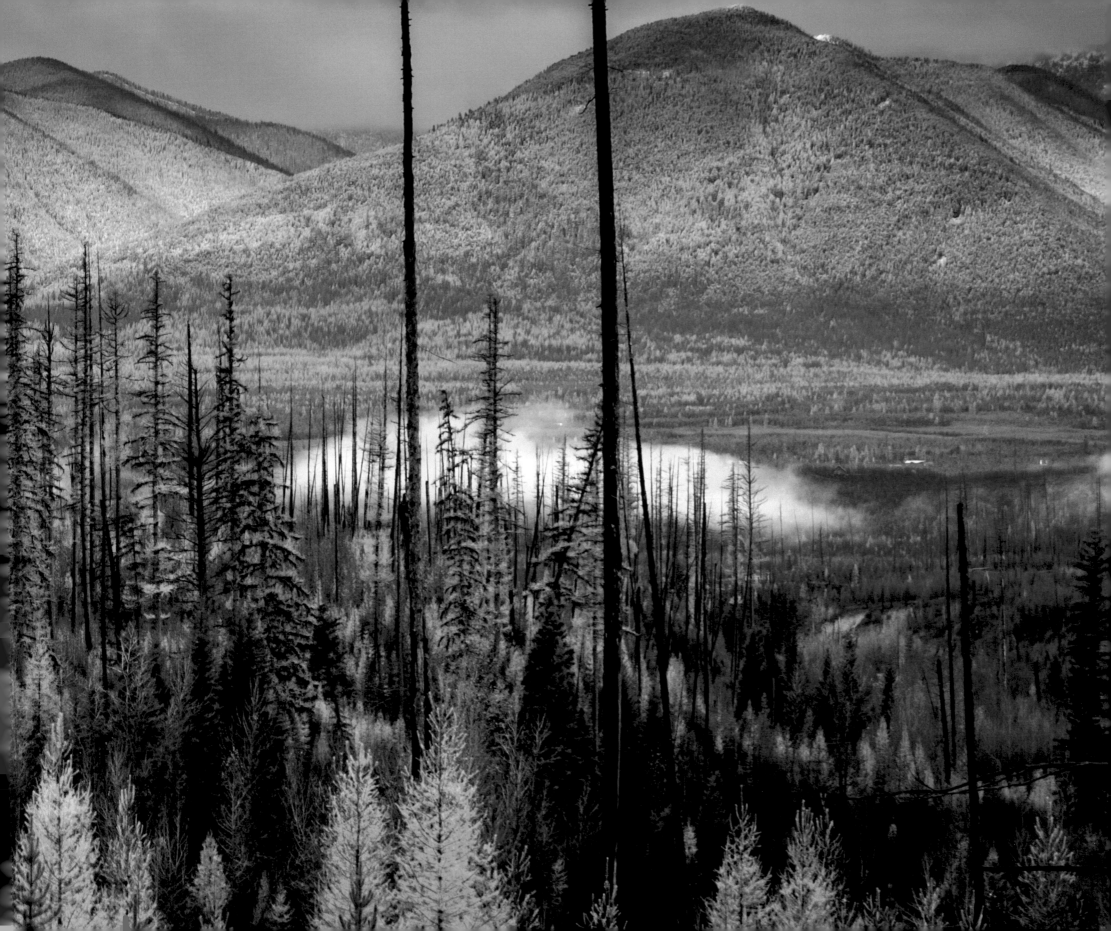

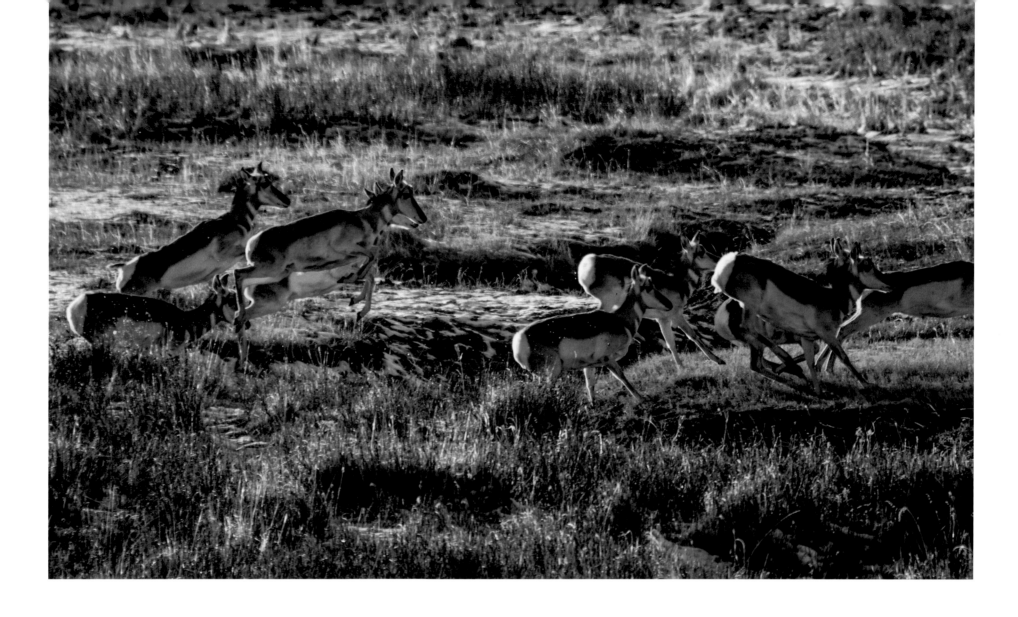

"I was told as a kid that antelope can't jump— and anyone who's watched them encounter a fence would think the same. Often when antelope come to a barbed-wire fence, they will walk the fence line until they find a spot to crawl under. Occasionally they do try to jump fences, but unlike deer or elk they usually don't clear the fence and end up tangled with a tragic fate. The solution for the thousands of miles of barbed-wire fence in antelope country: removing or replacing the lower wire with a higher, off-the-ground, smooth wire. This allows antelope to move freely, ducking under the fence, and keeps cows in. Antelope on the eastern edge of the Crown will travel more than 250 miles (400 kilometers) to get from wintering grounds to fawning grounds." —Steven Gnam

Antelope along the Rocky Mountain Front

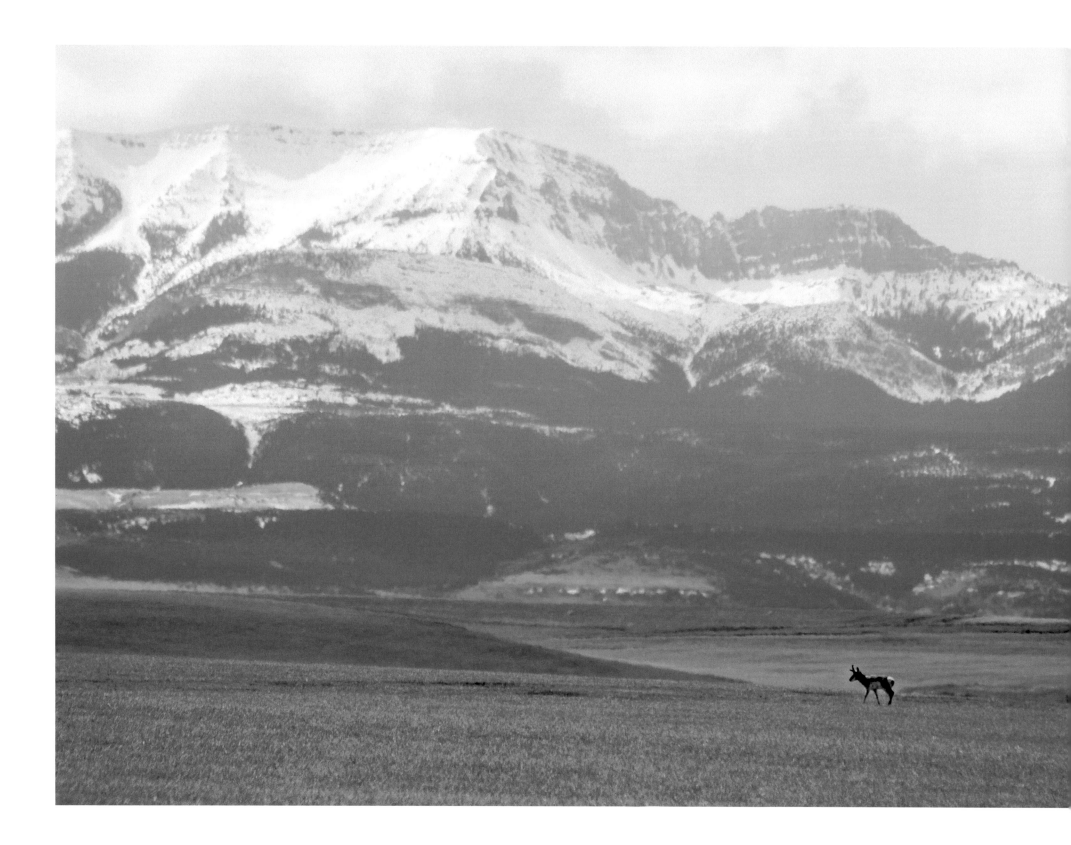

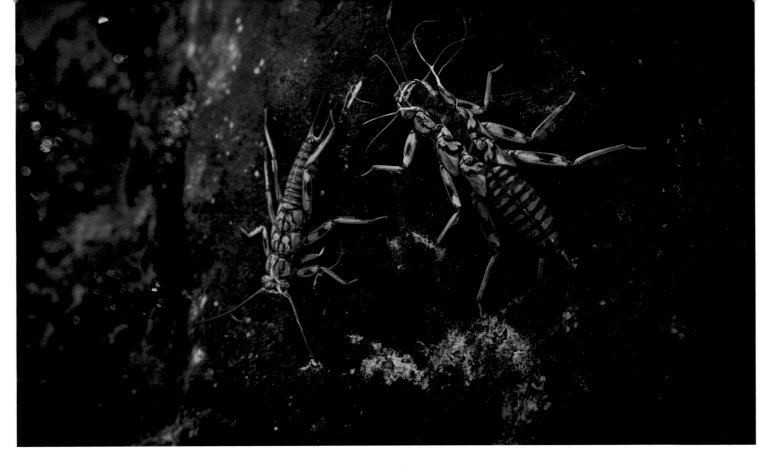

The presence of stone flies, a species at the bottom of the food chain, indicates that water is cold and clean.

The Flathead is a fluvial river, flowing through glacial sediments. Every season it changes course, shaping the landscape as it carves a new path each spring. Looking at the Middle Fork of the Flathead, you see only about 70 percent of the water—the rest is traveling under and through the stones and ground surrounding the river.

A CAUTIONARY TALE

While fly-fishing on a crystal-clear lake high in the Crown, the last thought on your mind may be "Are these fish safe to eat?" Sadly, in some cases, the answer is "no." Global use of contaminants such as mercury, polybrominated diphenyl ethers (PBDEs), pesticides, polychlorinated biphenyls (PCBs), and polycyclic aromatic hydrocarbons has affected the health of fish in the Crown. Molecules from pesticides and chemicals are releases into the air through industrial or agricultural processes, and eventually they fall back to the earth as precipitation. Toxins can accumulate in bottom-of-the-food-chain organisms such as phytoplankton and aquatic insects. Fish can consume enough of these organisms that their levels of contaminants become dangerous for humans to eat. In the Crown, some contaminants are linked to local industrial activity or are carried overseas by strong air currents from east Asia. Global circulation of toxins in air and water is a reminder of the fragility of vital natural resources shared throughout the world.

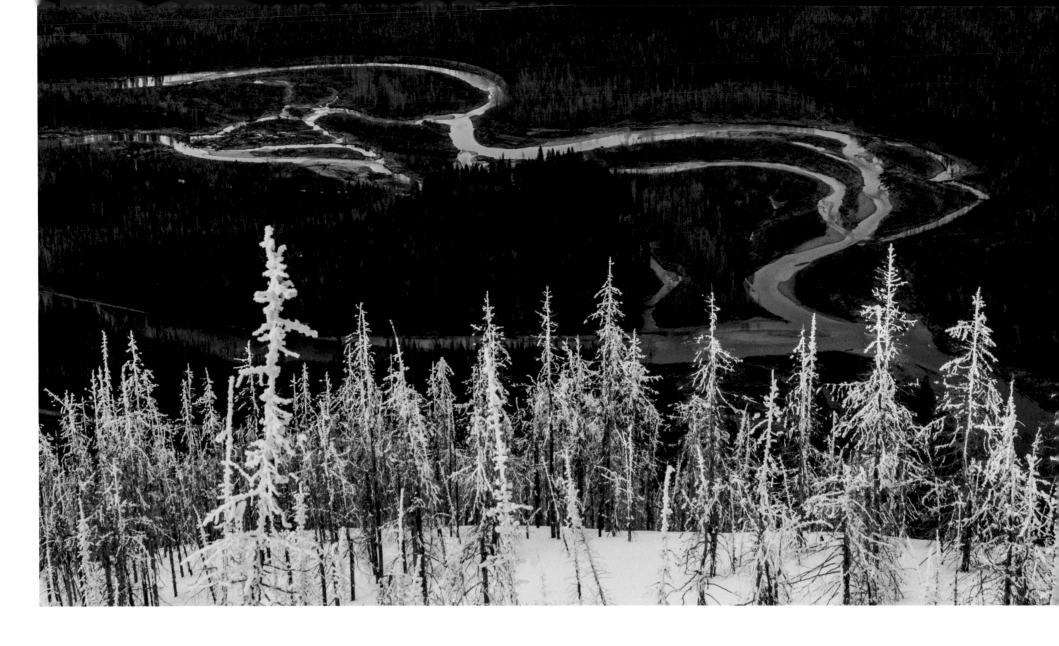

A LIVING RIVER

The streams of Glacier National Park are beautifully colored due to the pebbles of bright red and green argillite, quartzite, tan dolomite, and many hues in between.

Stone flies and freshwater shrimp have been found several miles away from the Flathead River where the river flows underground through glacial debris. In this underground world—called the hyporheic zone—the water is cooler, there is more dissolved oxygen, and unique nutrients provide the building blocks for a food web.

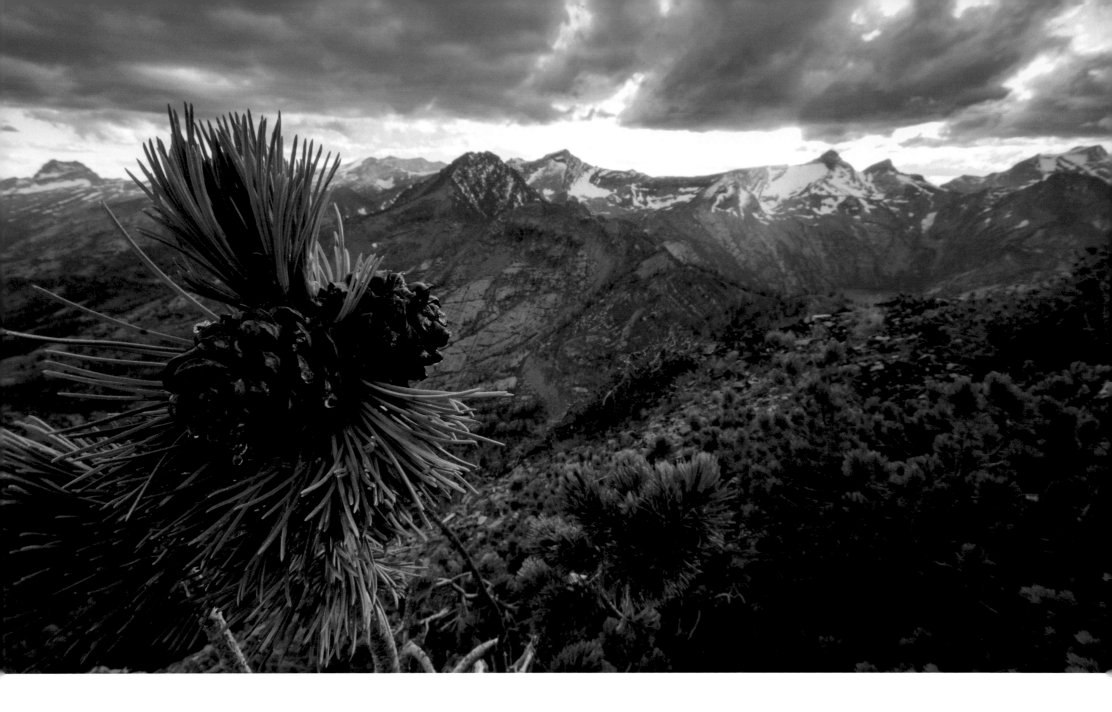

WHITE-BARK PINES

White-bark pines grow in the harshest mountain environments of North America. For thousands of years they have survived high winds, avalanches, and the dry and shallow soils of the subalpine ecosystem. The white-bark pine is a source of food for many species, a shelter for plants and animals where few other grand trees grow, and an anchor that prevents avalanches and erosion.

In the past fifty years, 90 percent of white-bark pines in most areas of the Rockies have died due to white pine blister rust, the effects of fire suppression, and mountain pine beetles. This trio of events has ravaged these great pines, changing the face of subalpine ecosystems across the West.

White-bark pine on a high ridge in the Mission Mountains Wilderness Area

WILD CONNECTIONS

The Clark's nutcracker
and white-bark pine have
developed a distinct
mutualistic relationship. The
Clark's nutcracker will take
the large wingless seeds of
the white-bark pine and fill
a sublingual (throat) pouch
with 50–150 seeds. The
nutcracker will fly—up to 14
miles (22.5 kilometers)—to
cache the seeds in sets of 3–5
at the right depth for white-
bark germination. Throughout
the year the nutcracker will
return to these caches and
eat the seeds. However, the
nutcracker will not return to
all of the nearly 100,000 seeds
it cached. These forgotten
seeds will often germinate and
grow into new trees.

A Clark's nutcracker in a
white-bark pine

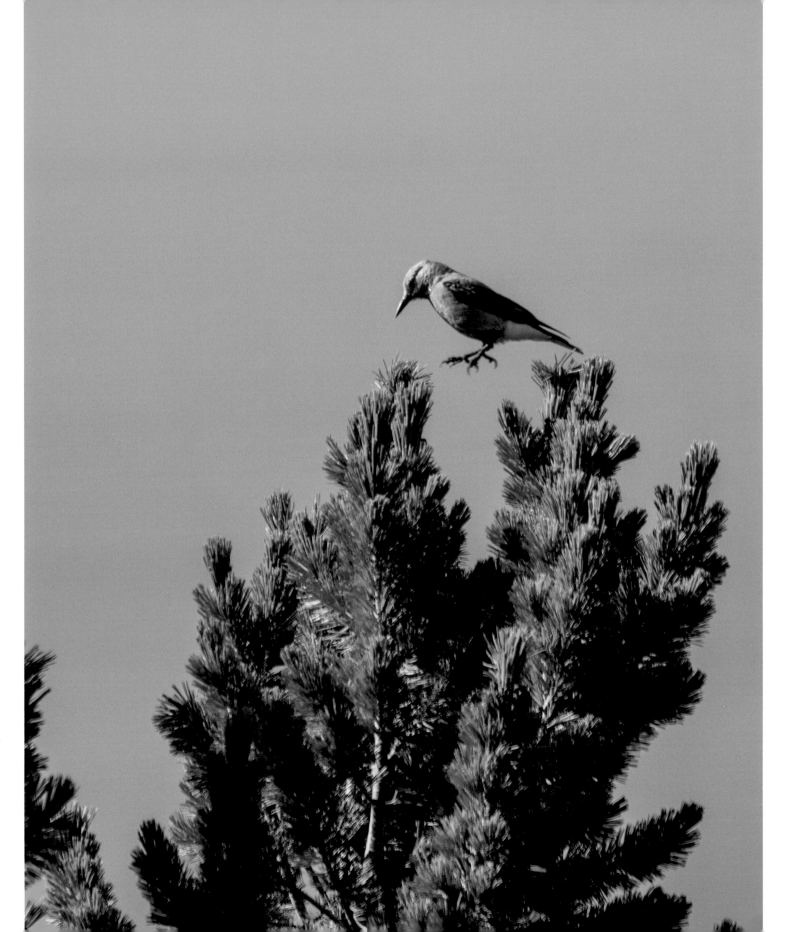

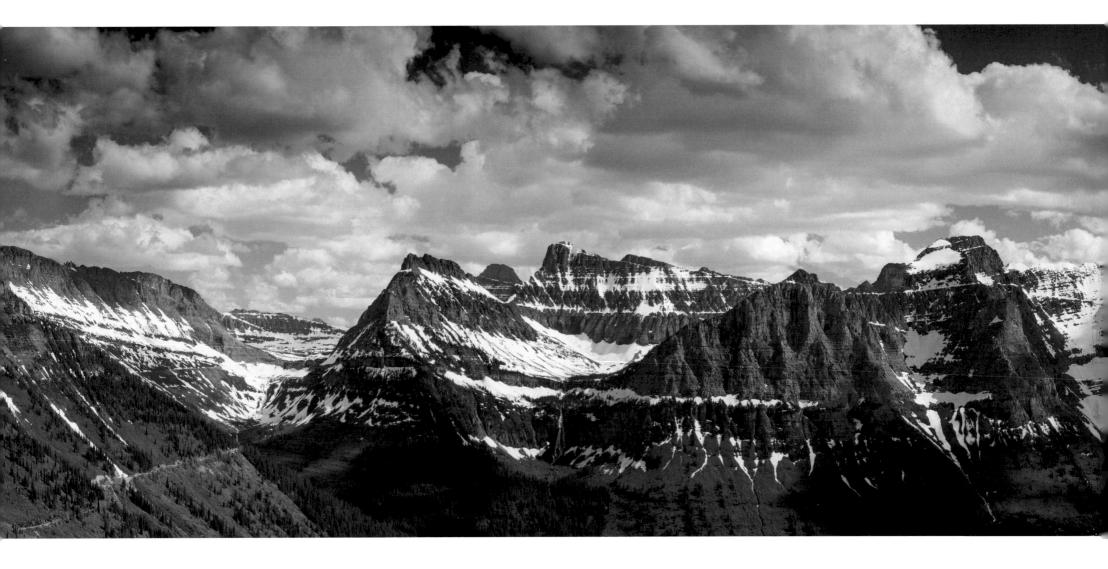

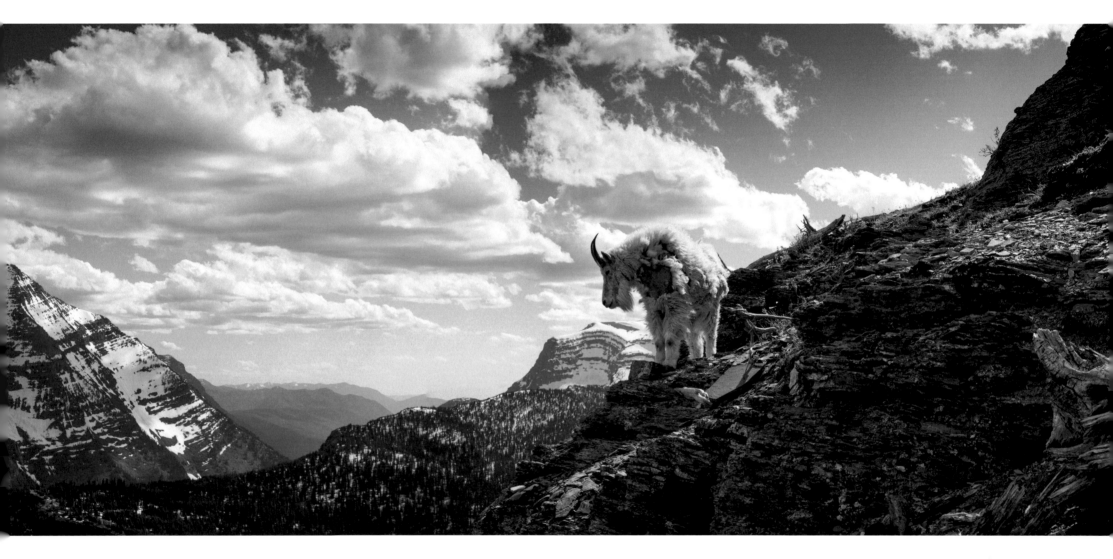

Mountain goat in the Lewis Range,
which extends from Waterton
Lakes National Park in Alberta to
the Blackfoot River in northwestern
Montana

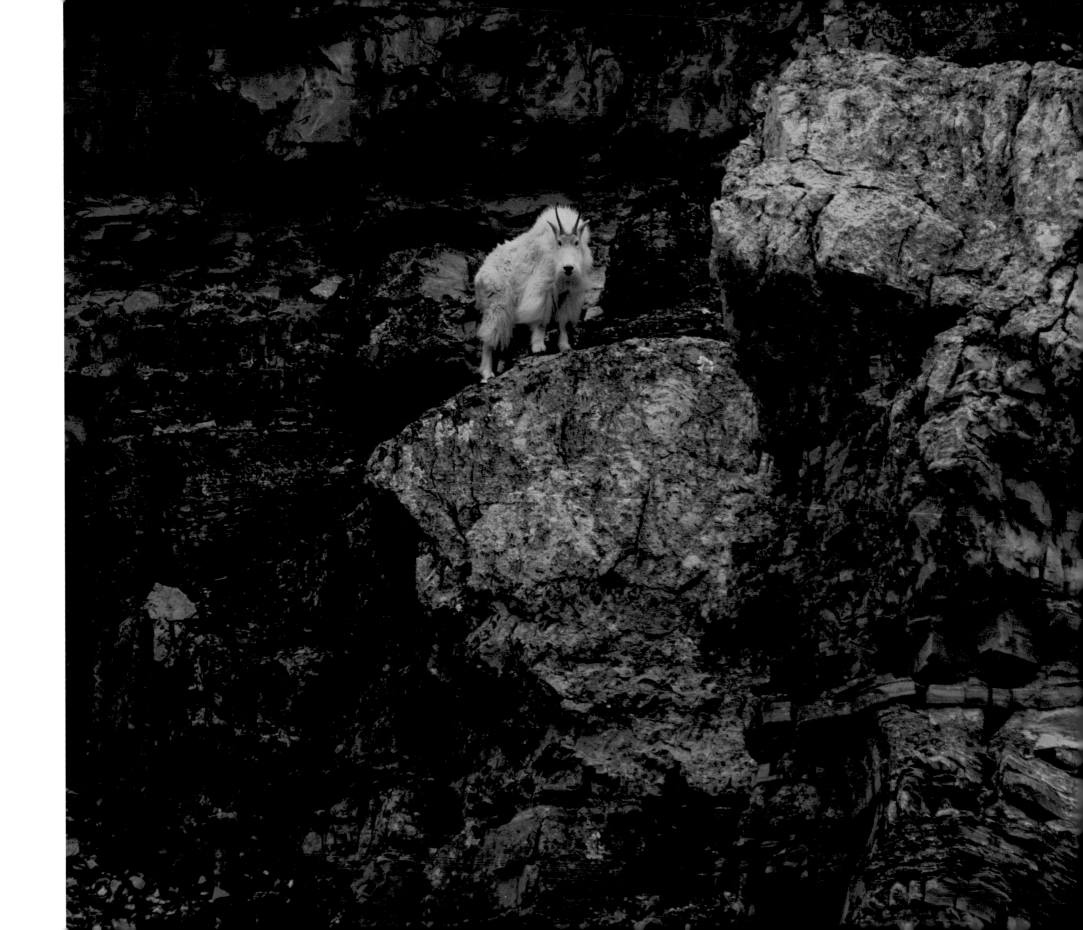

Mountain goats prefer to live on steep, windswept cliffs, where they feed on shrubs, grasses, and lichen that remain exposed throughout the winter. Cliffs also provide quick routes to escape from predators.

FOLLOWING PAGES An avalanche cascades down around a family of mountain goats protected by an overhanging rock face.

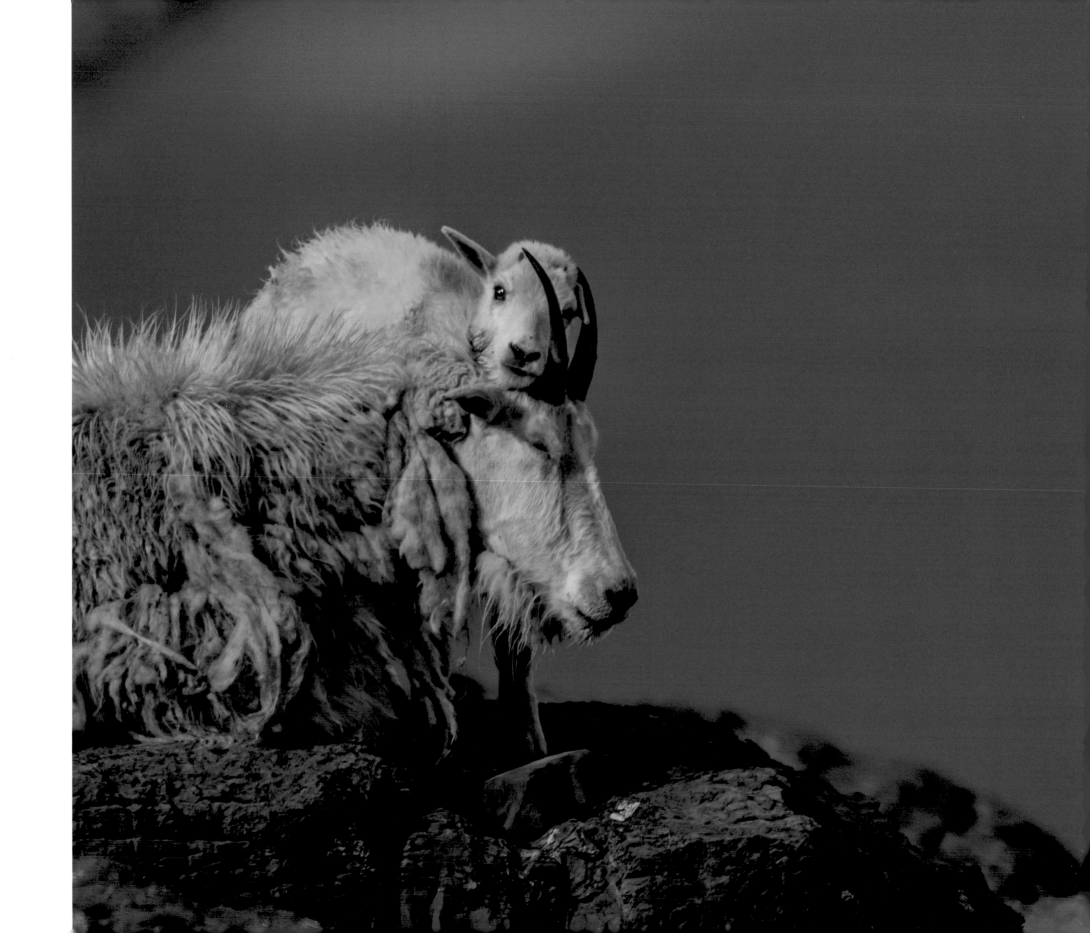

Female mountain goats typically have only one kid at a time, and young goats grow more slowly than juvenile bighorn sheep.

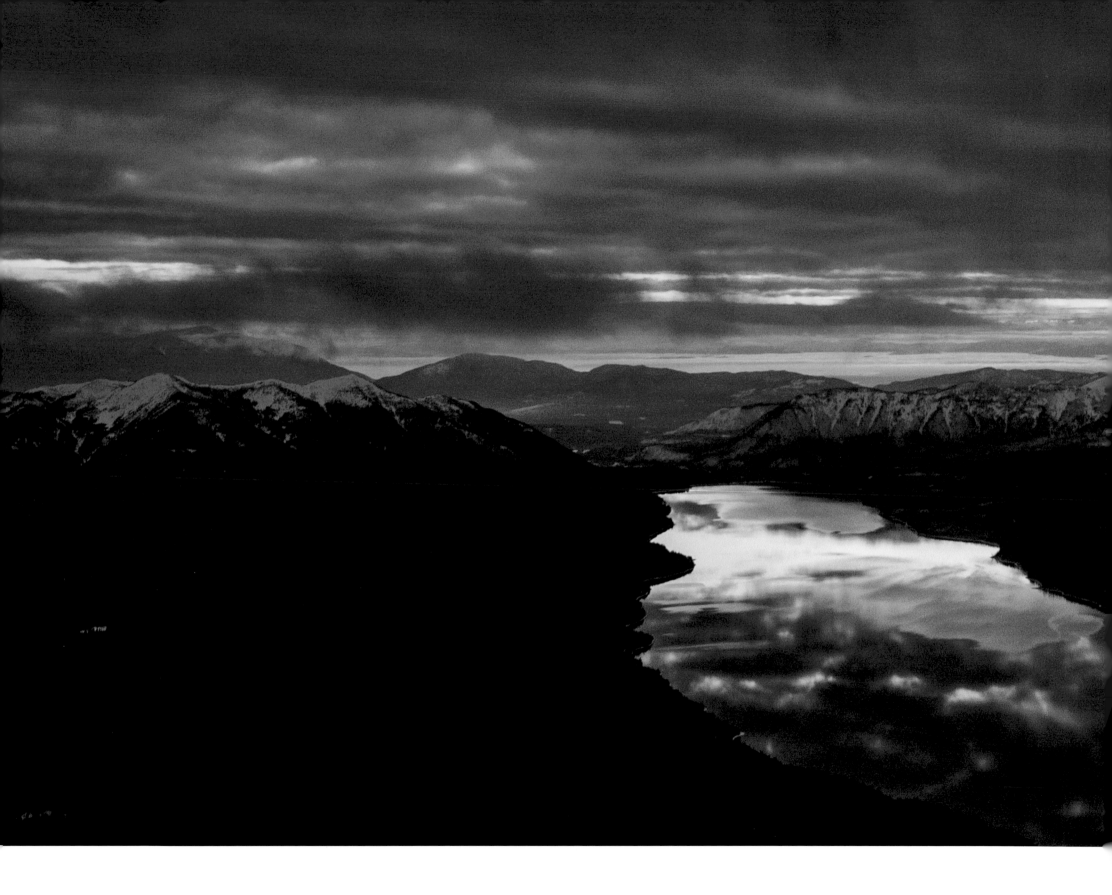

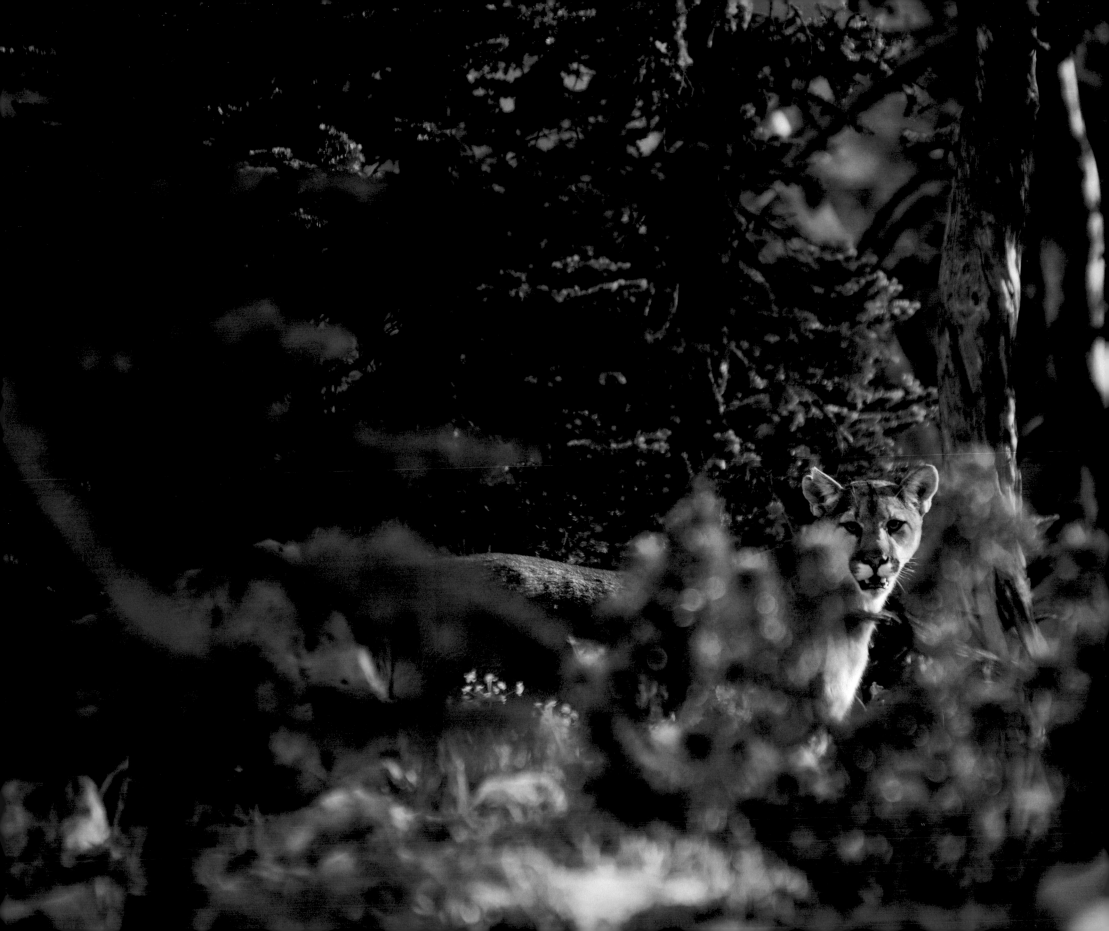

"While having dinner atop a knoll in the Bob Marshall Wilderness with a friend, I heard the sound of deer hooves on rocks. I grabbed my telephoto lens and walked over to the edge of the knoll to investigate. A large mule deer buck came bounding past, just 10 feet (3 meters) from me, with a mountain lion close on its heels. I managed to snap a couple frames of the lion before it noticed me. My eyes moved off the cat for a second and it was gone—disappeared right in front of me. That night the mule deer stayed close to camp. The northern lights were strong, so I headed back to the top of the knoll to photograph them, every so often spinning around and scanning the slope with my headlamp."

—Steven Gnam

IMAGINING THE PAST

"Hoodoos" along the Flathead River are probably Glacial Lake Missoula flood sediments deposited 8000–12,000 years ago (Pleistocene in age). The horizontal bedding indicates the sediments were on the bottom of the ancient lake. Now right on the edge of the river (touching during high water), the sediments have been carved through by the river. The columns and vertical features are the result of rain and snow eroding the sediments.

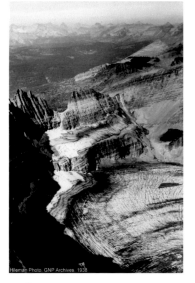

1938

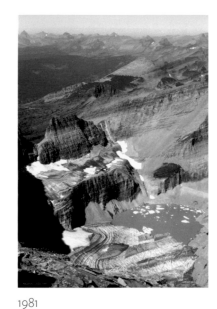

1981

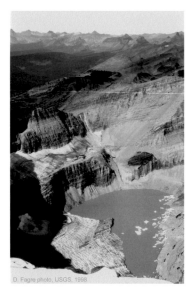

1998

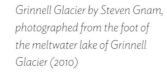

2009

Grinnell Glacier by Steven Gnam, photographed from the foot of the meltwater lake of Grinnell Glacier (2010)

EPIC MELTING

Oblique view of Grinnell Glacier taken from the summit of Mount Gould, Glacier National Park. The relative sensitivity of glaciers to climate change is illustrated by the dramatic recession of Grinnell Glacier while surrounding vegetation patterns remain stable.

CLOCKWISE FROM TOP LEFT
T. J. Hileman, courtesy of Glacier National Park Archives; Carl Key, courtesy of USGS; Dan Fagre, courtesy of USGS; Lindsey Bengtson, courtesy of USGS

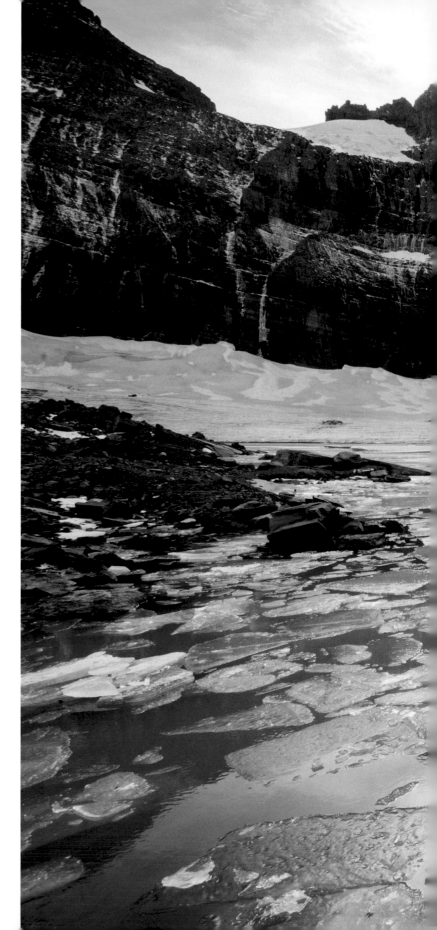

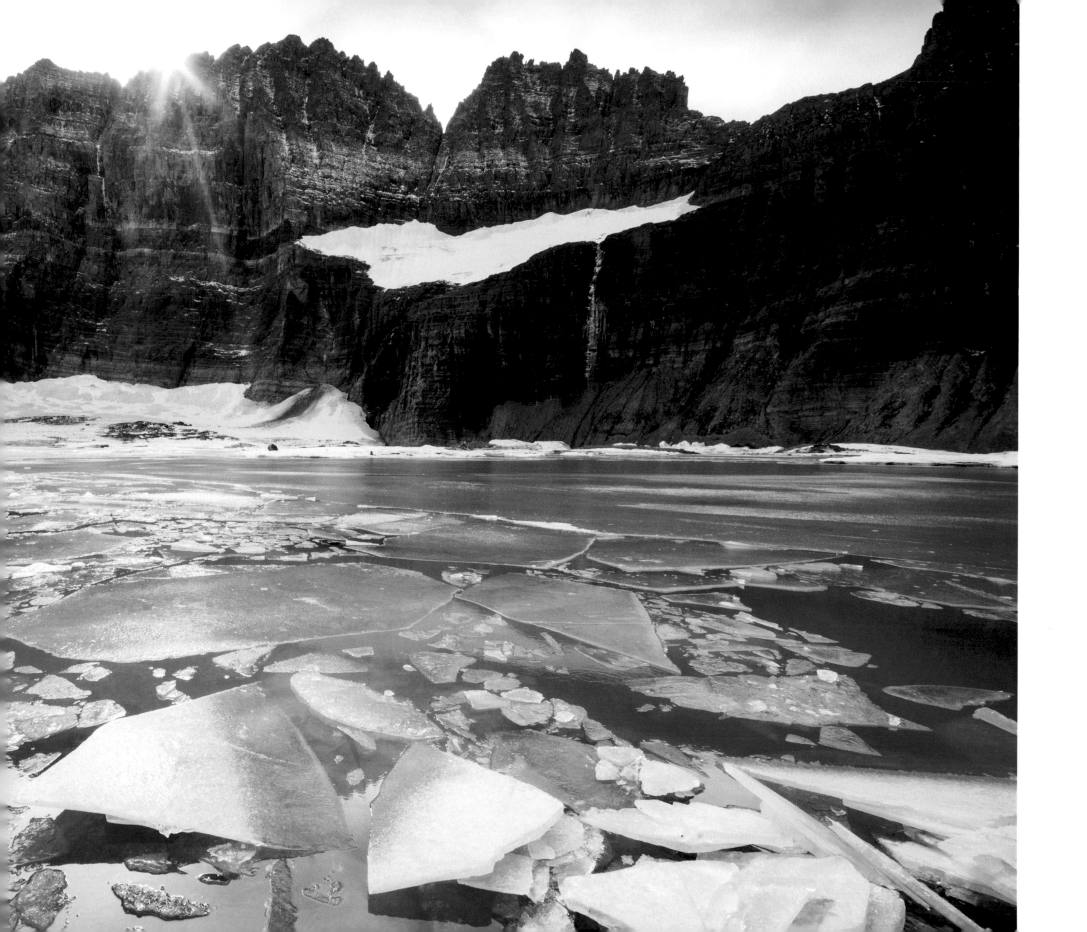

STORIES TOLD BY ROCKS

Argillite stone marked with glacial striations. The deep red color comes from freshwater algae that contain a bright red pigment. This red carotenoid pigment protects the algae from intense ultraviolet radiation and helps the algae absorb some heat energy, causing the surrounding snow to melt. The melting water carries the algae down into the soil and rocks beneath the snowpack. The algae overwinter there until increasing light, water, and nutrients in the spring cause them to migrate through the snowpack to the surface to start the cycle over again. The deep green color of glacial milk in these long, narrow meltwater ponds at the toe of the receding Sperry Glacier is accentuated by the unvegetated red and white beds of recently exposed Grinnell argillite.

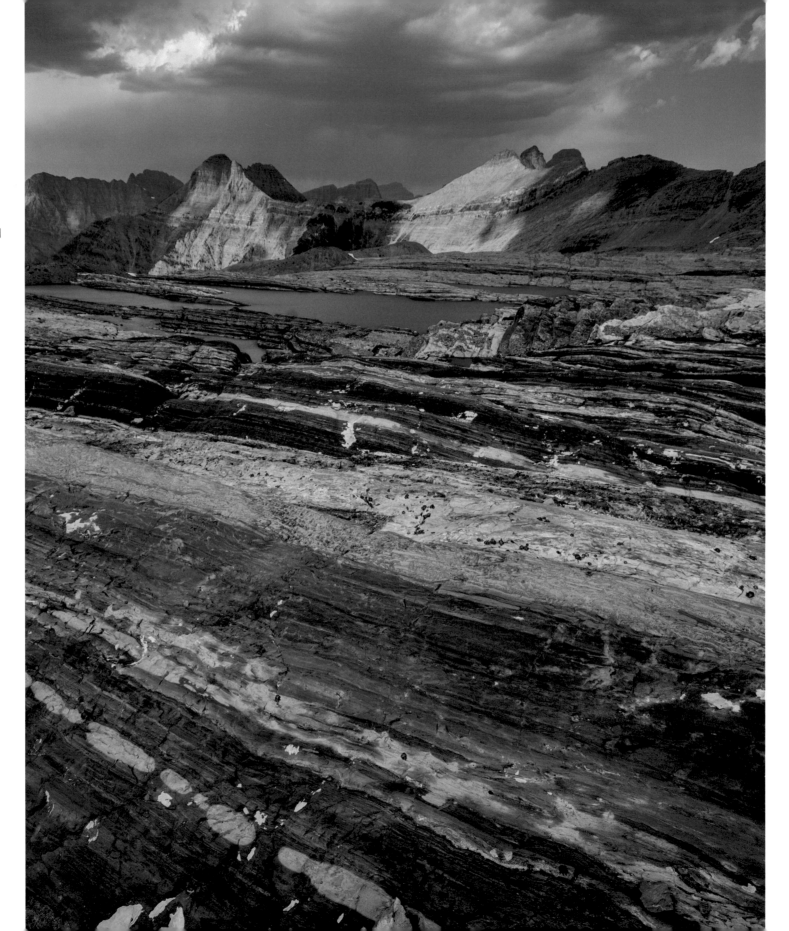

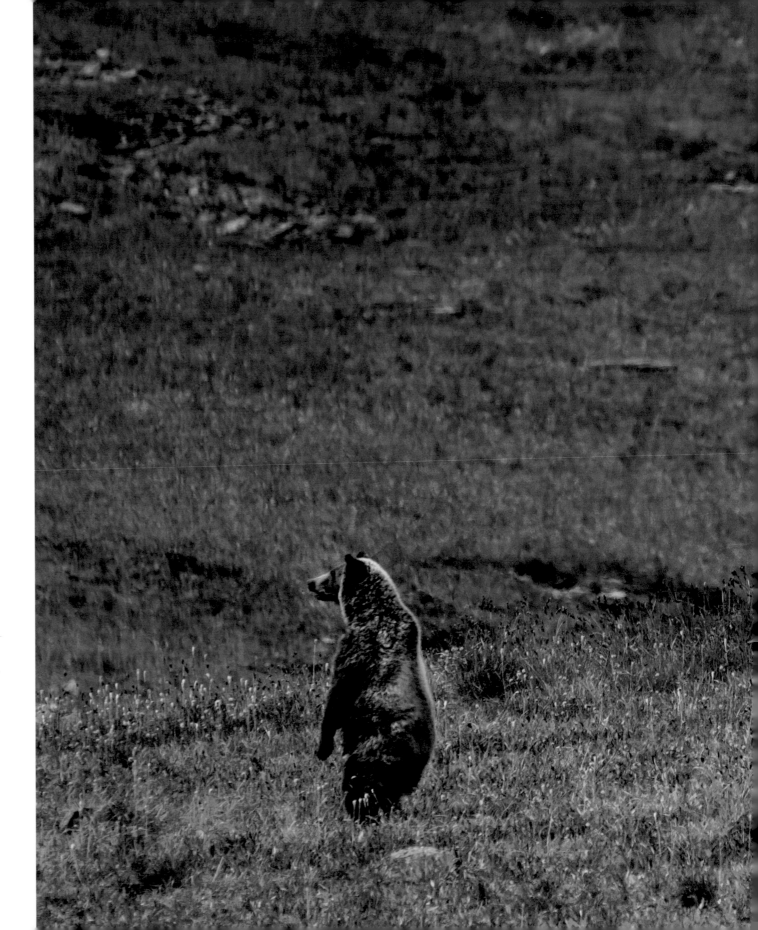

Three grizzly "cubs" stand up facing an approaching boar (male grizzly). The mother grizzly decided to leave, and eventually all four bears sprinted off, with the male chasing behind.

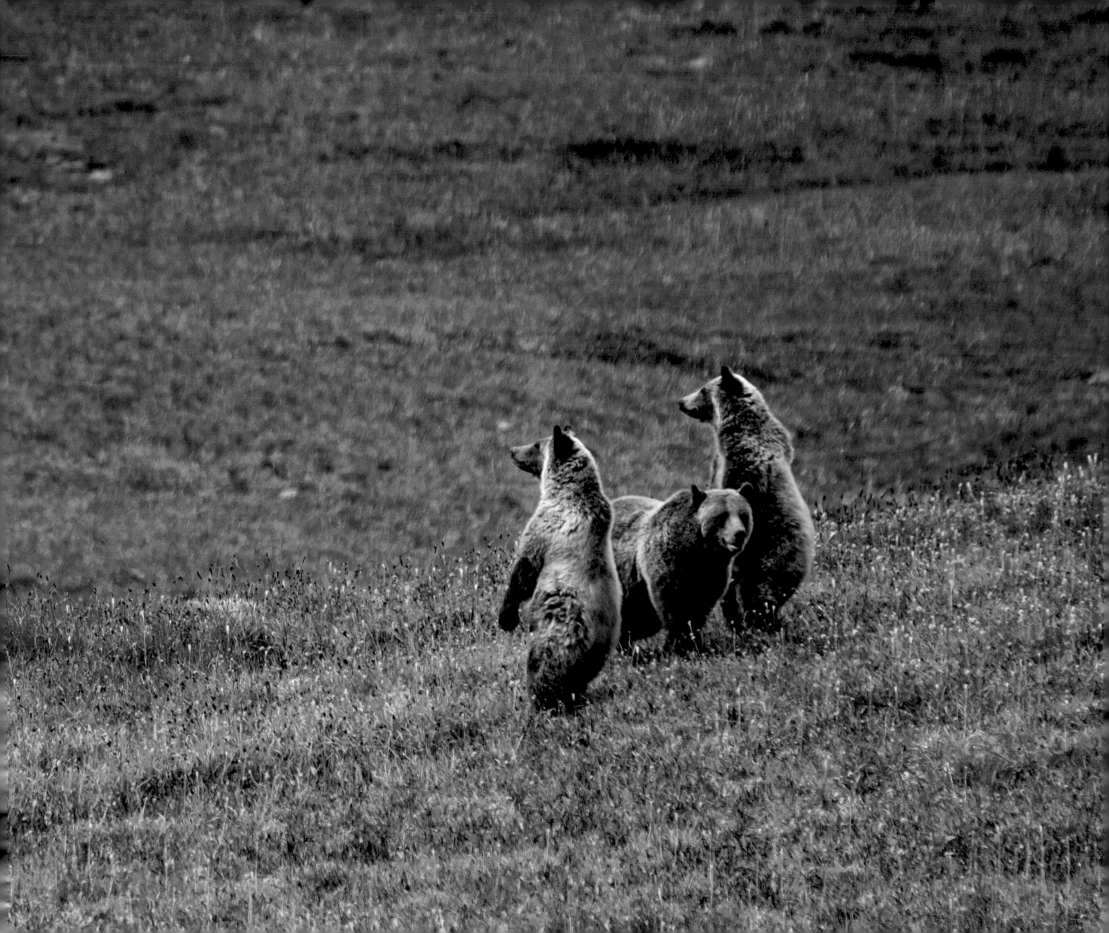

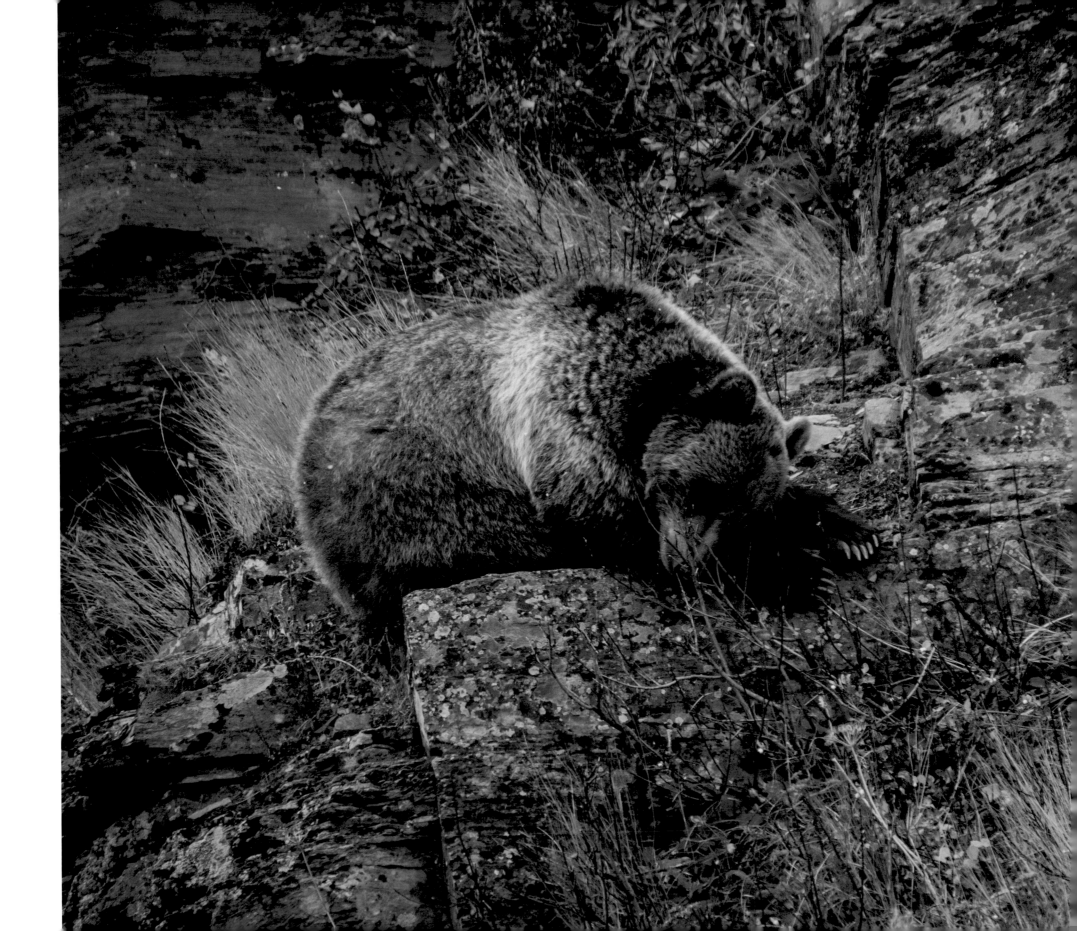

Napping grizzly bear

GRIZZLIES IN WINTER

Grizzly bears in the Crown of the Continent hibernate about five
to six months a year. Before hibernating a bear will often dig a den
or occasionally use an old den or a natural shelter. Once it enters
the den and is buried by an insulating layer of snow, the bear's
respiration rate drops to one breath every forty-five seconds and its
heart rate slows to eight to nineteen beats per minute. The bears
don't drink, eat, urinate, or defecate while hibernating. They live
off a layer of body fat they built up (by consuming various kinds of
berries, plants, insects, and carrion) before entering the den. Bears
also maintain bone mass while hibernating, a feat other hibernating
mammals can't do, instead experiencing osteoporosis.

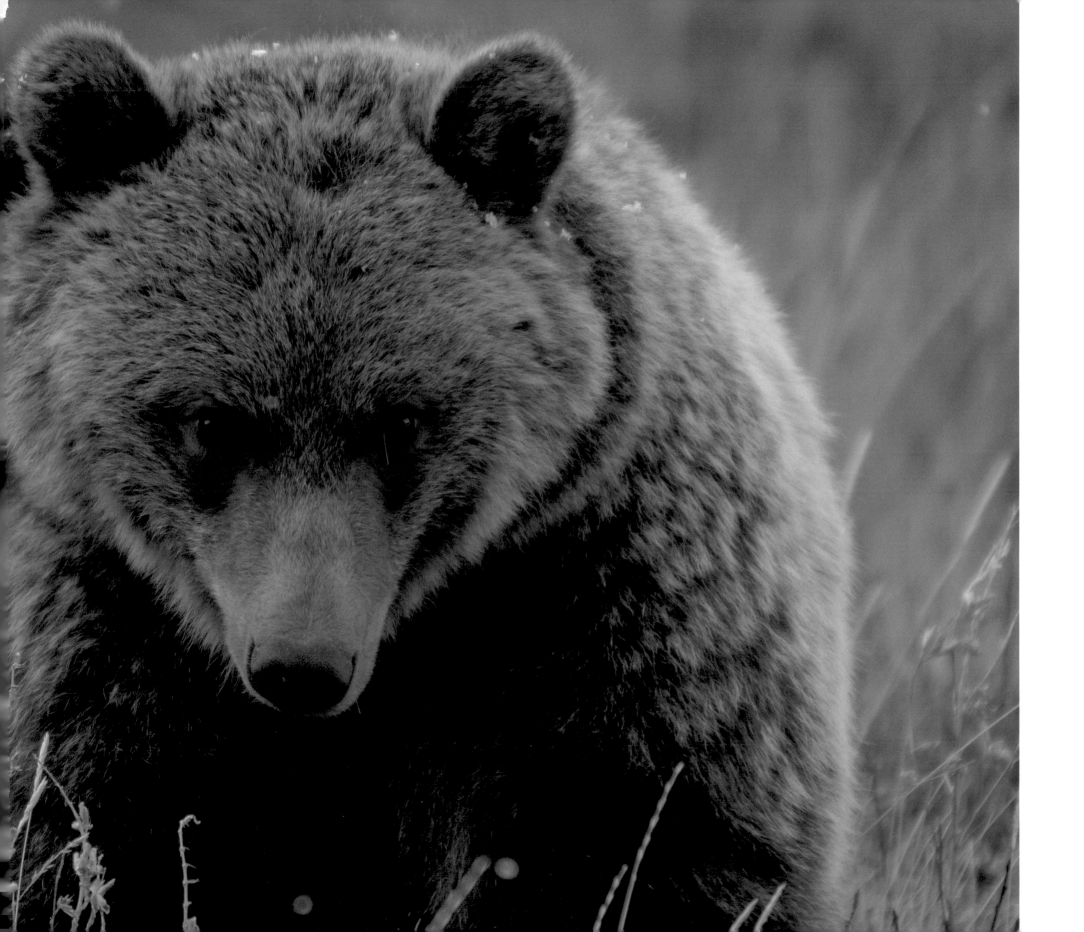

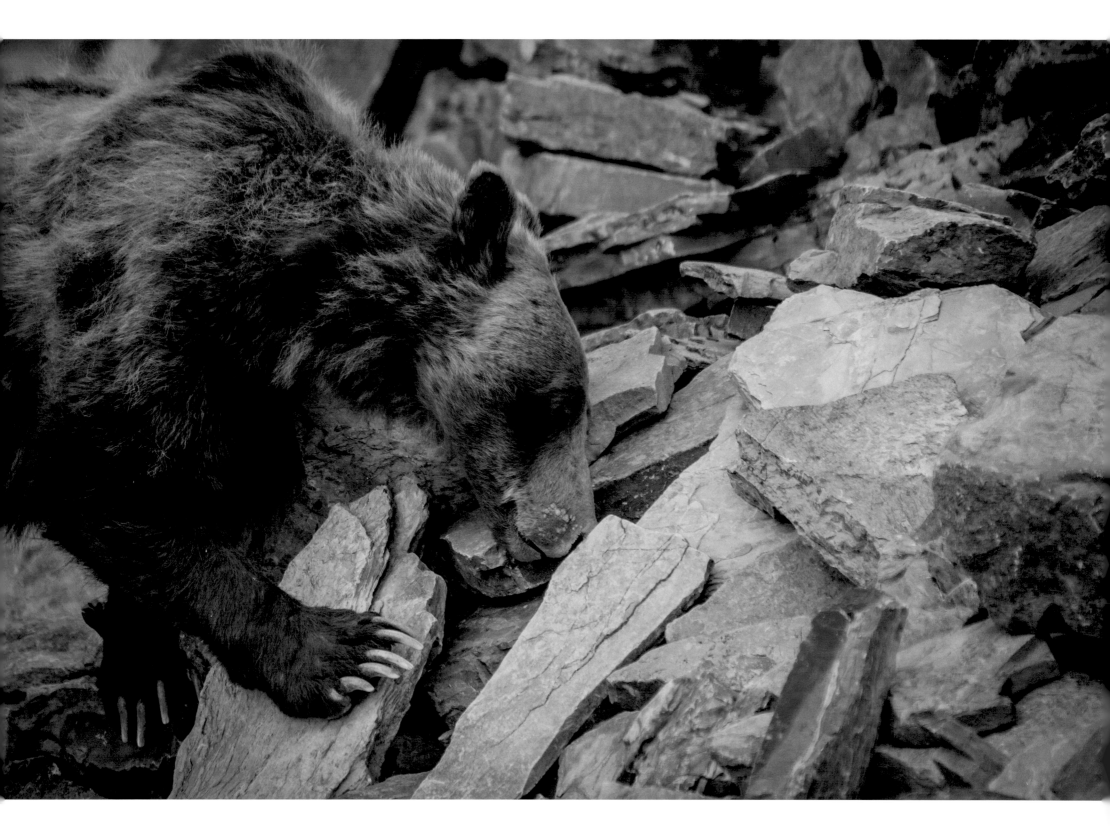

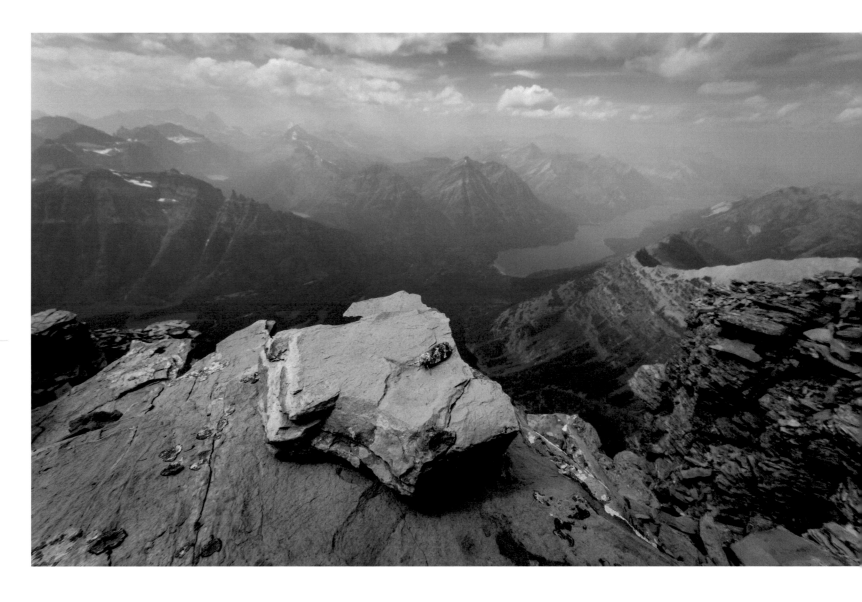

An army cutworm moth high in the Crown of the Continent, with Waterton Lake in the background

RESOURCEFUL BEARS

Every summer millions of army cutworm moths migrate from the Great Plains into the Rocky Mountains seeking nectar from wildflowers and cooler temperatures. During the day these moths find shelter in talus slopes and boulder fields. Some grizzly bears feed on these moths, consuming 20,000–40,000 moths a day (each moth is about a half calorie). In one month of feeding on the moths, bears can obtain one-fourth to one-third of their total calories for the year and by the end of the season can get half of their yearly calories from them. On the Great Plains army cutworm moths are considered an agricultural pest and are sprayed with insecticide. It's unclear how the numbers of migrating moths are affected by spraying and other agricultural practices. The food source keeps grizzly bears out of conflict with people by drawing them high into the mountains away from human settlement. This relationship hints at the complexities of nature, how an insect feeds the great symbol of wilderness, and how what we do on the Great Plains affects life in the Rocky Mountains.

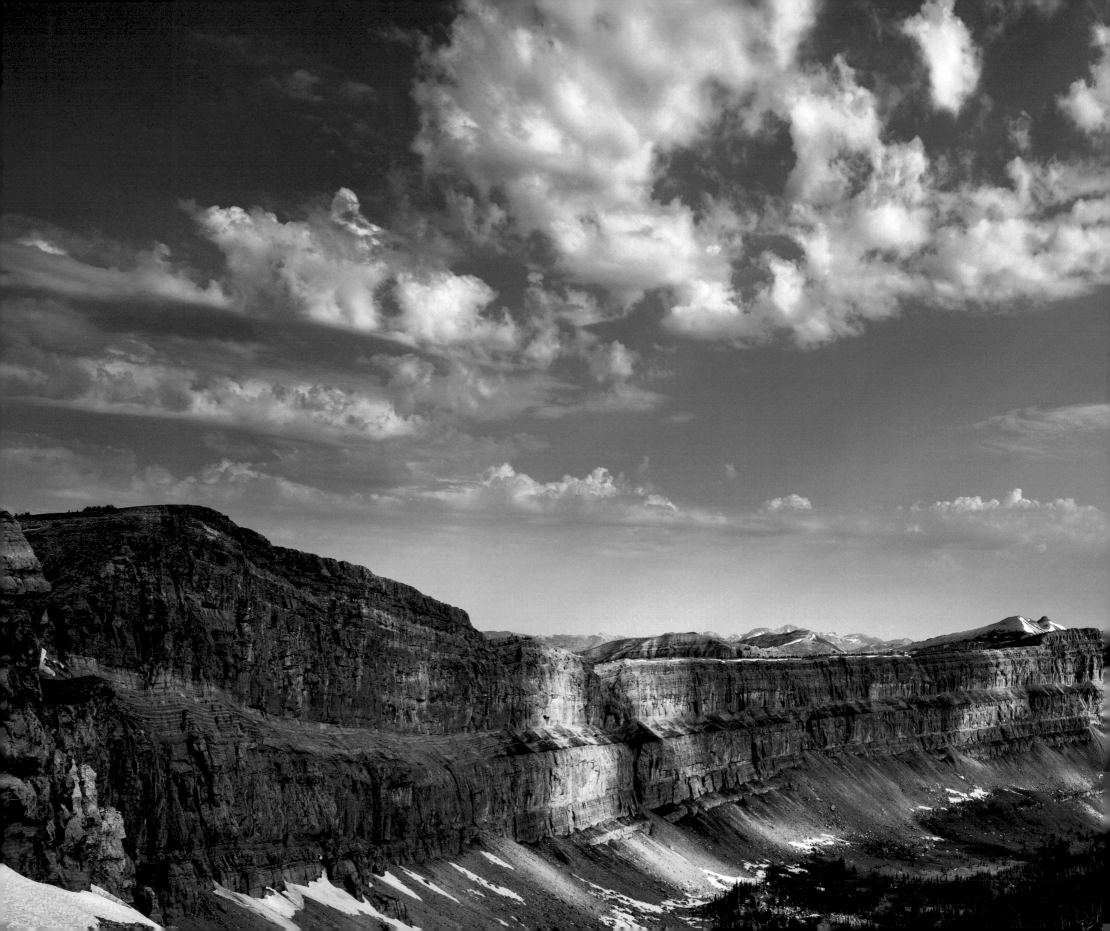

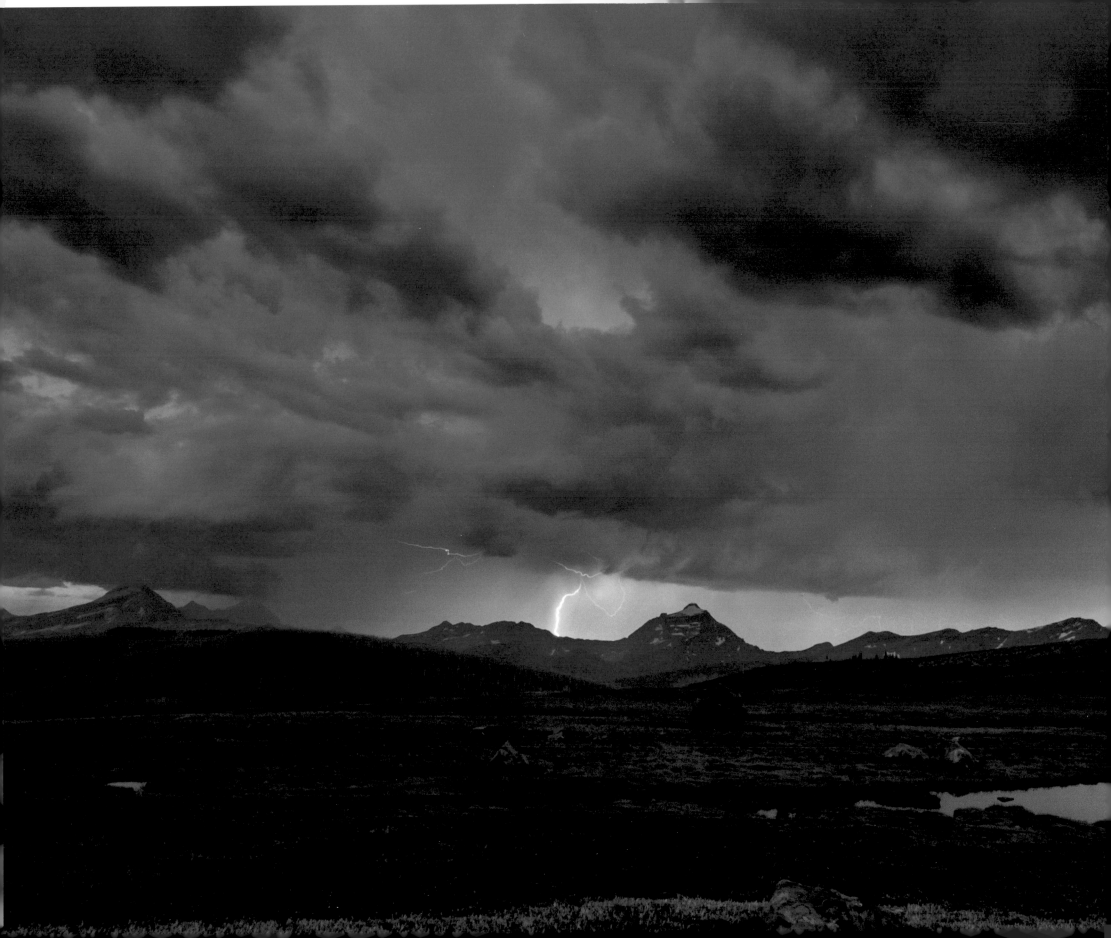

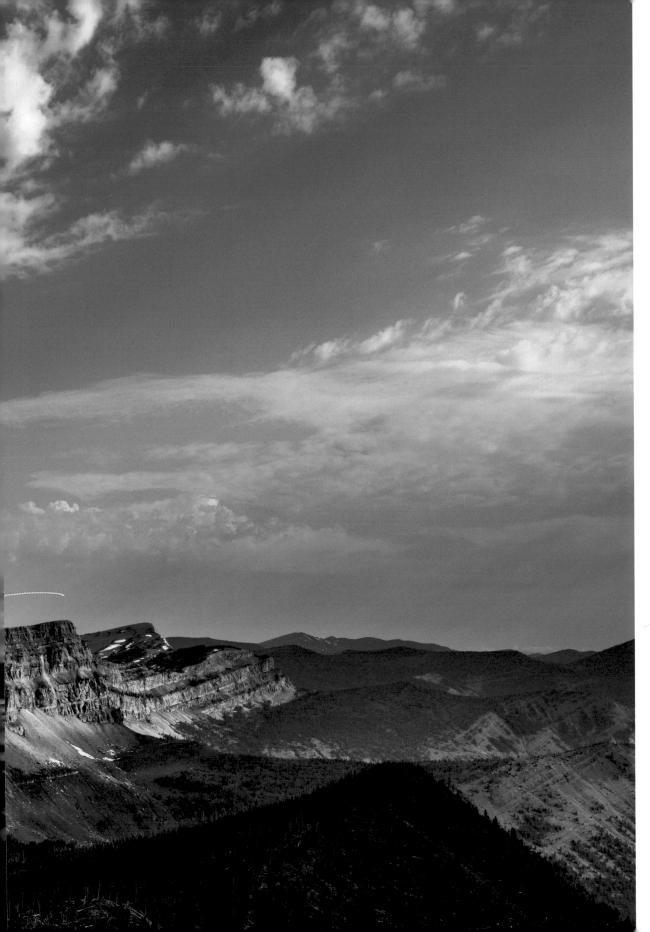

The Chinese Wall in the Bob Marshall Wilderness, with a pink glow on the horizon caused by two wildfires. Wildfires in wilderness areas are suppressed only if there is a threat to buildings or homes near the wilderness boundary.

Lightning over the Livingston Range along the Highline Trail, which roughly follows the Continental Divide

Clouds spill over mountains toward the headwaters basin to the North Fork of the Flathead River below.

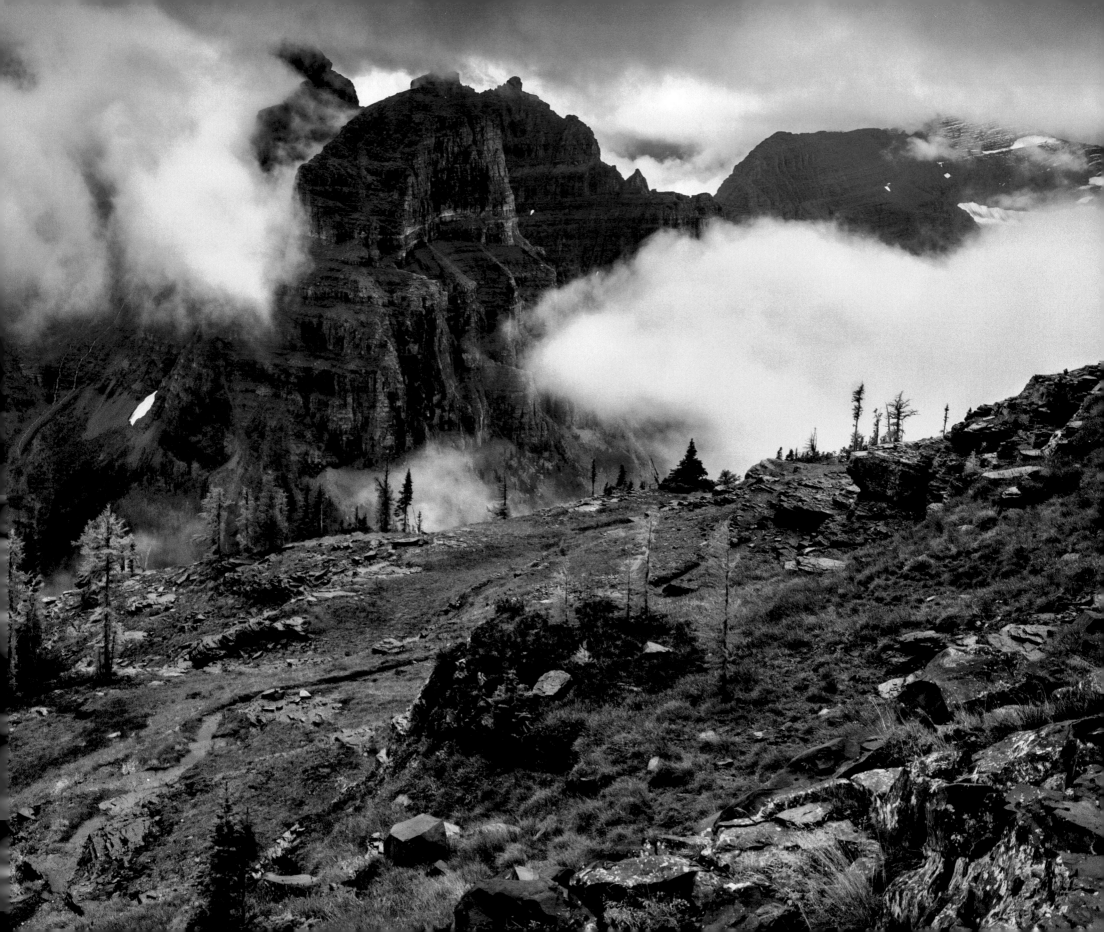

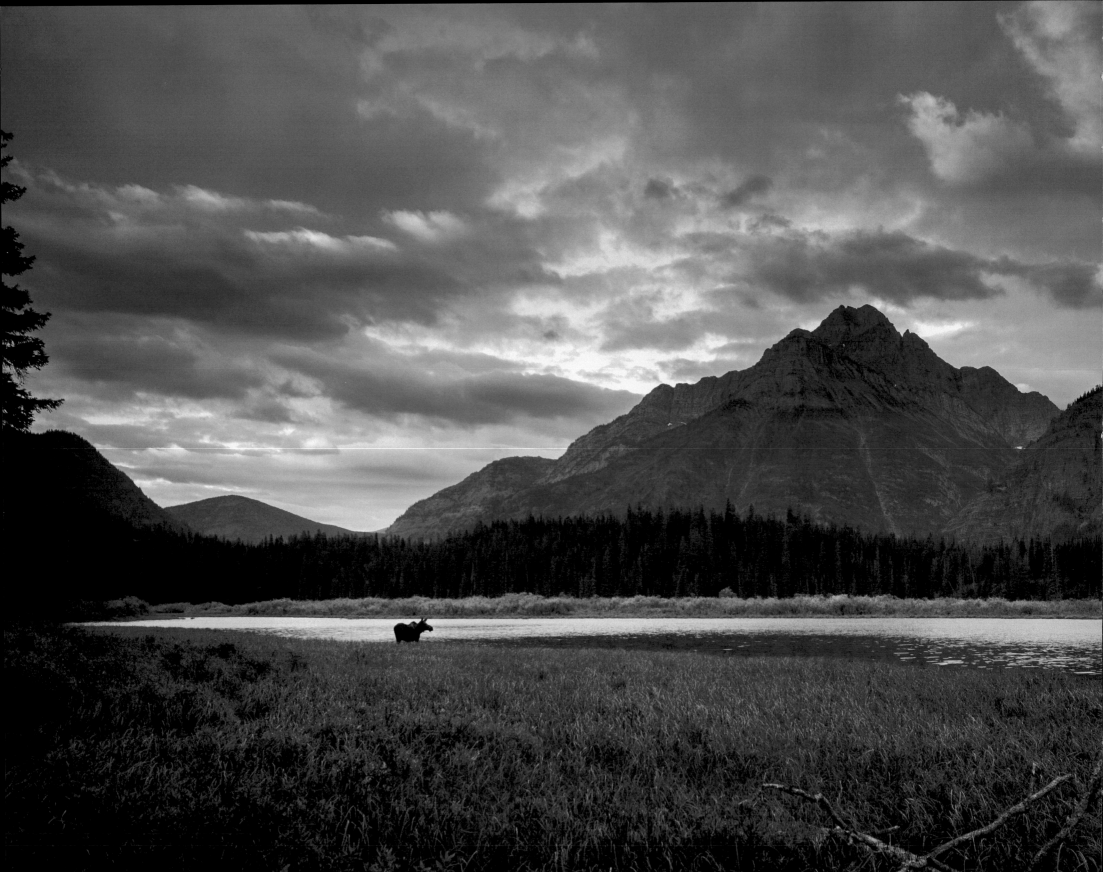

A moose near the US-Canada border. Moose numbers are plummeting in several areas of the Lower 48, with a complex array of possible reasons. Rising annual temperatures cause favorable conditions for parasites such as ticks, brain worms, and flukes. Moose also have complex digestive and thermoregulation systems that could be affected by minor temperature increases.

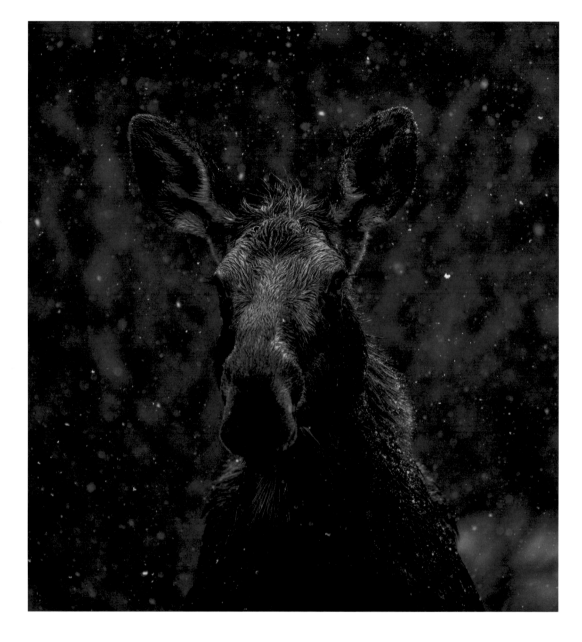

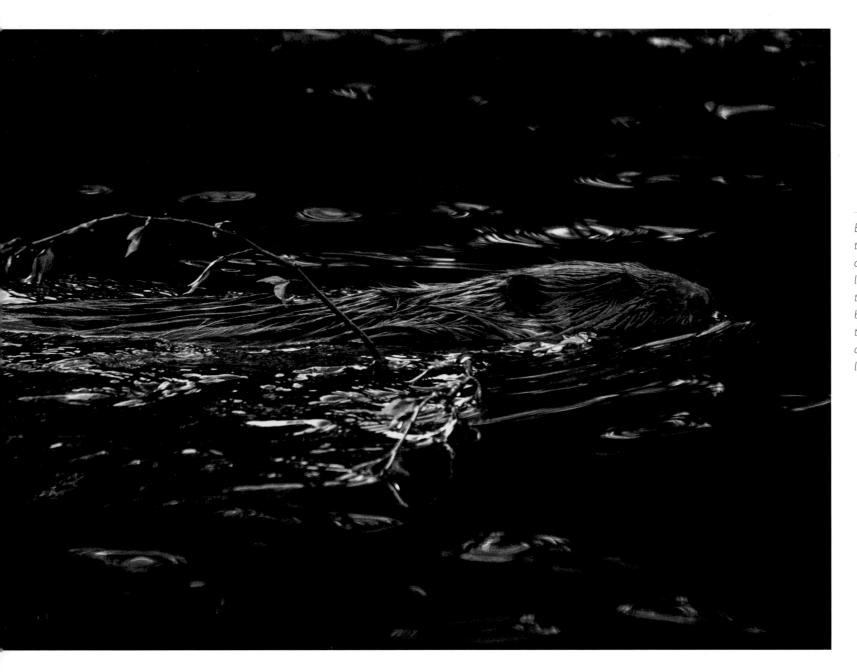

Beavers are engineers and farmers; they build dams that create marshy conditions for their favorite foods, like willow. These riparian areas then become host to all kinds of birds, fish, and mammals, including those found only in ponds; beaver-created ponds are rare features in a landscape of streams and rivers.

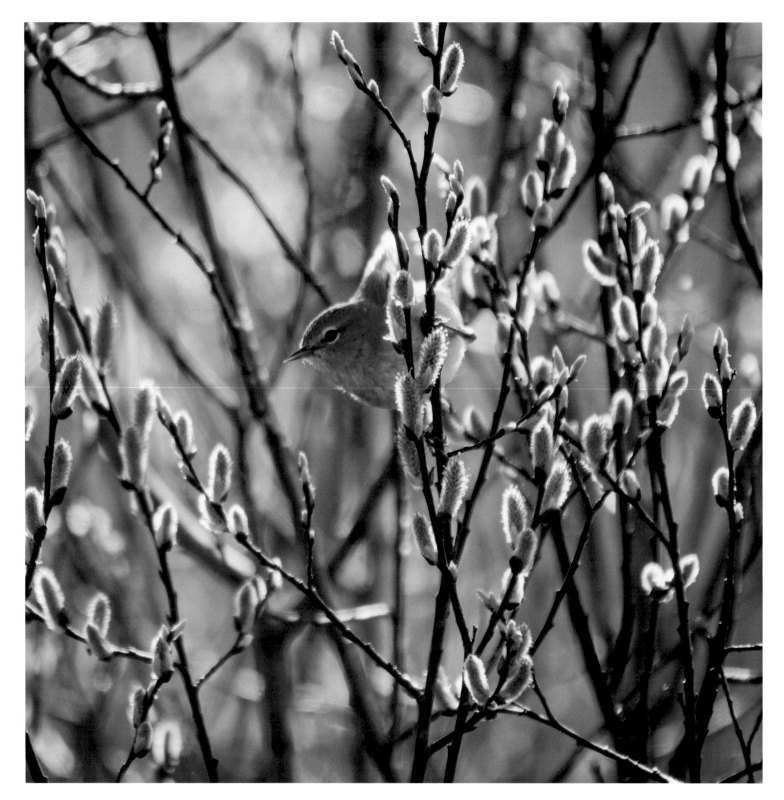

Songbirds like this warbler rely on willow riparian areas for nesting, feeding, and cover.

OPPOSITE Moose, like beaver, contain special microorganisms in their intestines to ferment and break down coarse woody matter like willow stems.

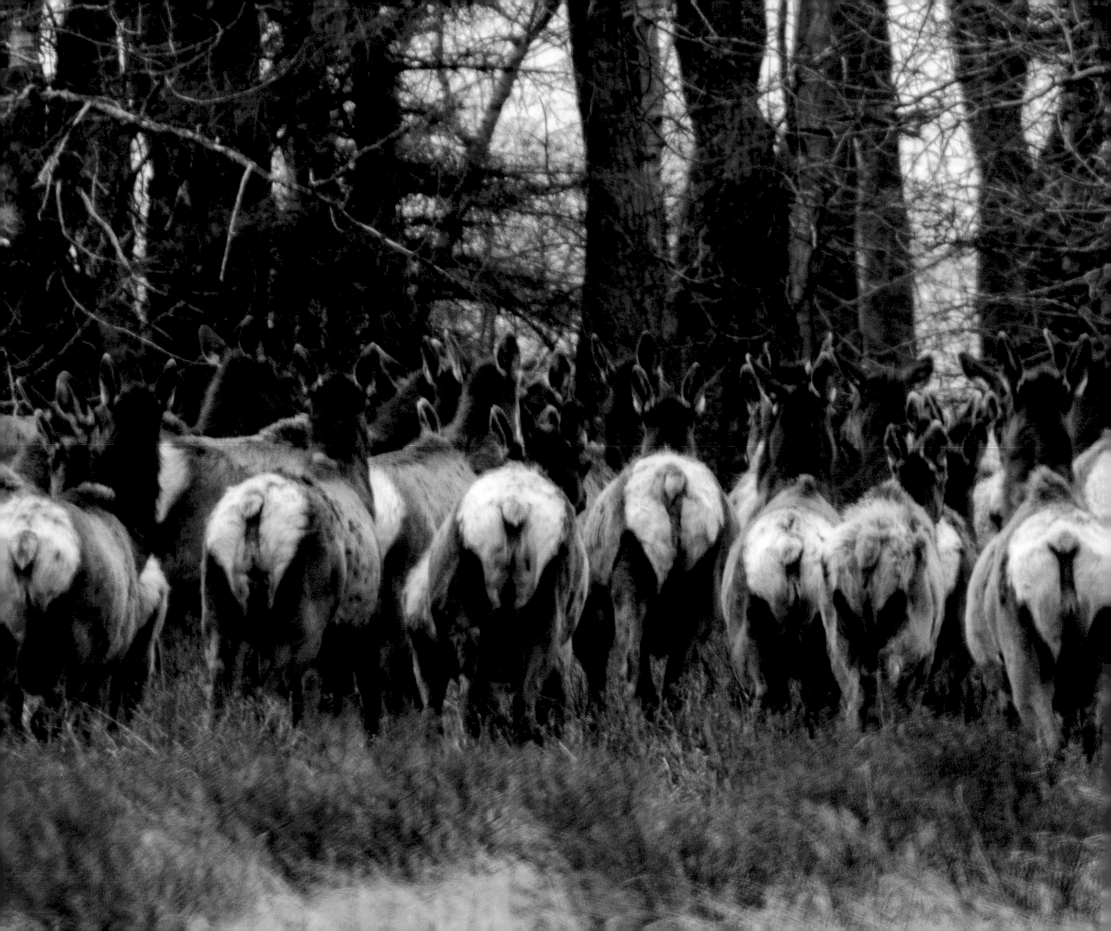

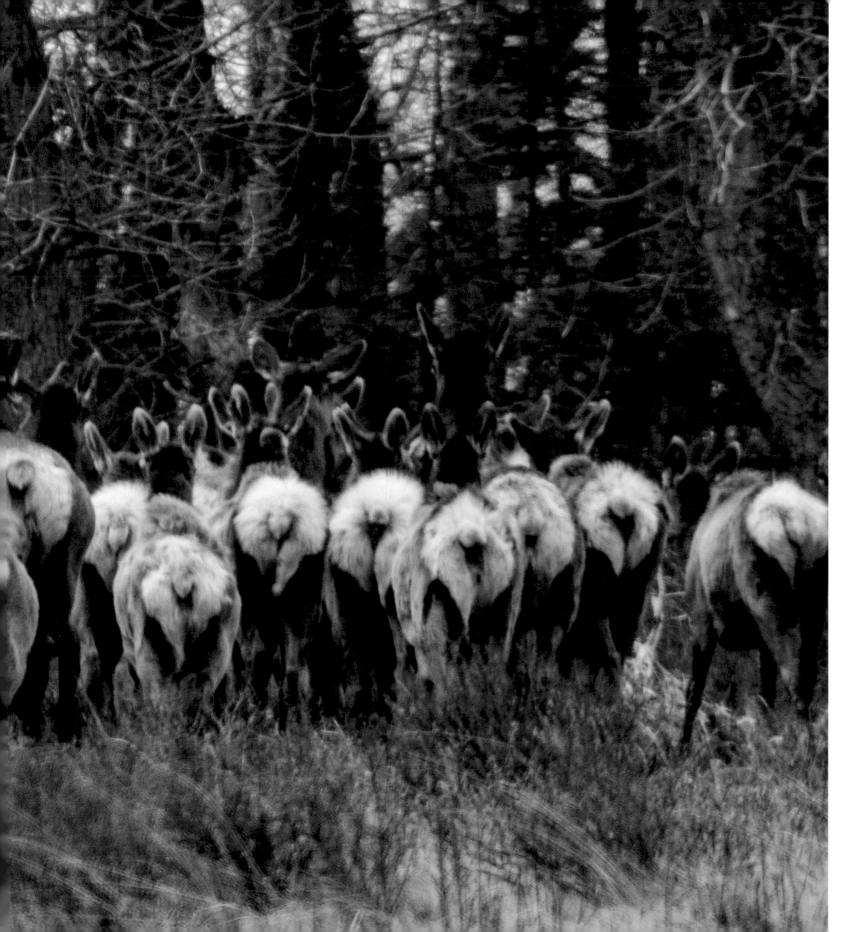

Female elk in Glacier National Park

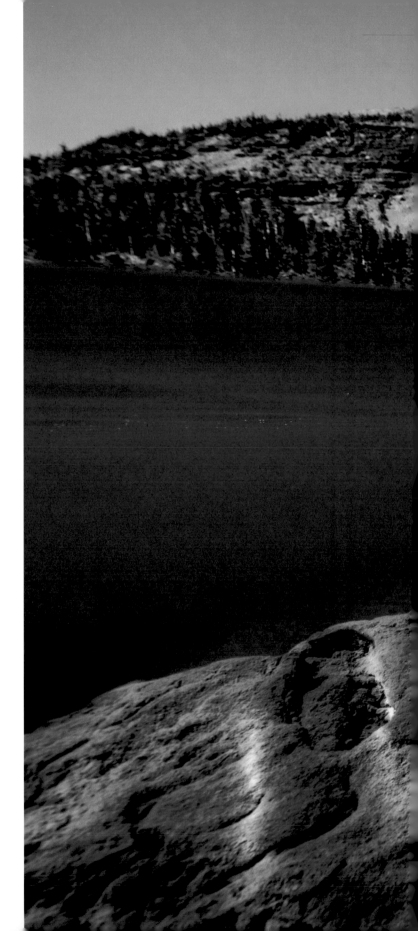

Cutthroat trout in a subalpine lake

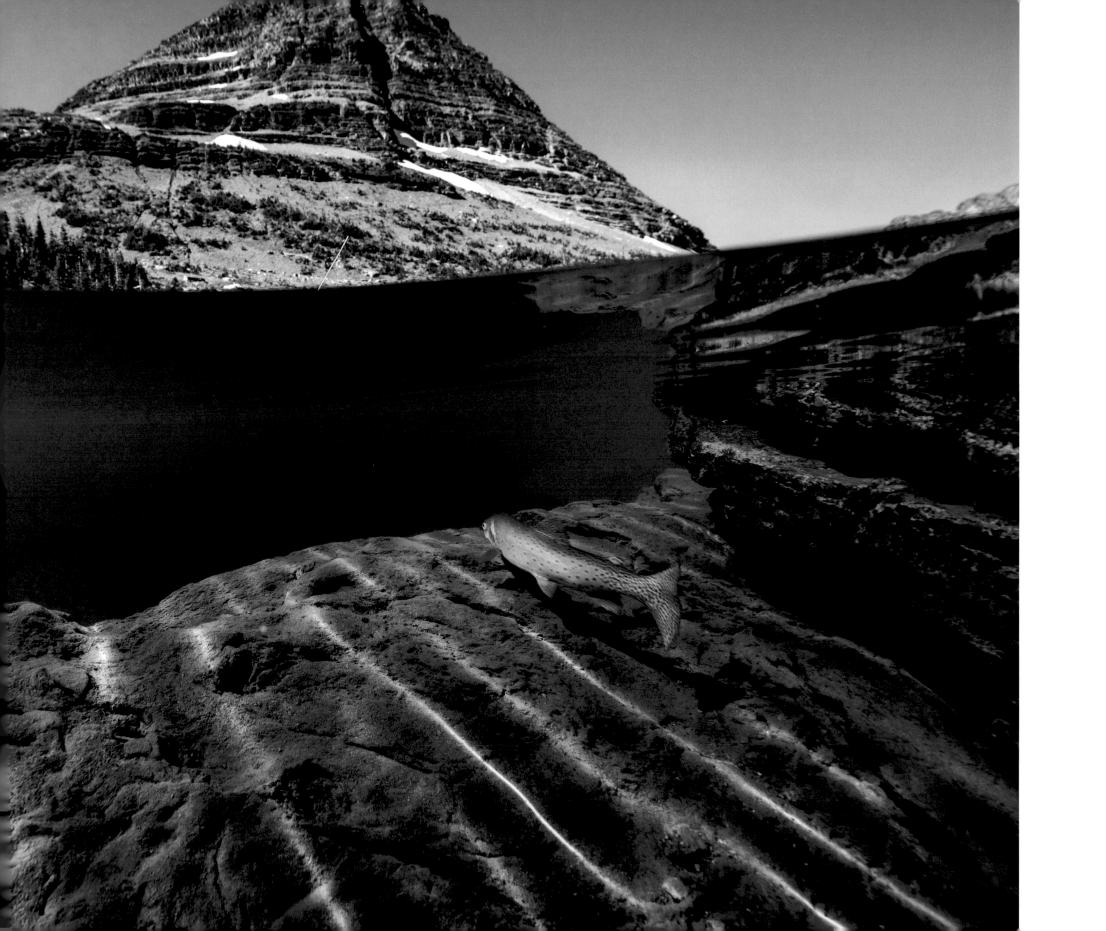

"Leaves fall from a birch tree after an evening frost. When the morning light warmed the leaves, they broke loose, drifting to the ground with an almost imperceptible sound complementing the silent forest."

—Steven Gnam

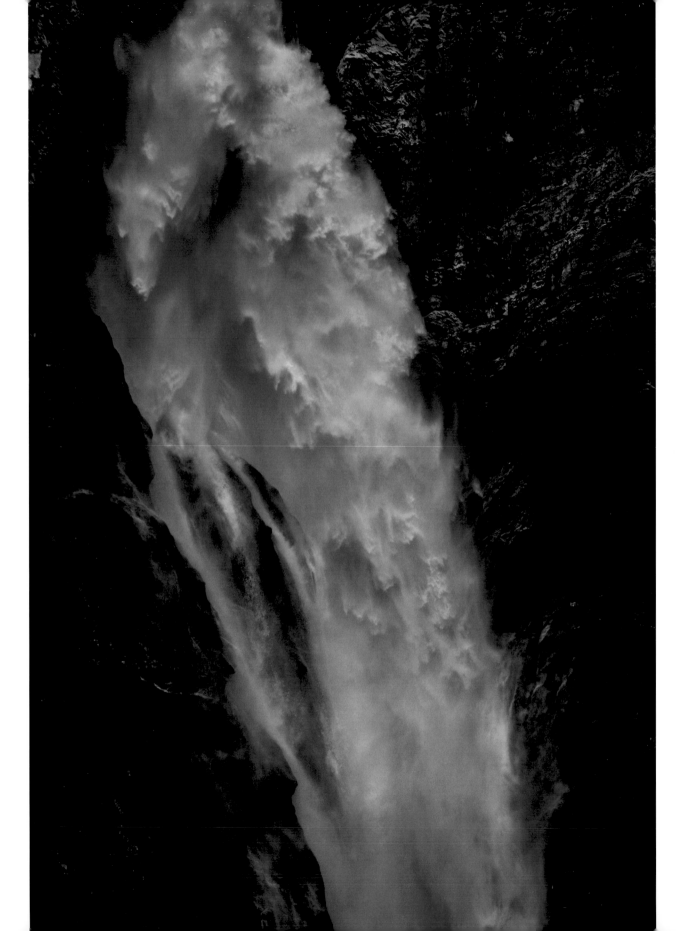

A waterfall in British Columbia

OPPOSITE *Mushrooms sprout in the inland temperate rain forest.*

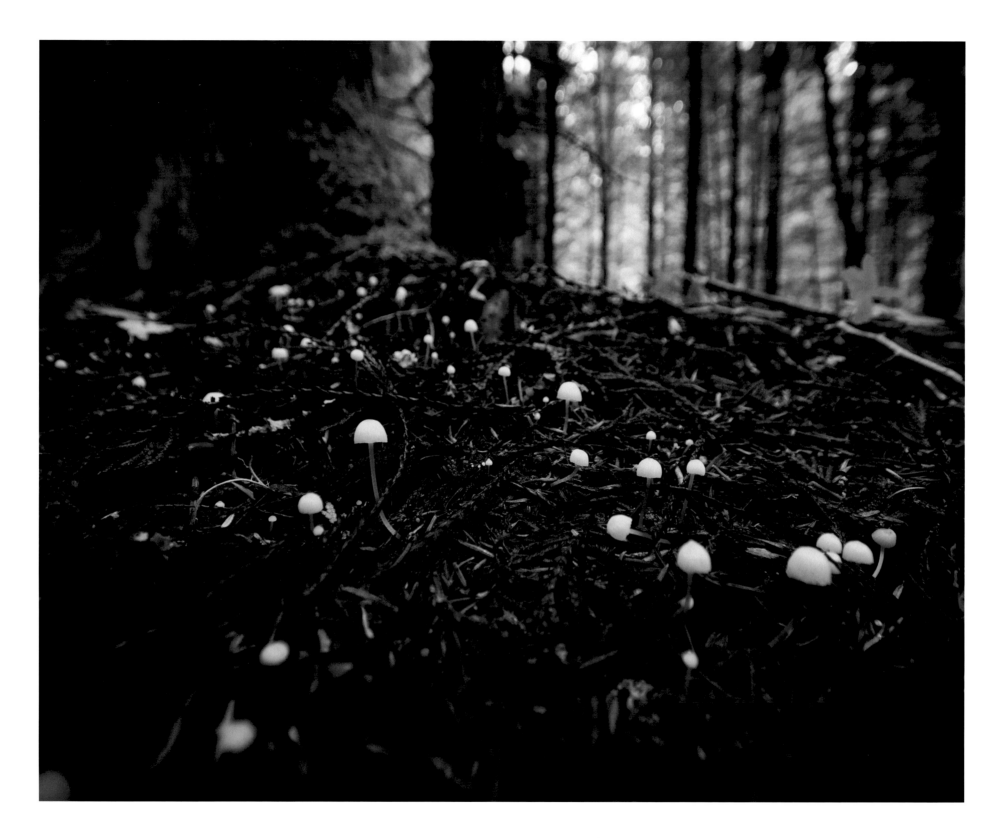

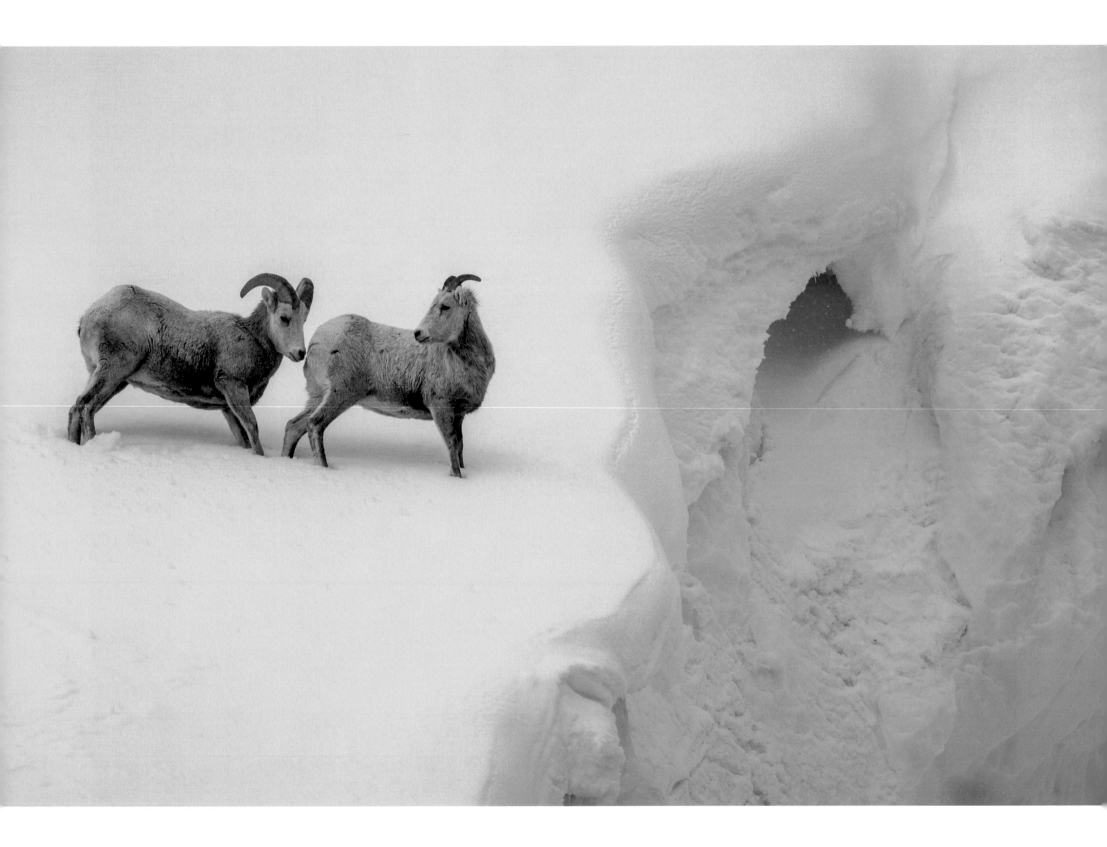

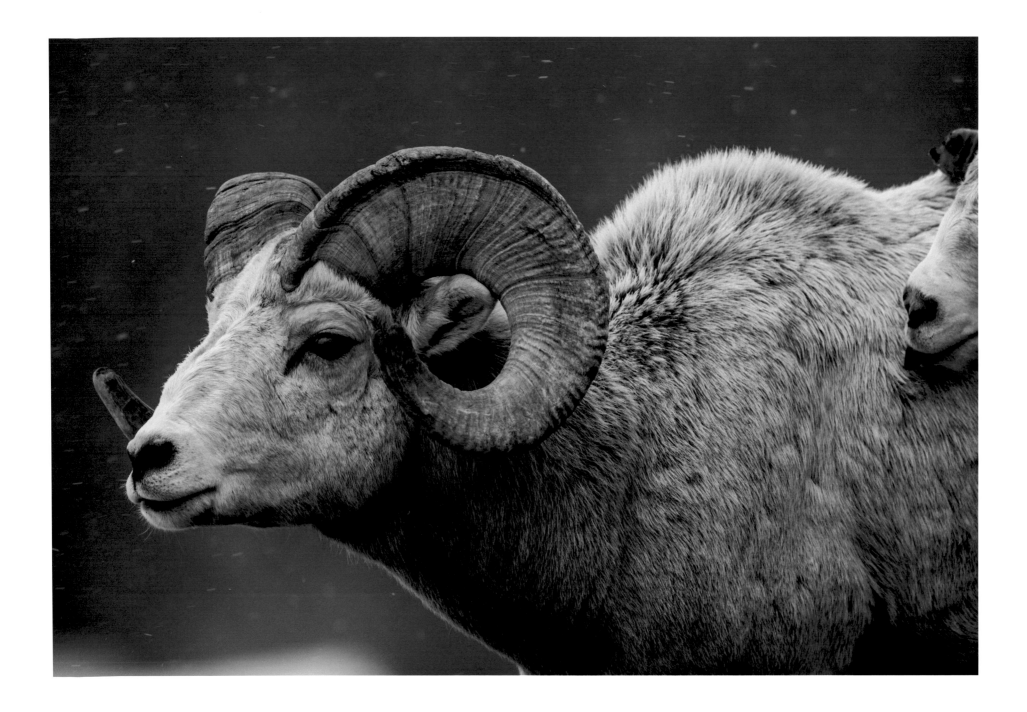

A male bighorn sheep has horns that can weight up to 30 pounds (14 kilograms), as much as the rest of the bones in his body.

Western hemlock in temperate inland rainforest in northwestern Montana

*Wind-sculpted aspen trees along
the Rocky Mountain Front*

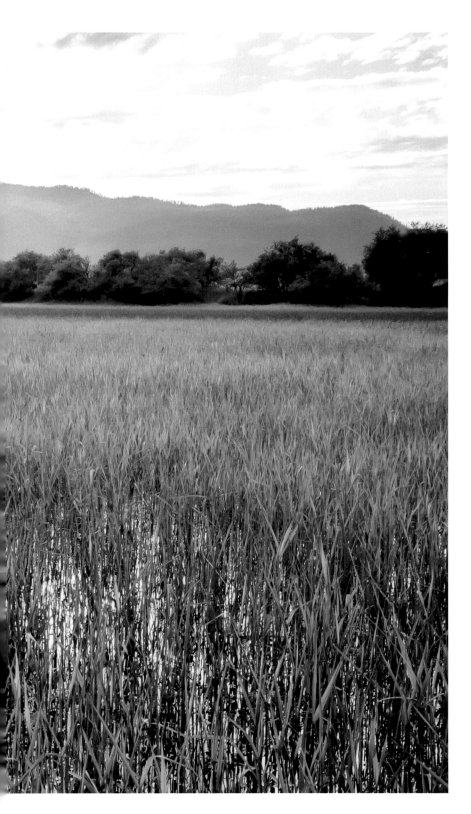

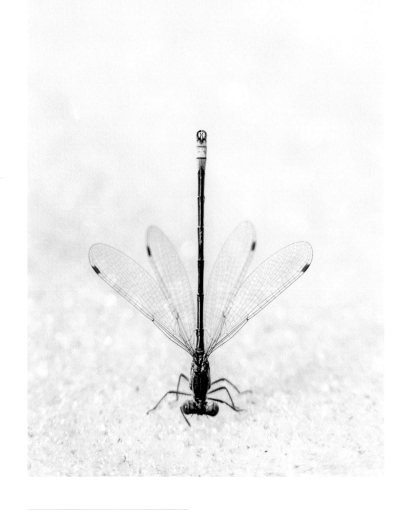

Wetland in Swan Valley

Damselfly on snow,
high in the alpine

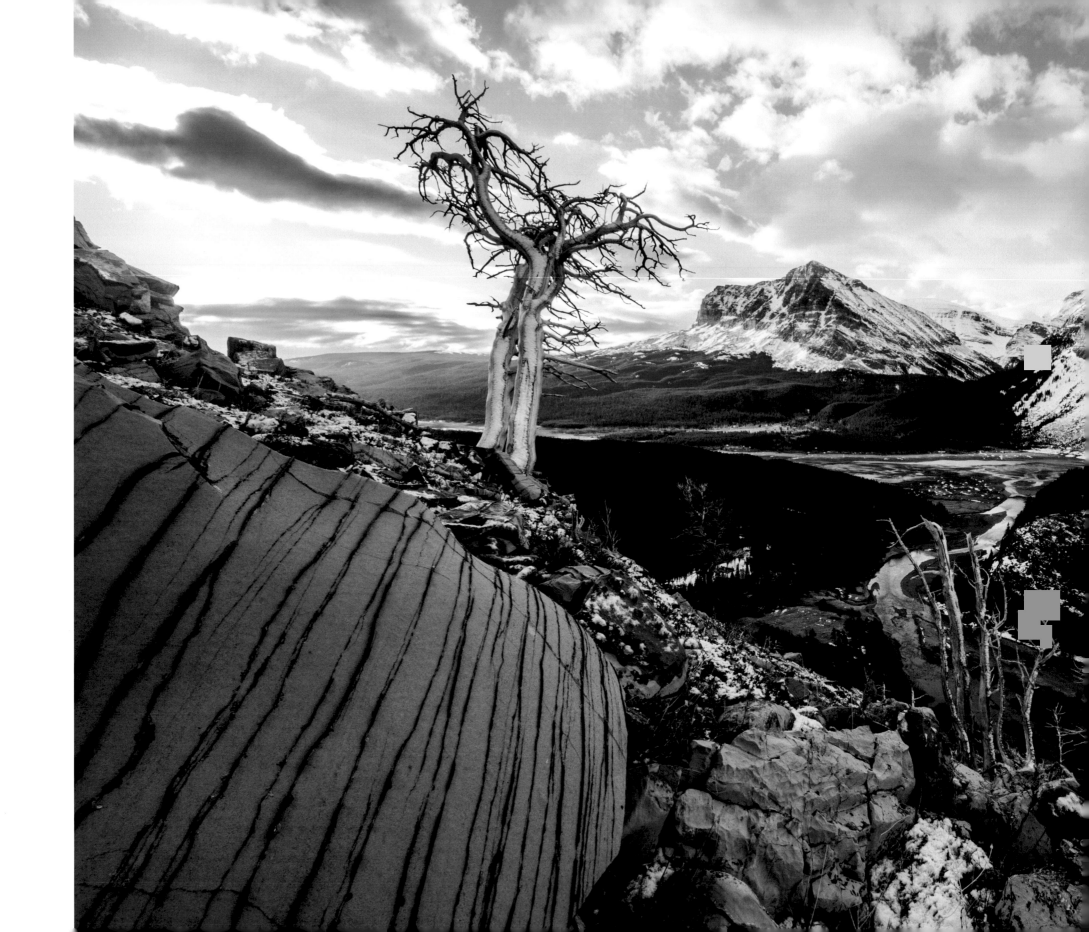

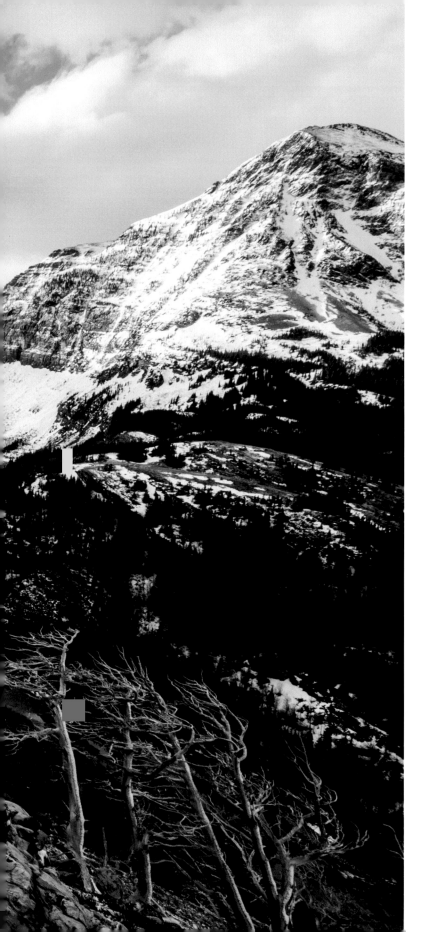

Swiftcurrent River on the
Rocky Mountain Front. The
area pictured is on the edge of
land currently not leased to
outside interests due to cultural
sensitivities involving local tribes.

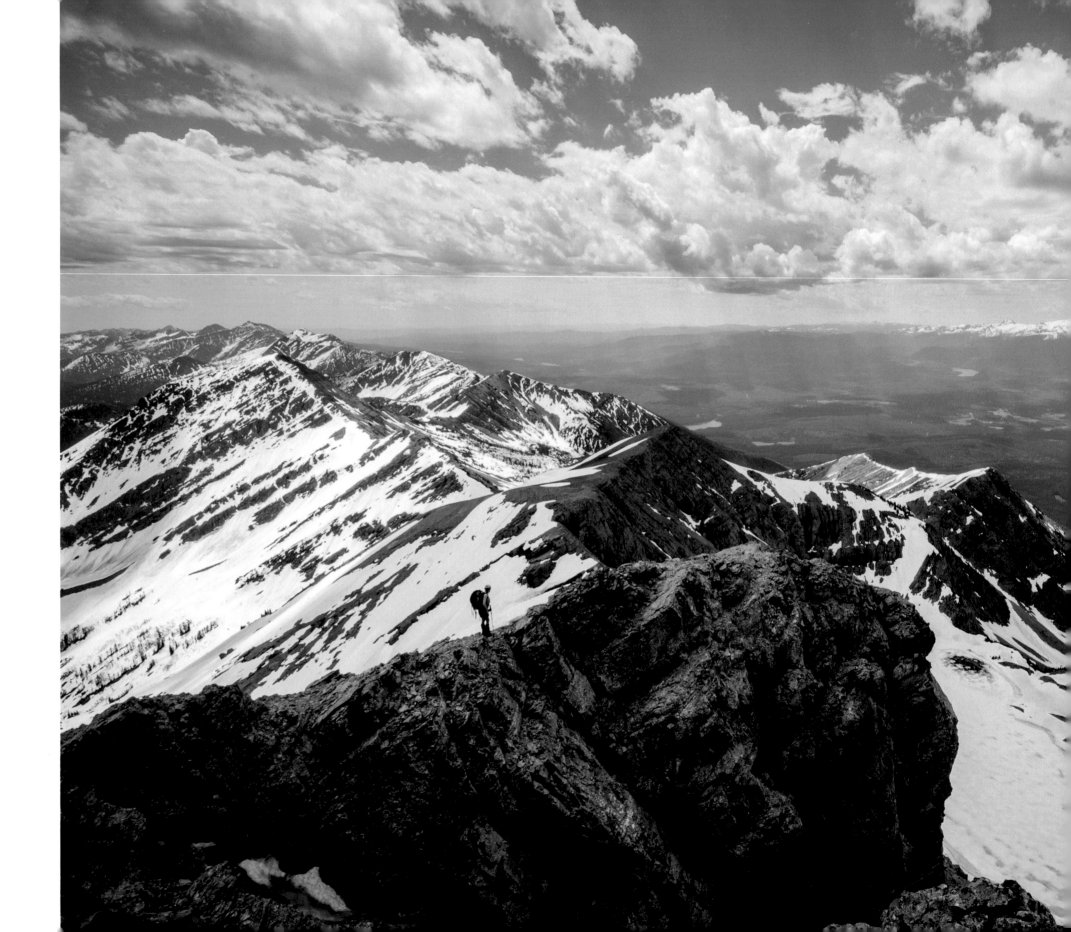

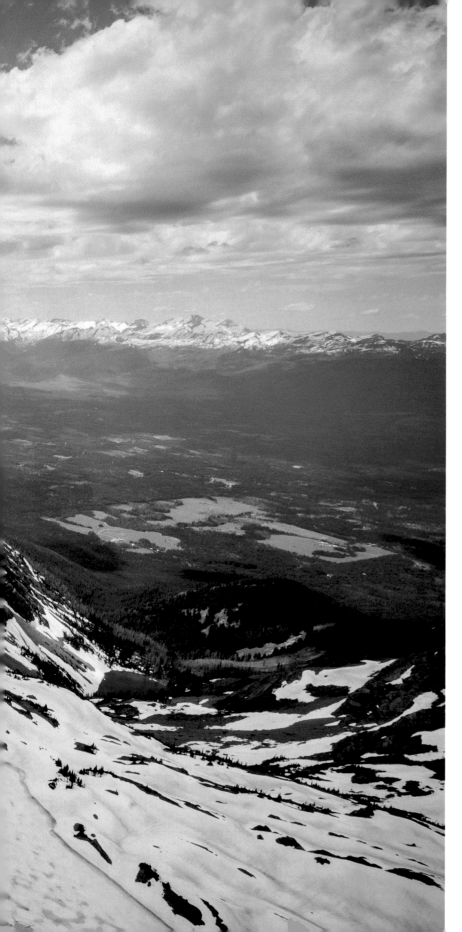

A woman climbing the ridge that
forms the western edge of the Bob
Marshall Wilderness Area

Indian paintbrush in the proposed Waterton-Glacier International Peace Park expansion in British Columbia

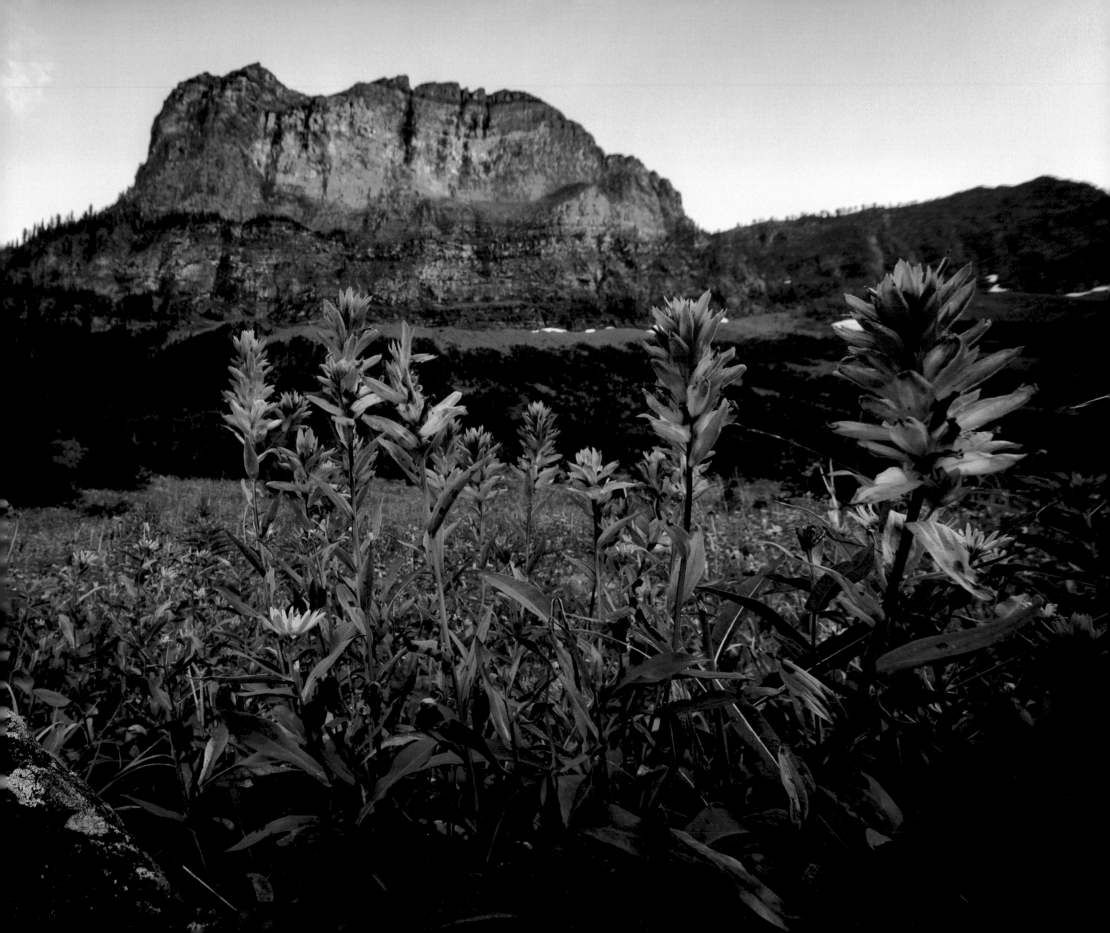

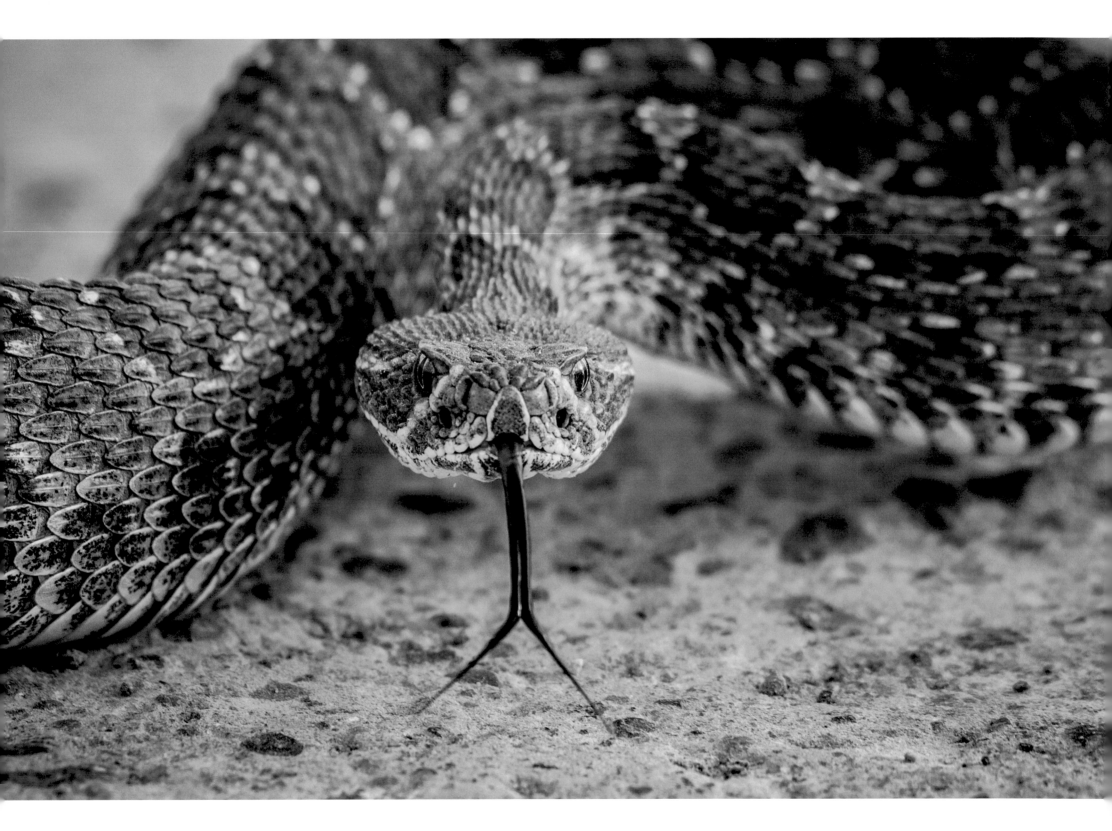

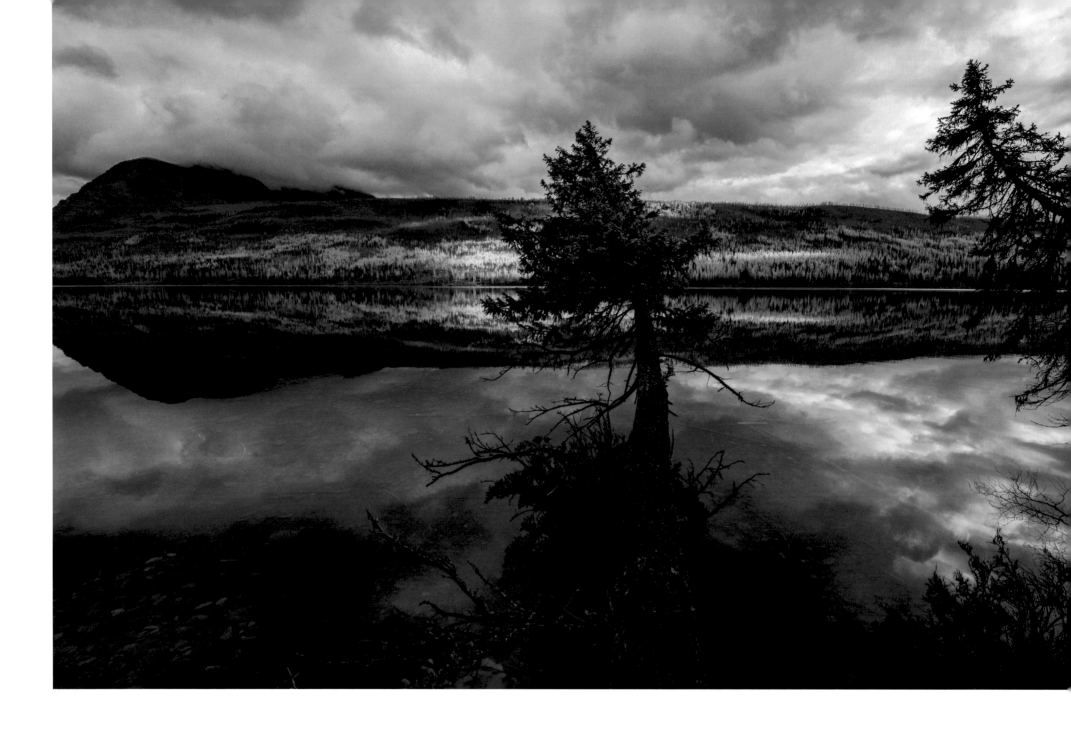

OPPOSITE *Rattlesnake in the*
Mission Valley

Kintla Lake in the North Fork
Flathead River Valley, in Glacier
National Park

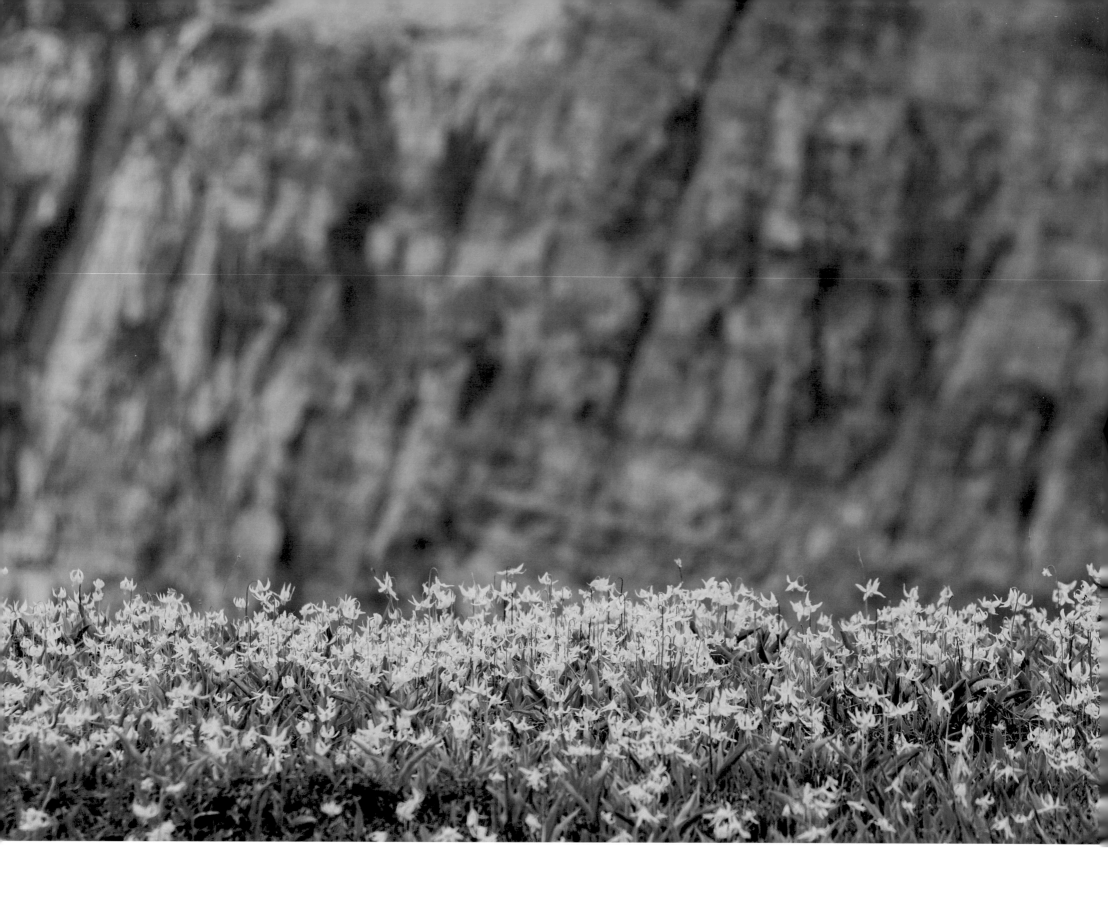

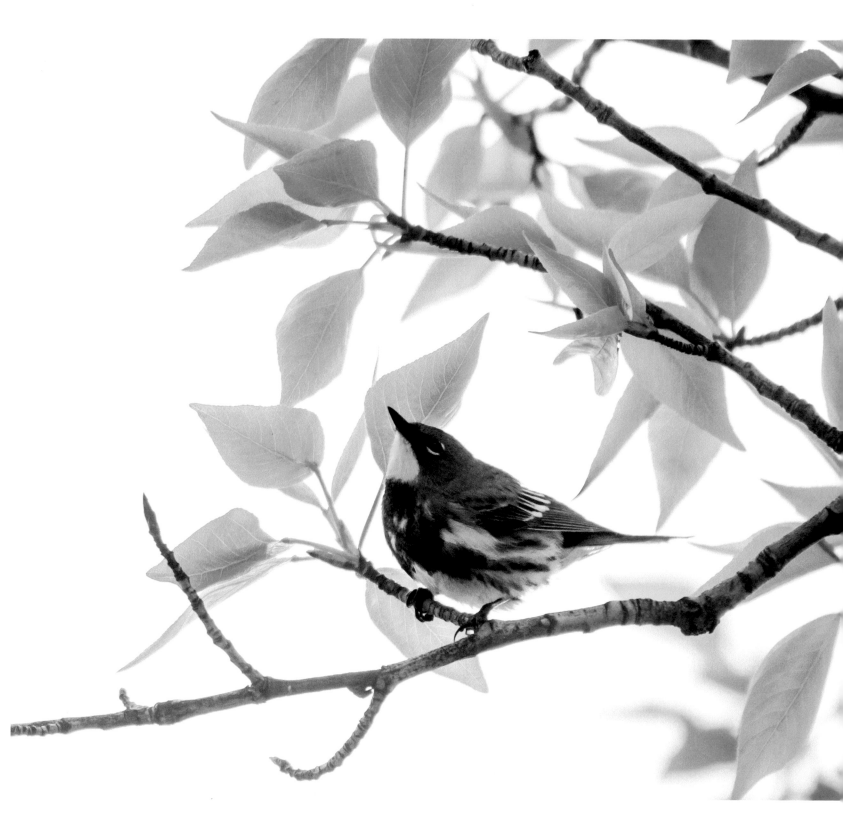

OPPOSITE *Glacier lilies*

*A yellow-rumped warbler along the
Rocky Mountain Front in Alberta*

Moving from Conflict to Conversation in the Crown

Michael Jamison

The community hall, a low-slung and broad-roofed log cabin, nestled just the other side of the middle of nowhere, sheltered by a tall pine forest that trailed away north, unbroken, out of Montana's backcountry and into the wild Canadian Rockies.

It was September, and we could feel seasons turning as our footsteps crunched through gravel in the last rays of daylight, taking us onto the rambling wooden porch. We had come—to this place well beyond the last power pole, where the bears far outnumber the people—to hammer out the unlikely details of urban planning.

Building setbacks. Twenty-acre (8-hectare) minimum lot sizes. Business zoning to limit mines and motels and hunting lodges.

Regulation—and in particular land-use regulation—may seem as ill suited to this wilderness as a cell phone or patent leather shoes. But here in the North Fork Flathead River Valley, 80 miles (129 kilometers) long and home to maybe fifty year-round residents, folks like it just the way it is. They also like to know they can dance to their own tune without bumping into a neighbor.

That's why we live here.

Inside the cabin, folding chairs flanked a barrel-chested woodstove; a couple dozen men in flannel already were raising their voices, working hard to bridge the gap between fierce individualism and the collective hunger to protect their shared backyard from any change other than the seasons. For the pro-planning liberals, John Frederick squinted behind round glasses, his back-to-the-land ponytail peeking from beneath a battered hat. For the conservatives, close-cropped Larry Wilson emphasized his property-rights position by jabbing the air with a tobacco-stained finger. The two men did not agree.

"Dammit, John . . ."

"Now settle yourself, Larry . . ."

Eventually, some peacemaker broke out hot coffee, calling a recess, and I grabbed the chance to corner John while Larry stepped out for a smoke. I wondered how we would ever manage to keep this place the way it is, to somehow find common ground in this argument. I told John he didn't have to sit right up close to his rival, that I worried they might throttle each other, that maybe they should put a few seats between them.

At which John looked mighty perplexed.

"Well," he said slowly, "you see, he *is* my ride home."

And in that moment, I understood perfectly how we would get from here to there.

Common Ground

From its headwaters in British Columbia's alpine heights, the transboundary North Fork Flathead River tumbles some 30 miles (48 kilometers) to the Montana border, then 50 miles (80 kilometers) more to its confluence with civilization, to powerlines, phone lines, and pavement. Along the way, it tracks the western boundary of Waterton-Glacier International Peace Park, more than a million

Whitetail fawn

151

acres (some 405,000 hectares) of wilderness as remote as any on the continent. Waterton Lakes and Glacier National Parks—surrounded by the Great Bear, Bob Marshall, Scapegoat, and Mission Mountains Wilderness Areas—in turn form the protected core of our remarkable ecosystem known as the Crown of the Continent.

The "Crown" was coined more than a century ago by explorer and writer George Bird Grinnell during his adventures along the precipitous flanks of Triple Divide—a pyramid of a peak whose summit snowmelt destined for the Atlantic, Pacific, and Arctic Oceans. This continental crest, North America's water tower, stirred Grinnell to his inspired christening of the Crown. Later he became known as the father of Glacier National Park.

I've covered the Crown's wild miles for most of three decades now, from Triple Divide's heights down all three of its watersheds, first as climber and skier, then later as writer and advocate. In recent years, I've been tracking Crown country in the company of talented photographer Steven Gnam, a tremendous and generous friend who has provided me yet another lens through which to know this place. Our explorations have revealed not only the transcendence of untamed summits, but also the sublime wonder of the wild within; Steven has shown me, quite powerfully, nothing less than the timeless nature of nature.

Today, our 18 million-acre (7.3 million-hectare) Crown ecosystem remains a place Grinnell would recognize, a place with its bark still on, home to grizzly bears and gray wolves, mountain lions, mountain sheep, elk, moose, deer, wolverines. And it also is home to John and Larry, their hardy and far-flung North Fork neighbors, and about 160,000 other folk living at the Rocky Mountain intersection of Alberta, British Columbia, and Montana.

Some of the Crown's towns have cafés and rodeos, lumber mills and ski resorts, movie theaters, malls, and museums. But to get to that community-hall cabin in the woods, you have to leave some things behind. First to go is cell coverage, lost before you're 5 miles (8 kilometers) out of town. Then you leave the landlines, powerlines, pavement, and plumbing. This road eats tires the way a cheese grater eats your knuckles, and if you're not careful, you'll leave behind your muffler too. Up here, you snowshoe to the outhouse and knock winter's icy rime off the seat before sitting down.

Which is to say, the Crown of the Continent is the sort of place where you need your neighbors, even if you'd prefer not to see

them every day. This is the inviolable rule of all life everywhere: no one, not Larry and not John, makes it on his own. We connect, conspire, compete, and cooperate—or we perish. The land, finally, is the great equalizer for people living throughout the Crown; rich or poor, urban or rural, we all of us must bundle against the same winter winds, must contend with wildfire and wildlife, with burly black bears breaking limbs from autumn apple trees.

The wildlands also serve as our common touchstone, the overpowering reason we all choose to live here. And although we might not agree on land-use planning—or wildlife management, timber harvests, grazing allotments, or much else, for that matter—we sure as hell can agree that we love this place deeply, fiercely, and for essentially the same reasons. We love it because it is absolutely America's best backyard: great towns and good neighbors living and working in a truly world-class landscape.

The wild Crown of the Continent is the place we've chosen to stake our collective future. It is our common ground.

Balancing Freedom and Community

Our modern notions of common ground date back to the "commons" of medieval England, when "common" folk held common rights to common grounds within the manor lands. The commons were the shared resources, the right to hunt and to fish, to run livestock and to cut firewood. They were, by definition, resources that could not be commodified, could not be privatized, could not be bought and sold. They were also, by definition, inclusive rather than exclusive, with ownership shared as widely as possible. And they persisted through generations, regardless of their return on capital, for the use of everyone. They were the community's common ground, literally and figuratively.

Such a multiple-user landscape required a few basic rules—don't take more than your share, leave some for the next generation—and not a small amount of self-restraint. And so, long before any system of statutory laws codified activity on the commons, these ancient rights demanded a code of honor and a community of trust, a sacred covenant between human folk and the earth underfoot. These are age-old, elemental, and deeply ingrained beliefs: our right to access the land and the obligations that come with that right.

When we exported those fundamentally democratic ideals to the New World and applied them to our vast public lands—

A whitetail buck in Montana's Flathead Valley

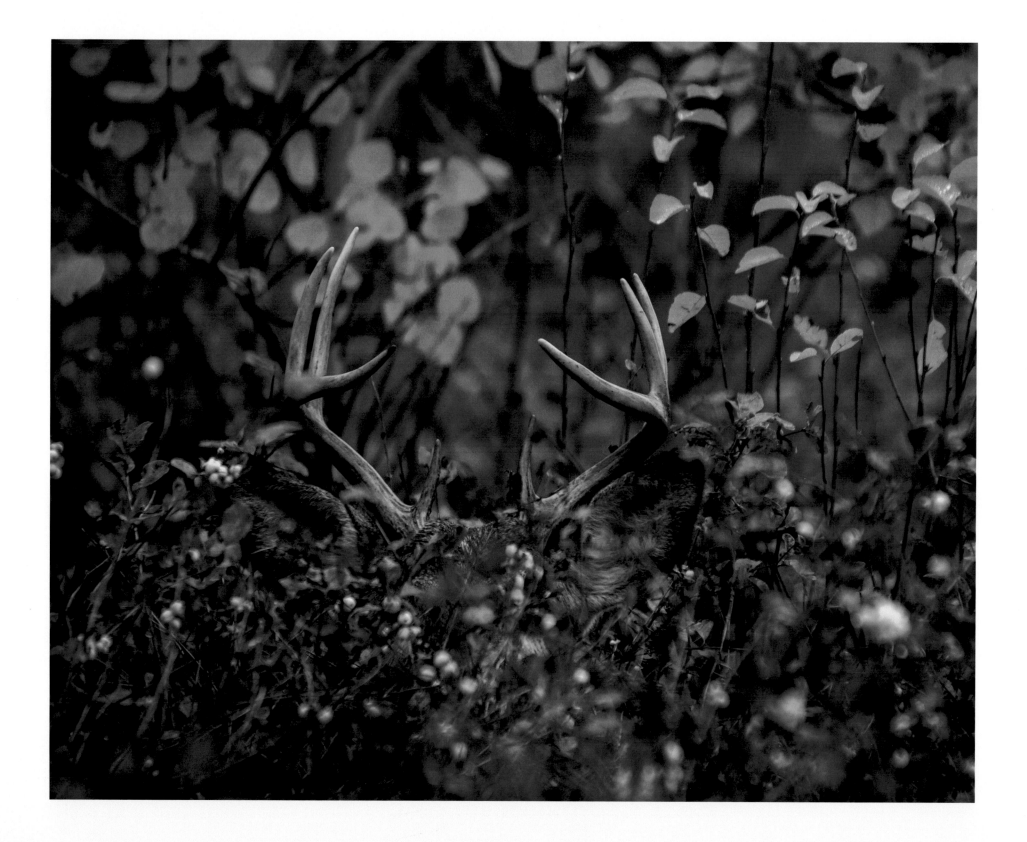

our national parks and forests, our expanses of wilderness, our unruly wild rivers—we broadened the definition to incorporate such concepts as the Scandinavian *allemansrätten,* defined in the Swedish Constitution as the "everyman's right" or the "freedom to roam." There is no resource profit in the *allemansrätten,* only the right to pleasure—to walk, ski, camp, pick some berries, or swim in a mountain lake. And, as always, this right to roam comes with a flip side: "Do not disturb, do not destroy."

Nowhere was this made more manifest than in the transboundary Crown of the Continent. Before Alberta became a province in 1905, the Canadian federal government set aside Waterton Lakes National Park in 1895; the United States followed in 1910 with Glacier National Park. The freedom to roam reached into the wilderness lands of Bob Creek and Black Creek, the Great Bear and the Scapegoat. Millions upon millions of acres of common Crown ground. Despite the fierce individualism of the Western myth—the tremendous tension between independence and interdependence—those of us who share the Crown understand the debt we owe this land.

It is a fine and deliberate and beautiful calculation, this unparalleled balance between freedom and obligation, use and protection. You can't log it all, you can't have it all for wilderness, and you must leave it in as good a shape or better for the next generation. Don't transform the landscape for your short-term needs; rather, serve as its steward and maintain it for tomorrow.

Up in the North Fork Flathead, the locals have long lived by a similarly balanced credo: "The only change we want," they say, "is the seasons."

But that's an awfully tough stand in a fragmented world where the only constant is change and where balance has in large part been abandoned—a modern world where (according to the Wilderness Society) less than 2 percent of the contiguous United States' land base has been spared for wilderness, where shared resources such as water and air have become industry's dumping ground. Even in the wild-open North American West, the commons can feel crowded—it's been getting so you can't dance your own jig without elbowing at least a few grumpy neighbors.

Balance was easier to come by when there were more miles between porch lights and everyone wanted pretty much the same things: room to hunt a bit and to gather some wood. But the commons have become less so as more and more people,

Swan Valley residents take special care to coexist in harmony with grizzlies.

with more and more interests, compete for space. Loggers and environmentalists, snowmobilers and skiers, ranchers and mountain bikers, hunters and hikers. Is a forest a place for wilderness solitude, or is it a place to open the throttle on your all-terrain vehicle? Is it log storage for the lumber mill, or is it a crucible for life's rich wonder? Or can it be all of these things?

That our ancestral connection to the commons is so profoundly ingrained can pose a very real problem—our opinions about land, both private and public, run as deeply as our beliefs about religion, politics, clan, and family. But that ancient web of land and rights and obligations also can provide solutions—we are, in the end, all in this together, sharing a potent and age-old bond with the dirt that is underfoot. What we need now, in these more complicated times, is not a new covenant with the land but, rather, a covenant with each other, a social contract rooted in the common ground that holds us fast.

Trust Gains Traction

Melanie Parker lives in a remote corner of northwestern Montana, in a dark and dense boreal forest where western larch blaze against October blue and mountain streams spill headlong into a slack-water river. Kingfisher, osprey, fisher, and peregrine. Bulldozer. Choker line. Log truck.

During the "timber wars" of the 1990s, choices here were stark, and Parker recalls a landscape that was at once "too much and not enough." Private timberlands were shorn for corporate profit, while adjacent public lands were held hostage to environmental litigation. Ecosystems unraveled, while timber towns boomed with sawyers, all racing to cut their way out of a job. Her neighbors, Parker said, faced two intolerable options: exploit their home for the sake of a paycheck, or protect the land and move to some other boomtown for work. Either-or. Us-and-them. The commons had become the front lines.

"It was so fierce, so much extreme polarization and violence," Parker said. "Everyone lost, and no one gained." No logs for the mill, no protection for the forests. Twenty-some mills closed in Montana alone during that decade—Tricon and Timberline, Champion and Crown Pacific. Meanwhile, the Crown of the Continent added exactly zero acres of new wilderness protection. "It was tearing whole communities apart. People were afraid to talk to their neighbors."

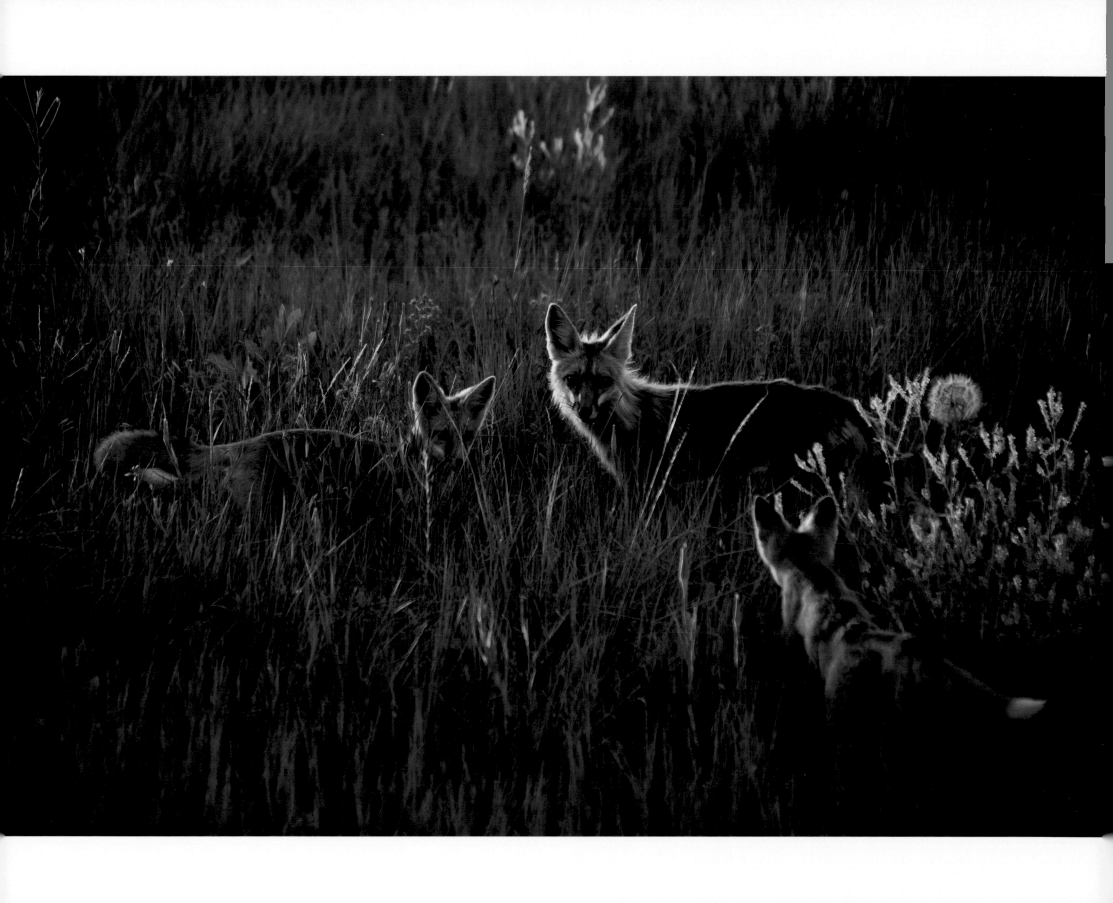

loggers and conservationists, motorheads and wildernuts, calling themselves a "forest collaborative." It was a fairly new phrase in the regional vocabulary—*forest collaborative*—and proved to be the first of many new words we found to talk about old ideas.

The language, for too long, had become diminished to a chorus of conflict—both sides were engaged in "campaigns," taking "actions" in the "war" for the West. Likewise, out in the field, the grammar of Cartesian reductionism had turned complex forests into simple production lines.

A student of mine in the University of Montana's School of Forestry did not so much as blink when he wrote in his year-end paper that "even-aged management is the most efficient silvicultural technique for treating these harvest units."

What he meant to say, of course, was that clear-cutting was the fastest and, so, best way to log the forests. But who could say that out loud and not wonder if fastest was, in fact, best? Technical euphemism had finally emptied the language, stripped it down to the absurd, and only by reducing a *forest* to a *unit,* and *logging* to a *treatment,* could this young forester keep his heart out of the way of his brain.

But words matter. They frame the way we think about things, serving as a kind of cultural architecture. A forest is rich and alive with context; a unit, impoverished and sterile. A partnership, a collaborative, an alliance suggests relationships, mutual interests, shared goals. What we call ourselves determines how we see ourselves, and just as ecosystems are defined by inter-relatedness, so must our management of them be informed by a web of human connections.

Call yourselves a partnership, and suddenly you have a stake in the views of your partners.

A fellow writer, reflecting on why you might strive to have your river listed under the Wild and Scenic Rivers Act—despite the fact that the act has few regulatory teeth—observed that *if you call it a church, it's a lot less likely to be used as a whorehouse.* The Crown is our home. By calling it home, we're more likely to treat each other as family.

Our home, ultimately, is our shared space and our shared values, defined by our cultural connection to common wild places. Residents of the Crown understand what it is to live alongside wolverines and avalanches, where ice-slicked paths lead to frozen outhouse seats. Loggers and environmentalists alike brush the ice off before we sit.

Adult red fox with kits

In claiming (and reclaiming) the new words of the commons, the people of this region claimed their shared future. And in doing so, we mined our new vocabulary straight from the geography of Grinnell's boundless Crown.

The Ground Underfoot

On an early September morning, when the river bottoms were just turning crackly and golden, I rattled across a narrow goat trail to a notch high on a Canadian mountain ridge. Slipping through the notch, alongside Steven Gnam, I stepped into a drainage where the earth's oldest fossils spiral into a soaring stone tower and a skeletal grove of tremendous white-bark pine shade wildflower meadows. This is the rugged confluence of Alberta, British Columbia, and Montana, heavy with the scent of elk and grizzly and alpine fir. In a partnership of words and images, Steven and I were chronicling rock and ice, fur and fin and bone, creating a narrative of this place we felt should be British Columbia's next national park. Though a creased and mud-smudged map was tucked deep into my pack, we had long since climbed beyond its borders and, so, had no names for these tremendous peaks and streams. But we knew where we were.

Steven and I stood in Canada's southern Rockies, looking south into Montana's northern Rockies. How could that be? How could we look north to Canada's southern Rockies or south to the northern Rockies? The words we've used to "manage" this transboundary treasure simply didn't align with the ground underfoot. For the griz, whose nose is his map, this is one chunk of country. There can be no north that is south of south.

Yet to the bear's great detriment, we have parsed our wildlands with irrational and invisible borders—international borders, provincial borders, federal lands, state forests, private property, tribal reserves. Farms and ranches and working timberlands, mines and parks and ski resorts. Continental divides, social divides, economic divides. Haves and have-nots. Old-timers and newcomers. Lines and words, abstractions and ideas, intellections that make no sense to critters, four-legged or two, living close to the bone.

When George Bird Grinnell looked across this landscape a century ago, he did not see borders and divides. He saw a whole and unbroken wild, punctuated by great peaks and threaded by powerful rivers. "An unmapped corner," he called it in a 1901

Century Magazine article titled "The Crown of the Continent," "a land of striking beauty." Grinnell made no jurisdictional distinctions other than those imposed by the topography itself: "The water from the crusted snowdrift which caps the peak of a lofty mountain there trickles into tiny rills, which hurry along north, south, east, and west, and growing into rivers, at last pour their currents into three seas."

What we need in our century is a return to a map that makes sense, that blurs the distraction of lines, a map where north is north and south is south. And so we have called on old words and named it all the Crown of the Continent, even named ourselves residents of the Crown, identifying ourselves as the culture of the Crown. These aren't Canada's southern Rockies or Montana's northern Rockies. These are the shared lands of Grinnell's Crown of the Continent. What we call it matters, because with words we break down boundaries and redefine ourselves as one people in one place.

When Steven and I stepped onto that goat trail, we left our bootprints in a muck puddle maybe three feet (a meter) across and a dozen feet (four meters) long. The muddy canvas already had been painted by wolf prints, griz prints, elk prints, deer prints. Mountain bike tracks, all-terrain-vehicle tracks, boot tracks. A horseshoe lay cast aside at the soggy edge. There is room enough for all of us, it seems, even in a tiny patch of damp earth, so long as we do not insist on drawing ever bigger and bolder lines to capture more for "us" and less for "them."

But first we must silence the impoverished language of division and learn to trust what we see in the mud underfoot. This landscape is honest. It does not prevaricate or quibble or beat around the bush. If we are receptive, the Crown will define itself in its own authentic tongue, rich with the mingled syllables of river song and bugling elk. Only once we learn that native vocabulary of connections and relationships—between critter and country, people and place—can we begin to understand it for what it really is: a single and singular mountain ecosystem that is our home.

Dollars and Sense

A bear will define the Crown's periphery for you. Biologists have tagged the big bruins, trailed them with radio telemetry and Global Positioning System devices, watched them wander from one wild limit of their range to the other. Trace those tracking lines, and you follow the contours of the Crown. The Crown's boundary is not limited by our jurisdictional edges; instead, the borders of our ecosystem are scribed by scent and track, by habitats, niches, and the wild corridors between.

People also define the Crown, by our shared cultural touchstones, our way of life, our values—our common ground. The day-to-day life of a software engineer in a ski town may differ vastly from that of a rancher on a dry-prairie spread, but over the seasons we all of us walk the same trails, through the same public lands. The scope of the Crown, in many ways, is the reach of the land's ability to touch people. If you live within the Crown, you inevitably take your summertime visitors to Waterton-Glacier International Peace Park. If you live beyond the boundaries of the Crown, your landmark might be Yellowstone or perhaps Banff.

The Crown of the Continent is a choice. People here have chosen to protect wild mountain parks and wilderness areas, to trade a corporate promotion for a trout stream, to live in a place where we are not always at the top of the food chain. The Crown is who we are, and it has shaped us in fundamental ways—far more than we have shaped it. This is our landscape, our lifestyle, our livelihood.

So a businessman, a banker, and a conservationist walk into a bar. No joke—I was the conservationist.

Tired of confrontation, weary of social and economic gridlock, hungry for a new standard, we sat down and started talking about what we want our community to be, why we live here, what we have in common, about our kids and our ambitions for them. In this conversation, we started to use our newly minted Crown vocabulary to spark dialogue rather than a debate. Turns out, we all wanted close-knit neighborhoods, authentic and true to rural roots. We wanted clean water, fresh air, good schools. We wanted vibrant downtowns and the chance to float the river after work. We wanted our kids to want to stay. We wanted good jobs, but not at the expense of what makes this special place our home.

When the National Parks Conservation Association asked chambers of commerce members why they chose to operate their businesses in the Crown, the answer wasn't tax structures or market shares, and it wasn't proximity to commercial hubs or transportation infrastructure. Instead, NPCA heard all about Flathead Lake and Waterton-Glacier International Peace Park, Fernie's ski slopes in British Columbia, beauty and hiking and fishing and wildlife. About our shared culture and how we imagine ourselves.

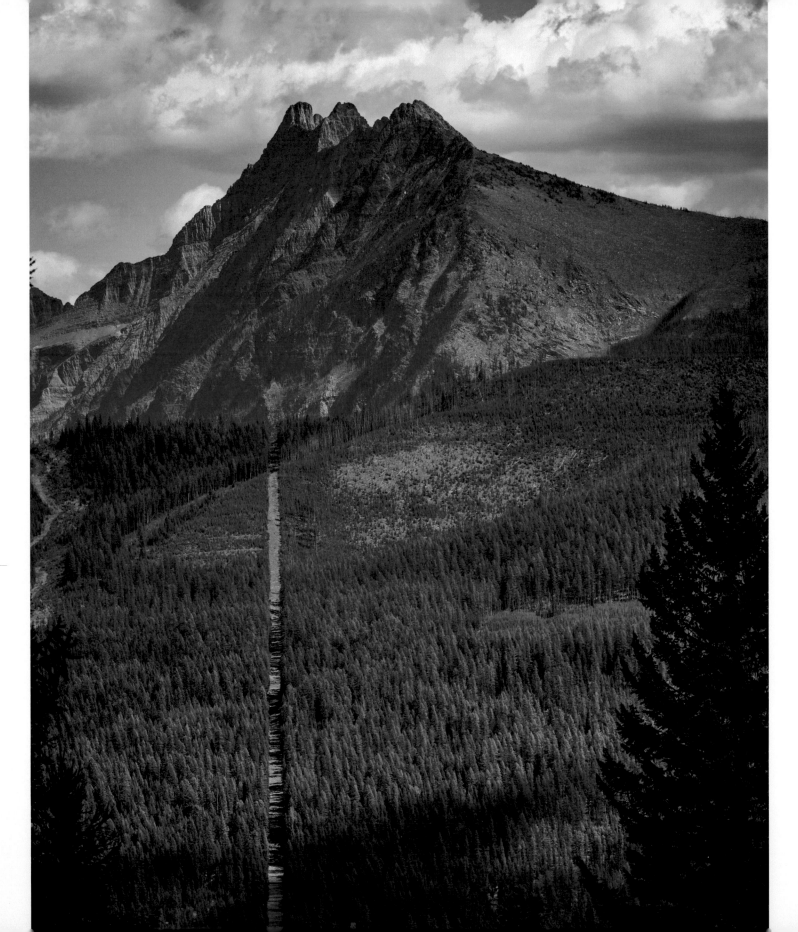

The US-Canada border is marked by a boundary clear of vegetation, about 20 feet (6 meters) wide.

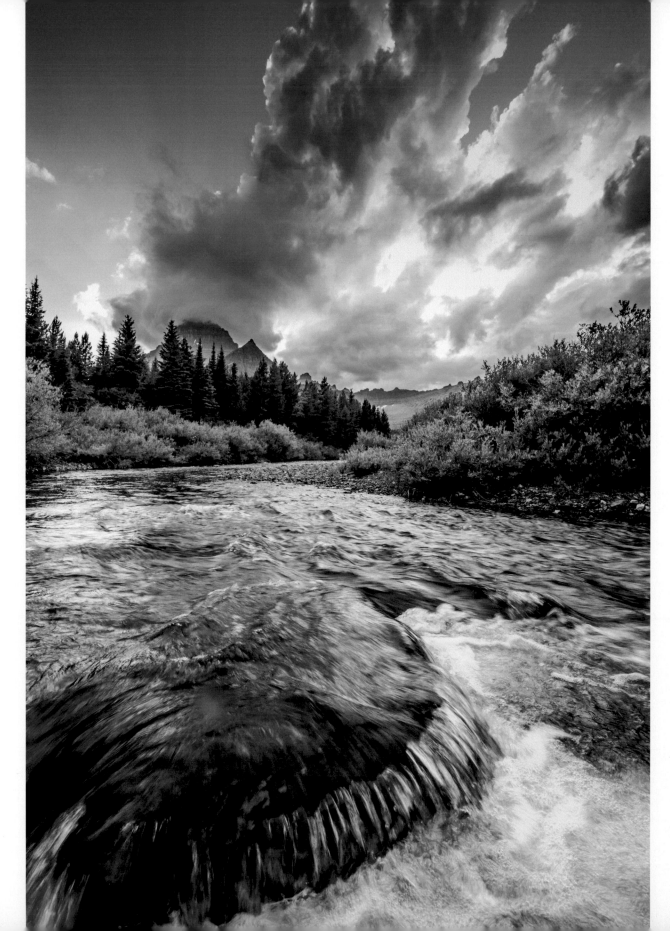

Headwaters of the Missouri River, which eventually flows to the Gulf of Mexico

What matters here is not reduced to how much you make or when the next promotion is coming. What matters is whether you got your elk or saw that griz or spent the evening on the river with your kids. The freedom to live close to things you value, with people who share those values. Because I was in that bar with a banker and a businessman, we began our new dialogue from the bottom line, with the old native tongue of economics. But it's a very short leap from how we make our living to how we want to live.

Throughout the Crown, economist Chris Mehl said, "Protecting public lands is good for the economy. If someone has a ten-minute drive to a trout stream after work, that is a big draw. National parks, wilderness areas, national forests, and other public lands play into our quality of life, and high-quality jobs are following."

We never left our barstools that afternoon, but we traveled miles—from controversy to conversation, from economics to environment to community values to a shared vision of our collective future. That, finally, is the Crown's economic and cultural niche: this alpine region attracts employers, employees, and entrepreneurs with its outstanding "natural infrastructure," as I like to call it. The Crown's wild amenities are in high demand and limited supply, and they not only are driving our expanding economy but also serve as the cultural foundation upon which our very identity is built.

Over time, we have come to understand that living trees often are worth more than logs, to recognize the manufactured fiction of "jobs *versus* environment," and to understand the fundamental reality of "jobs *because of* environment." In this new grammar of the commons, investment means conservation, and a capital asset is a community trail. It's a whole new vocabulary, a lexicon rooted in the poetry of place. Dollars and sense.

"We're all here for similar reasons," says rancher Megan Lee. "It's the land that sustains us, in so many ways. Sure, we could make an easier living elsewhere. But that would mean living somewhere else."

The Elders' Insight

Annie Pierre never lived "somewhere else." Neither did Christine Woodcock. Nor Louise McDonald.

They were the three *yayas,* or grandmothers, from the Confederated Salish and Kootenai Tribes' Flathead Indian Reservation, the women who back in 1974 politely requested a moment of the Tribal Council's time. The council, according to formal tribal history, was at that time considering a proposal to log the western slopes of the Mission Mountains.

The *yayas* talked a bit about our short time here on this earth and our obligation to leave this place to our children in good shape. Forests aren't dollars, after all, just waiting to be converted. The elders asked that the council take the long view and protect what really matters in the Mission Mountains. They carried with them the heavy weight of generations.

When the three grandmothers finished, the council chairman thanked them and waited for them to be seated. But still the *yayas* stood. The chairman asked if they had anything else to say.

"Well," one replied, "we'll just wait here until you vote."

And so the council voted, right there on the spot. The logging proposal was denied, and those lands subsequently became the Mission Mountains Tribal Wilderness Area—the first of its kind in America. The Crown is full of firsts, layered with a cultural depth that, like the ancient sediments at the roots of our mountains, underpins even our modern shared values, a connection to land so fundamental that identity cannot be imagined absent the landscape.

As introduction to that tribal history, published in 2005 under the title *Mission Mountains Tribal Wilderness: A Case Study,* elder Clarence Woodcock wrote that the mountains "have served as a guide, passage way, fortification and vision-seeking grounds as well as a place to hunt for food. . . . They have become for us, the descendants of Indians, sacred grounds."

This is conservation, community, and culture all rolled into one, a wise insight into what it really means to be wealthy, writ large on ice-capped peaks that march like white-haired elders to the horizon, leading the way to a new-old way of knowing. Be patient. Show some respect. And humility—know how much you do not know. And leave behind something worth leaving. Your children will cherish the tangled perfection of an uncut forest or a crystal-clear river far more than an orderly bank account. Take seriously the knowledge that our legacy is their inheritance.

I learned a bit of this lesson in the drear of a midwinter melt, a January day more slush than snow, when Steven and I made a pilgrimage to meet the elders of the Confederated Salish and Kootenai Tribes. They wanted to talk about the timeless Crown, and we wanted to show them Steven's pictures.

Talk turned to protection of natural resources, and I asked about other resources. Cultural resources. Steven Smallsalmon looked puzzled—what did I mean, "other"? Is a buffalo a natural resource? Of course. And is that buffalo also a cultural resource? Absolutely. Same goes for that bull trout, that stream, that mountaintop. The elders we met made absolutely no distinction between natural and cultural—that was a boundary I had brought with me.

We compartmentalize our thinking, quarantine natural resources and economics and public policy as somehow apart from culture. But the elders are right. There is no distinction. When I take friends to Glacier National Park and we see a great grizzled bear rumbling over the alpine tundra, I do not talk about that bear as a natural resource. I do not exclaim, "Hey! Look at that top-tier predator, whose presence on the landscape is sending trophic cascades all the way down to soil biota!"

Instead, it is a cultural experience—that bear, living here in my backyard, somehow says something about who I am, how I choose to live, what I value in the world. It's our cultural commons: landscape, livelihood, lifestyle—all alive in that griz. There is no separating the human from the wild. Our species has not seceded from nature. We are the wild. There is no "other."

Turns out, the scientists and the elders actually speak the same language—the world is connected, they say, interconnected and indivisible. Naturalist John Muir, in 1911 in *My First Summer in the Sierra,* noted that "when we try to pick out anything by itself, we find it hitched to everything else in the universe."

"There is no separation between you and me or between humans and the wild," echoed tribal elder Tony Incashola that damp January day. "We are all part of the same life. We respect the land because we respect ourselves."

Collaboration: Not for the Faint of Heart

Respect feeds trust. Trust feeds respect. Each perishes without the other. Here again, that essential law of life: none of us can make it on our own. Back in the 1980s, up near John and Larry's neighborhood, wolves wandered south out of Canada, reclaiming country they had been hunted from nearly a century before. The elk, made suddenly wary by the sharp edge of natural selection, no longer lingered to browse young willow shoots to the dirt. Soon songbirds made homes in the new growth, and insects, too, and

the willows grew to overhang the river, shading bull trout pools, where the bugs fell off, occasionally, feeding the fish. The wolves chased the coyotes, so the ground squirrels those coyotes had been eating returned to the meadows, plowing the soils and spreading wildflower seeds, which blossomed and attracted butterflies, which fed the songbirds and the bull trout, too. This intricate web represents a tremendously complex symbiosis, a multiplicity of unfathomable connections.

The Crown of the Continent is that way, too: far, far greater than the sum of its parts. The ultimate secret to its success is its diversity and connectivity. Biological diversity and habitat connectivity. Cultural diversity and human connectivity. From the Blackfoot-Clearwater region in the southern Crown to the Canadian headwaters of the Elk River in the northern Crown, neighbors have, like those wolves, begun the work of rediscovering their common ground and knitting new and surprising relationships. Community increasingly means common unity. "But collaboration is not for the faint of heart or the impatient," Melanie Parker warns. "It is not for folks who cling rigidly to firmly held ideological points of view." Collaboration requires time and honesty. "And face the fact that that there's going to be some screaming and shouting."

Which is all as it should be. The nature of nature is that there will be some screaming and shouting. Our problem has been that people care too fiercely about their connection to the land, and that, finally, is an awfully good problem to have. The spectacular potential of the Crown of the Continent forces us to take notice; we can't not care.

The more we come to understand this ecosystem, the more we realize the critical importance of working at the proper scale. Sure, my little valley is a pretty special place—but what makes it truly remarkable is the fact that it's connected to the next valley and to the valley after that. You can still, if you're careful, walk from Missoula, Montana, to Sparwood, British Columbia, and cross only a half dozen roads—a fact biologists say is a primary reason the Crown remains home to such world-class wildlife.

And just as the landscape is connected, so are its people: more than 160,000 people; more than a hundred government agencies, tribes, First Nations, nonprofit organizations, and community-based partnerships—their whole, too, is much greater than the sum of their parts. Even our partnerships and collaboratives have linked, creating unprecedented intellectual corridors.

Rancher repairing stirrups at a branding along the Rocky Mountain Front

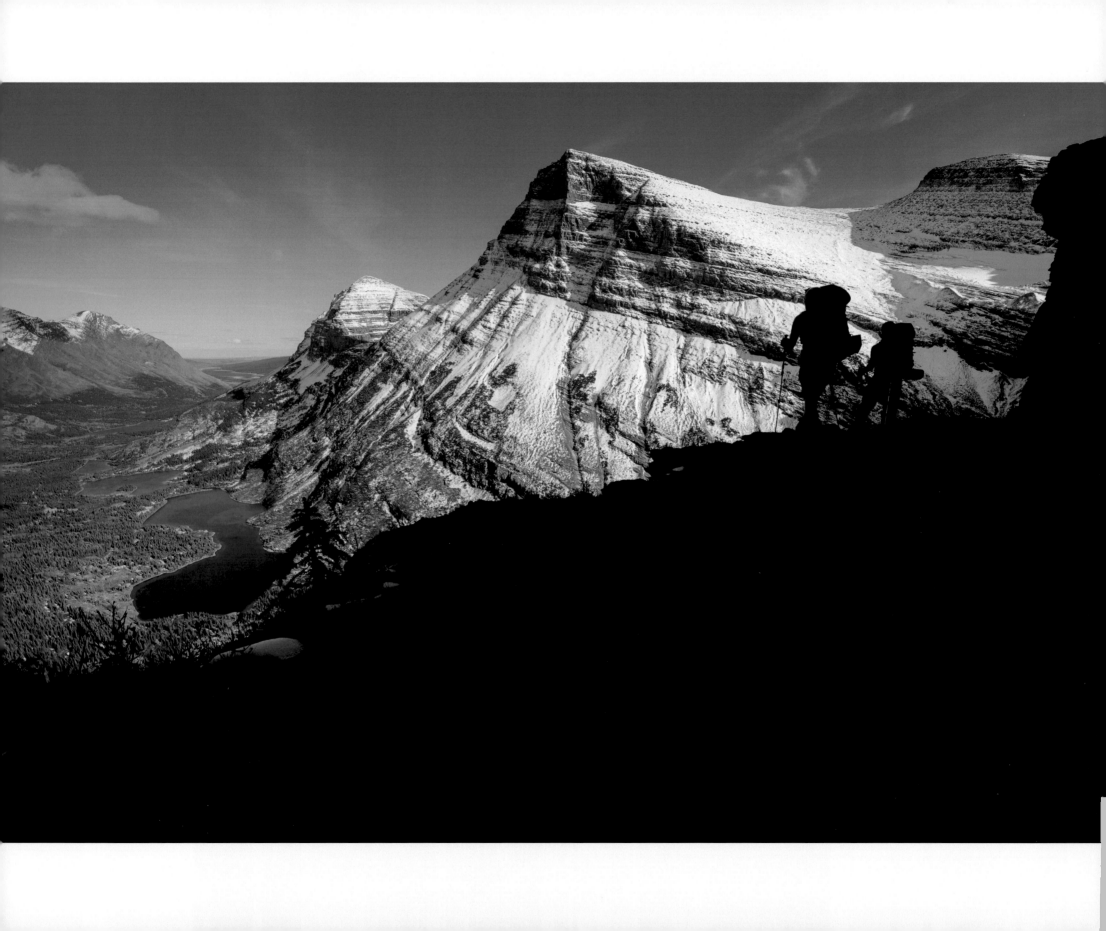

The Crown Managers Partnership binds some two dozen state, provincial, federal, and tribal land-management agencies to work across the entire landscape. The Crown Research Learning Center, in Glacier National Park, coordinates science and community outreach regionwide. The Crown of the Continent Ecosystem Education Consortium develops regional curricula, tying people to place, and the Crown of the Continent Geotourism Council marries conservation with sustainable business. (It's often more of an arranged marriage, and sometimes one partner or another winds up sleeping on the couch. But it works.)

The Crown's universities have teamed up across international borders, to study the implications of both physical and psychological boundaries; the Crown of the Continent Initiative coordinates academic research; the Crown Round Table provides an umbrella under which all those initiatives can huddle. And all throughout the region, the Crown of the Continent Conservation Initiative is working to ensure that, once and for all, each of the parts remains connected to the whole.

"We absolutely need to combine our efforts across the entire Crown region," Melanie Parker says, "if we're to have any hope of influencing policy." But, she warns, "Anyone who thinks that conservation is accomplished at the scale of 18 million acres (7.3 million hectares) is seriously misguided. This kind of work has to be done at the scale at which people live, work, and understand their landscapes." Watershed by watershed, she says, we're doing the hard work with neighbors, then stitching a network of connections—an intact cultural ecosystem.

I know of nowhere else in the world where so many people representing so many interests have come together over so many years on behalf of so much public land. When the Canadian and US federal governments sought a model for large-landscape conservation—for a template of people and place, environment and economy—they looked here, to the Crown. They turned to the corridors we've created both for wildlife and for ideas, because there are important lessons in the Crown of the Continent about how to inhabit a common ground. Unearth the values you share. Break down false borders. Look to the opportunities, not the obstacles. And know the wild is not the other. Steven Gnam's exquisite art is possible because he sees so clearly the human connections as well as the wild. His remarkable work illustrates that we are the wild, and the wild is us. The Crown of the Continent and its people are, ultimately, inextricably, one and the same.

Michael Jamison

Hiking in Glacier National Park

Experiencing the Crown of the Continent

Dylan Boyle

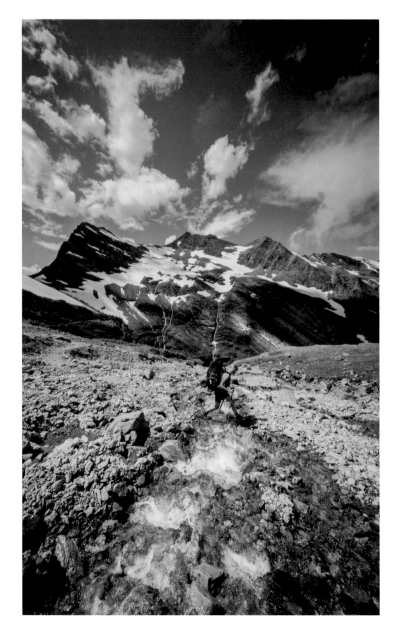

Alyson Dimmitt Gnam, the photographer's wife, in the backcountry of Waterton-Glacier International Peace Park

Vast is one way to describe the 18 million-acre (7.3 million-hectare) Crown of the Continent ecosystem. However, within this vastness comes an interconnectedness of people and place. Regardless of the forty-ninth parallel separating Canada and the United States, residents of the region are inextricably tied by common history, economic opportunity, stewardship of the land, and the sheer fortitude to live in such a harsh climate. When there is this much open space, it's good to know that you aren't the only one out there.

Just because there is open space does not mean that there is nothing here. The few urban areas and many small communities offer plenty of amenities, serving as gateways to the Crown region. There is a lot in between them to see and explore. With more than 60 percent of the Crown of the Continent managed as public land, the recreational opportunities are seemingly endless.

This combination of environmental, aesthetic, cultural, and historical aspects of the Crown provides the visitor with a one-of-a-kind experience that is unlike anywhere else in the world. The following pages provide you with a jumping-off point to begin your own adventure.

As a visitor, you have the opportunity to enjoy the Crown of the Continent while contributing to the economic and environmental well-being of the region. Consider staying at local accommodations, eating local food, and volunteering or donating to local community or conservation organizations during your visit.

Recreation in the Crown

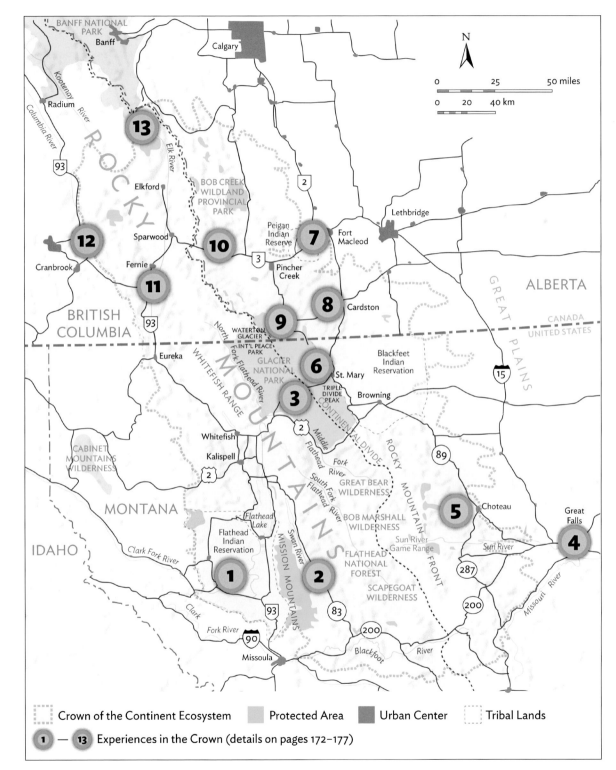

Montana West

The Montana side of the Crown of the Continent is home to an astounding array of federally protected land, including Glacier National Park, the Bob Marshall Wilderness Complex, and the Mission Mountain Tribal Wilderness, the first tribally established wilderness area in the United States. The landscape is visibly bisected by the Continental Divide, which runs north to south through the Crown of the Continent. The west side of Montana takes the brunt of storms from the Pacific Northwest coast of the

United States. This precipitation leads to a wet and lush climate, by Rocky Mountain standards. Flathead Lake, the largest natural freshwater lake in the United States west of the Mississippi River, is located in this area. In addition, the Flathead Valley, including the towns of Kalispell, Whitefish, and Columbia Falls, serves as the main gateway to the western portion of Glacier National Park. The following experiences will provide an authentic journey through the area.

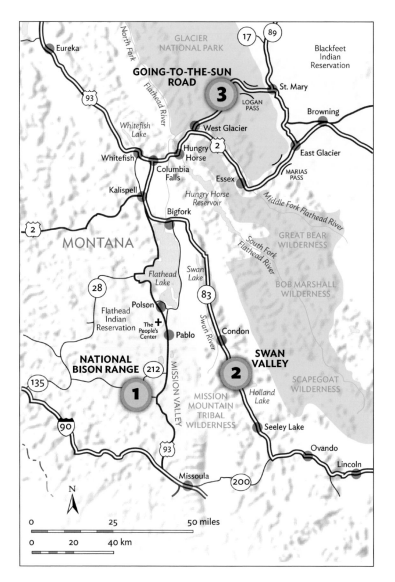

1. Explore the National Bison Range

Access from Highway 212

Located in the Mission Valley and established in 1908, the National Bison Range is one of the oldest wildlife refuges in the nation. The 18,500-acre (7,487-hectare) bison range includes a variety of habitats, including native prairie, wetlands, streams, and forests. It is home to an estimated 350 to 500 bison, as well as coyote, black bear, pronghorn antelope, bighorn sheep, elk, and both white-tailed and mule deer. More than 200 species of birds also inhabit the bison range. The most popular way to see the National Bison Range is on the scenic driving loops, but there are some short walking trails as well. Check in at the **VISITOR CENTER** for more information and to see an impressive display of how the local tribes hunted and used bison.

While in the Mission Valley, make sure to stop at **THE PEOPLE'S CENTER** in the town of Pablo to learn more about the rich cultural heritage of the Kootenai, Pend Oreille, and Salish tribes, who call the Flathead Indian Reservation home.

2. Hike the Swan Valley

Holland Lake Hike: Access from Highway 83
Round Trip: 3 miles (4.8 kilometers)
Difficulty: Easy
Elevation Gain: 600 feet (183 meters)
Trailhead: Follow Holland Lake Road 44 for 4 miles (6.4 kilometers), staying left; road dead-ends at trailhead

Located 20 miles (32.2 kilometers) north of the town of Seeley Lake, the **HOLLAND FALLS NATIONAL RECREATION TRAIL** provides a stunning view of the Swan Valley and pristine Holland Lake from the base of Holland Falls. The hike is accessible year-round, and the scenery changes with each season. In late fall when the western larch trees turn bright yellow is an especially striking

time to visit. This area is also one of the main access points to the Bob Marshall Wilderness Complex, so do not be surprised to see professional outfitters with their horse pack "trains" gearing up for the long trek. Canoeing or kayaking around Holland Lake is also pleasurable activity, as is checking out the historic **HOLLAND LAKE LODGE,** built in 1924. Camping is available at Holland Lake.

3. Drive Going-to-the-Sun Road
Access from either West Glacier or St. Mary
Open: Approximately late May to early September depending on weather; check status

Completed in 1932, the architectural marvel of the Going-to-the-Sun Road covers 50 miles (80.5 kilometers) of the interior of Glacier National Park, traversing the Continental Divide. It is the only road that travels through the center of the park. Make sure to stop at the pinnacle of the Going-to-the-Sun Road, **LOGAN PASS,** home to families of mountain goats. There are a multitude of accessible hikes throughout the distance of the road. Two historic backcountry chalets, **GRANITE PARK** and **SPERRY CHALET,** are accessible via hiking or guided horseback riding. Reservations for the chalets should be made well in advance. **JACKSON GLACIER OVERLOOK** is another must-see. It gives you a view of one of an estimated 26 remaining glaciers in the park, down from 150 in 1850. For a truly authentic experience, take an alternative mode of transportation, including an interpretive tour on a historic bus, a free Glacier shuttle, or a bicycle.

Montana East

On the east side of the Continental Divide, the Great Plains meet the Rocky Mountains. This intersection is known as the Rocky Mountain Front. Abrupt elevation gains of thousands of feet characterize the overlap of these two vastly different ecosystems. Flora and fauna from both ecosystems are present on the Rocky Mountain Front, which includes Glacier National Park and the Bob Marshall Wilderness Complex. Much of this arid landscape remains similar to that experienced by the Lewis and Clark Expedition in the early 1800s. This area has a rich indigenous history of the Blackfoot Confederacy and is also home to farmers and ranchers, many of whom have homesteaded for generations. The following information will lead you to unique towns and experiences in this area.

4. Visit Great Falls
Access from Interstate 15

Rich pioneer history abounds in the high plains town of Great Falls. Overlooking the Missouri River, the **LEWIS AND CLARK NATIONAL HISTORIC TRAIL INTERPRETIVE CENTER** features historical exhibits and displays from the 1804–1806 Lewis and Clark Expedition, covering 8000 miles (12,875 kilometers) of northwestern America. Guided tours of this modern interpretive center are also available. While in Great Falls, make a stop at the **C. M. RUSSELL MUSEUM,** dedicated to local artist Charles M. Russell, who captured the culture and landscape of Montana and the Rocky Mountain Front during the late 1800s and early 1900s.

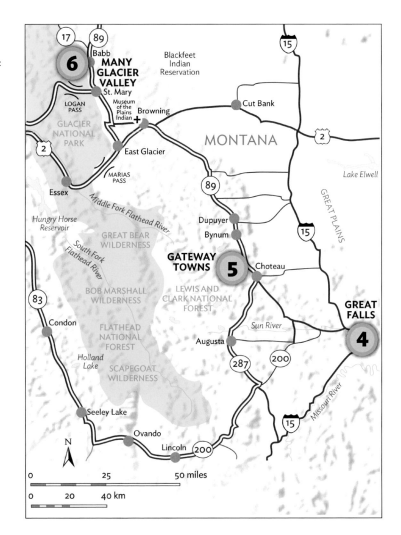

5. Visit Gateway Towns

Augusta and Choteau: Access from Highway 287

Browning: Access from Highway 89 and US Highway 2

The dramatic and expansive Rocky Mountain Front is home to the quaint towns of Choteau and Augusta. Augusta hosts one of the largest and oldest rodeos in the state, the **AUGUSTA AMERICAN LEGION RODEO AND PARADE,** which takes place in June. Augusta is also one of the entry points to the vast Bob Marshall Wilderness Complex, where outfitters with horse pack "trains" are the preferred mode of transportation for access to camping, hiking, fishing, and hunting.

Located north of Augusta near the town of Choteau, **PINE BUTTE GUEST RANCH** (owned and managed by the Nature Conservancy) provides a variety of trail rides, naturalist-led hikes, and workshops. The Pine Butte Guest Ranch serves local food from the Rocky Mountain Front as well as produce grown right on the ranch.

Backpackers in Glacier National Park

Travel north along the Rocky Mountain Front to the Blackfeet Indian Reservation and the **MUSEUM OF THE PLAINS INDIAN,** located in the town of Browning. This museum houses an outstanding collection of historic art created by tribal people of the Northern Plains.

6. Hike Many Glacier Valley

Grinnell Glacier Hike: 12 miles (19.3 kilometers)
 west of Highway 89 at Babb, Montana
Round Trip: 12 miles (19.3 kilometers)
Difficulty: Moderate
Elevation Gain: 1600 feet (488 meters)
Trailhead: Just beyond Many Glacier Hotel
 on shore of Swiftcurrent Lake

The beautiful Many Glacier Valley is tucked away on the northeast side of Glacier National Park. Take in the view from the back deck of the **MANY GLACIER HOTEL,** built in 1915, and look for moose along Swiftcurrent Lake. Hiking the **GRINNELL GLACIER TRAIL** provides an outstanding view of one of the last remaining glaciers in the park. In fact, Salamander and Gem Glaciers are also visible, making this a truly unique hike. You have the option of cutting off significant mileage by taking the scenic boat cruise across both **SWIFTCURRENT LAKE** and **LAKE JOSEPHINE**. It is important to keep in mind that the Many Glacier Valley is home to a healthy population of grizzly bears. Be sure to educate yourself on proper hiking procedure in bear county, carry bear spray when hiking, and make noise to mitigate the chance of encounters.

Alberta

The southwestern portion of Alberta is an extension of the Rocky Mountain Front in Montana. This area is home to ranching and farming to the east and rugged mountains to the west along the border with British Columbia. In the southern portion is Waterton Lakes National Park, established along the Alberta-Montana border in 1895 and later combined with Glacier National Park to become the world's first international peace park. Every year since the establishment of Waterton-Glacier International Peace Park in 1932, Rotary clubs from Alberta and Montana have gathered to commemorate their relationship of peace and goodwill in the "Hands Across the Border Ceremony." Waterton-Glacier International Peace Park was also formally

recognized as a United Nations Educational, Scientific, and Cultural Organization (UNESCO) World Heritage Site in 1995, making it the second UNESCO World Heritage Site with roots in southwestern Alberta. In addition to visiting Waterton, experience the rich indigenous and pioneer heritage of this part of Alberta.

7. Visit Head-Smashed-In Buffalo Jump

Access from Highway 785

Near the town of **FORT MACLEOD,** Alberta, lies one of the oldest and best-preserved buffalo jumps in the world. This archaeological site was used for close to 6000 years by the indigenous people of the North American plains in order to harvest herds of bison. In 1981 Head-Smashed-In Buffalo Jump was designated as a

UNESCO World Heritage site. The interpretive center, open year-round, provides detailed information and artifacts.

On your way back, take a stroll down Main Street in Fort Macleod to find the **EMPRESS THEATRE,** the performing-arts hub for the region since 1912 and designated as an Alberta Historic Resource. Fort Macleod is also home to the **FORT MUSEUM OF THE NORTH WEST MOUNTED POLICE,** the first outpost established by what is now known as the Royal Canadian Mounted Police.

8. Visit Remington Carriage Museum

Access Main Street from Highway 2

Located in the town of **CARDSTON,** the Remington Carriage Museum houses the largest collection of horse-drawn vehicles in North America. The museum provides visitors with a one-of-a-kind interactive experience with nineteenth- and early twentieth-century horse-drawn transportation. The 20-acre (8-hectare) plot includes a museum, theater, restoration shop, and working stable with horses, and carriage rides are featured during the summer months.

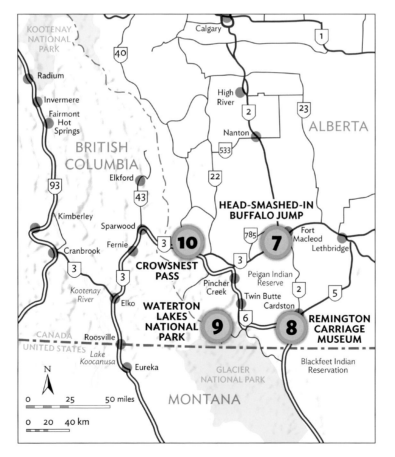

9. Hike Waterton Lakes National Park

Bears Hump Hike: Access from Highways 6 and 5
Round Trip: 2 miles (3.2 kilometers)
Difficulty: Easy to moderate
Elevation Gain: 700 feet (213 meters)
Trailhead: Waterton Visitor Resource Centre

Take a scenic boat cruise on Upper Waterton Lake aboard the historic **MV INTERNATIONAL,** in service since 1927. In true Peace Park fashion, Upper Waterton Lake resides in both Alberta and Montana, and the cruise stops at Goat Haunt, Montana, before returning to the Waterton town site.

While visiting Waterton, make sure to have afternoon high tea at the historic **PRINCE OF WALES HOTEL,** perched above the town site. The back wall of the hotel lobby is a giant picture window with a view of azure Upper Waterton Lake and the rugged peaks of Waterton-Glacier International Peace Park.

Hike the **BEARS HUMP,** a short but rewarding trail. The view from the top is nothing short of spectacular, giving the hiker a bird's-eye view of the Waterton town site, Upper and Lower Waterton Lakes, and the surrounding peaks.

10. Experience Winter in Crowsnest Pass

Access Allison Creek Road from Highway 3 at Coleman, Alberta

Open: December through March, depending on weather; check status

The solitude and stillness of winter in the Crown of the Continent can be found atop the Crowsnest Pass at the **ALLISON–CHINOOK LAKE CROSS-COUNTRY SKI TRAILS.** This network of trails for nonmotorized users has plenty of opportunities for novice and experienced cross-country skiers, with more than 19 miles (30 kilometers) of weekly groomed trails across 741 acres (300 hectares) of rolling forest and lakeshore in the Crowsnest Mountains. There are a variety of backcountry trails to explore as well.

British Columbia

From the top of the Crowsnest Pass in Alberta begins the British Columbia side of the Crown of the Continent. This area includes the historic towns of Fernie and Cranbrook, as well as a vast network of natural hot springs and provincial parks. The Flathead River Valley, or "Canadian Flathead," is a spectacular centerpiece of the area. This valley, which has never been permanently settled, is a stronghold for breeding grizzly bears that provides an important migration corridor for many animals moving north and south from northwestern Montana into the Canadian Rockies. This treasure, considered part of the headwaters of the North American continent, has been internationally considered as the missing piece of Waterton-Glacier International Peace Park. Here are some unforgettable ways to experience this stunning part of the Crown of the Continent.

11. Hike the Elk River Valley

Ancient Cottonwood Trail: Access from Highway 3

Round Trip: Less than 1 mile (less than 1.6 kilometers)

Difficulty: Easy

Elevation Gain: None

Trailhead: At Morrissey Bridge, 10 miles (16 kilometers) southeast of Fernie

Running through the communities of Elkford, Sparwood, Fernie, and Elko, the **ELK RIVER** flows approximately 140 miles (225 kilometers) before emptying into Lake Koocanusa, located on the British Columbia–Montana border. The Elk River is home to native fish species, including west-slope cutthroat trout, bull trout, and mountain whitefish. Due to the ecological quality of the river and strict regulations, the Elk River is considered one of the finest fly-fishing destinations in the world. Hire one of the many local guides to take you down the river in a drift boat or raft. The banks of the Elk River contain some of the oldest and largest black cottonwood trees in the world. The **ANCIENT COTTONWOOD TRAIL,** a nature walk through a forest managed by the Nature Conservancy of Canada, gives visitors an up-close look at these 400-year-old trees.

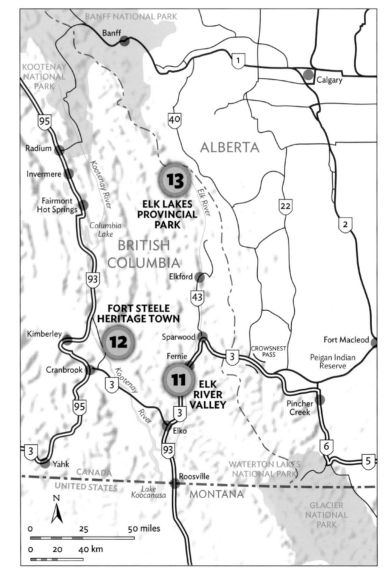

Climbing in mountains high above the Swan Valley

four distinct periods of settlement, told historically by townspeople. Clydesdale **HORSE-DRAWN WAGON TOURS** are available, in addition to Fort Steele's **STEAM TRAIN.**

13. Hike Elk Lakes Provincial Park

Lower Elk Lake Trail: Access from Highway 43 at Elkford
Round Trip: 1.2 miles (1.9 kilometers)
Difficulty: Easy
Elevation Gain: None
Trailhead: 43 miles (69 kilometers) north of Elkford

North of the town of Elkford on the British Columbia–Alberta border sits Elk Lakes Provincial Park, the headwaters of the Elk River. The park setting is predominately subalpine, with jagged peaks surrounding high-elevation lakes and old-growth forests. Three remnant glaciers exist in the park, as well as **PETAIN FALLS.** No roads run through the park, making it a true wilderness experience. Backpacking, backcountry camping, canoeing, and kayaking are the most popular activities. It is important to note that there is no motorized boat use, mountain biking, or vehicle camping allowed at Elk Lakes Provincial Park. Backcountry permits must be obtained for overnight stays. Take the short hike to **LOWER ELK LAKE** to begin your trip. From here, you can continue on to **UPPER ELK LAKE,** which doubles the round-trip length of the hike and adds 100 feet (30 meters) of elevation gain. This main park trailhead provides access to many other hikes as well.

12. Visit the Fort Steele Heritage Town

Access from Highway 93/95

Located northeast of **CRANBROOK** on the banks of the Kootenay River, the Fort Steel Heritage Town provides an interactive visitor experience of nineteenth-century pioneer life. Fort Steele began as a **GOLD RUSH TOWN,** peaking in 1865. Prior to the first bridge being built in 1888, the only means of crossing the river was by a ferry service started by the town's founding family. The first post of the North West Mounted Police west of the Rocky Mountains was established here prior to the second mining boom, in the 1890s, and subsequent decline of the town. This restored community is open year-round, and visitors are treated to a **LIVING MUSEUM** of the

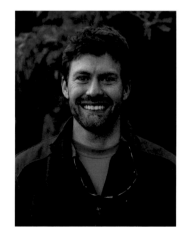

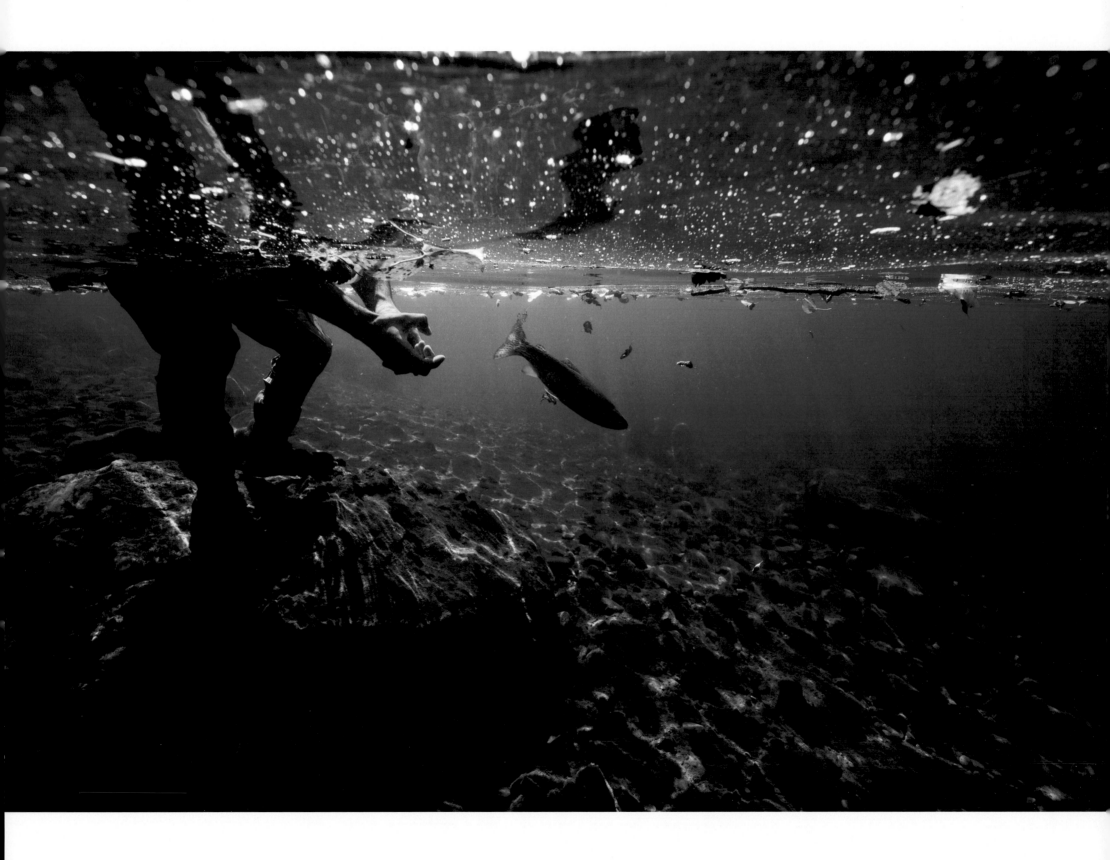

A Fragile Legacy

Karsten Heuer

This book, with its beautiful photographs and wise words, is both hopeful and disquieting. Hopeful because it celebrates the legacy of people working across political and socioeconomic boundaries to conserve something larger than themselves. Disquieting because, as big and amazing as that accomplishment is, the Crown of the Continent remains a fragile place, a wild but narrow peninsula where wildlife is in grave danger of being cut off from needed habitat.

As you've read elsewhere in this book, peninsulas getting cut into islands is how extinction happens. Look at a historic distribution map for any major North American carnivore, and you'll see what I mean. Like a rising tide, our roads, railways, residences, and recreational developments have forced bears, wolves, wolverines, and lynxes onto ever smaller chunks of land where, unable to escape fire, disease, flood, or inbreeding, they eventually "wink out." Yellowstone National Park is a good example: isolated by human development, its 600-plus grizzly bears are becoming inbred, showing 20 percent less genetic variation than their still-connected cousins in the Crown of the Continent to the north.

The fragility of the Crown of the Continent became apparent to me when I hiked its 250-mile (402-kilometer) length as part of a longer 2200-mile (3541-kilometer) trek from Yellowstone to the Yukon in 1998. It wasn't just a walk; I did the trek to assess the plausibility of an inspiring, if not audacious, vision: the Yellowstone to Yukon Conservation Initiative. This initiative aims to reverse the pattern of extinction by linking reserves and parks throughout the Rocky Mountain expanse in the United States and Canada with wildlife corridors. The Crown of the Continent plays a vital part.

I will never forget approaching the Crown from the south. I hadn't seen any signs of grizzly bears in a month of walking north of Yellowstone, but that was about to change. Footsore and weary, I flagged a boat to get across the Missouri River, dashed over Interstate 15, and climbed over the last few barbed-wire fences onto the forested crest of north-central Montana's Continental Divide. And that's when I saw them: a line of pigeon-toed prints with the distinctive claw marks, leading from one half-chewed biscuit root plant to the next.

I was 20 miles (32 kilometers) shy of the Scapegoat Wilderness at the time, but within a few days I came face to face with my first Crown bear. He was close enough for me to see the waves of muscle ripple under his silvery coat, and if it hadn't been for the serviceberries that hung in globs off the bushes, things might have unfolded differently. Thankfully, he was too busy gorging himself to pay me much heed. Mumbling apologies, I skirted the berry patch and yielded him the trail.

I didn't know it then, but signs of and encounters with grizzly bears would pepper each of my remaining days to the Yukon, with one notable exception: a 30-mile-wide (48-kilometer-wide) swath of clear-cuts, open-pit coal mines, four-wheel-drive tracks, railways, residences, and a busy highway that cuts across the spine of the Rockies just north of the US-Canadian border a day's walk from the northern end of the Crown. I walked into it after thirty days among goats, marmots, ptarmigans, bears, and other critters, and the contrast was so stark I stopped and cried.

I barely got *myself* through that maze, never mind looking for signs of grizzly bears that had made it through, and when a friend picked me up to begin a short speaking tour of the local towns, I tried not to be depressed. It was a losing effort; few people showed

Catch-and-release fishing on the North Fork Flathead River

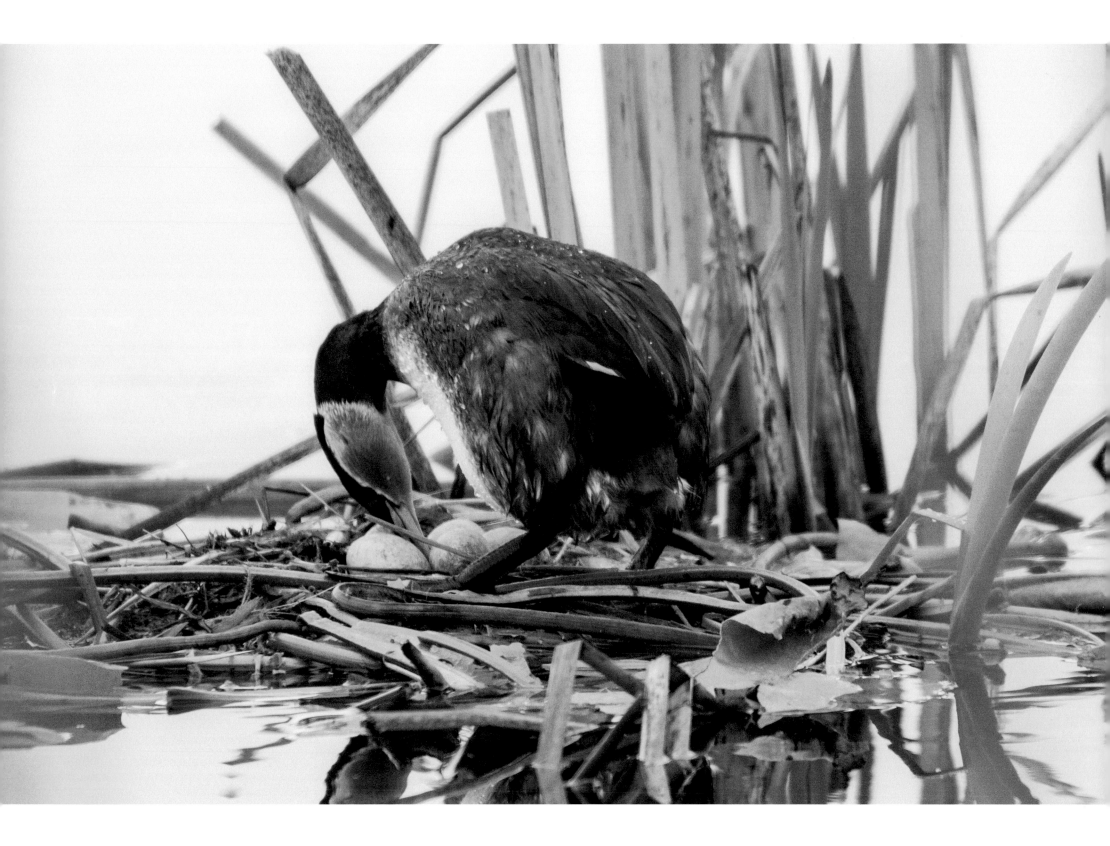

Twelve Fast Facts about the Crown

1. The Crown is one of the most biologically intact ecosystems in North America—and, for that matter, the world—encompassing 18 million acres (7.3 million hectares), or about 28,000 square miles (72,000 square kilometers), of the Rocky Mountains where Montana, British Columbia, and Alberta converge.

2. All of the Crown's original native species are still present, which is true for only about a score of regions around the globe today. The Crown is home to about 65 species of mammals, 260 species of birds, and more than 1400 species of native plants. Of note, the bison in the Crown are no longer truly free-ranging, and the unique type of woodland caribou known as mountain caribou have become extremely rare.

3. From the summit of Triple Divide Peak, rising to 8020 feet (2446 meters) midway along the Crown, rainfall and snowmelt flow to the Pacific Ocean, Hudson Bay, and the Gulf of Mexico, through sixteen states and four Canadian provinces.

4. The lowest elevation in the Crown, at just 2523 feet (769 meters) above sea level, is at the bottom of Montana's Flathead Lake, the largest body of freshwater in the western United States. It is 371 feet (113 meters) deep.

5. Sixty percent of the Crown is public land, including Waterton-Glacier International Peace Park, the Bob Marshall Wilderness Complex, and numerous state and provincial parks and forest reserves.

6. The Crown has always been important to native North Americans and continues to be so today, as they participate in shaping a conservation vision for the Crown. Seven tribes and first nations occupy their historic territory in the Crown. Their reserves include the Blackfeet Indian Reservation and the Flathead Reservation of the Confederated Salish and Kootenai Tribes in Montana; the Piikani Reserve and the Blood or Kainai Reserve in Alberta, and the Ktunaxa Reserves in British Columbia.

7. The Crown contains the first designated tribal wilderness in the United States: the Confederated Salish and Kootenai Tribes designated 92,000 acres (37,231 hectares) of tribal lands in the Mission Mountains, establishing the Mission Mountains Tribal Wilderness, in 1982.

8. One of the oldest and best-preserved buffalo jumps in the world, Head-Smashed-In Buffalo Jump, is located near the town of Fort Macleod, Alberta. It was used continuously for 6000 years, and in 1981 it was designated as a UNESCO World Heritage Site.

9. Waterton-Glacier International Peace Park, the first such transboundary park in the world, straddles the US-Canada border. It was formally recognized as a UNESCO World Heritage Site in 1995, making it the second UNESCO World Heritage Site in southwestern Alberta.

10. Of the rivers within the Crown, British Columbia's Elk River is home to native fish species including west-slope cutthroat trout, bull trout, and mountain whitefish; this river is considered one of the finest fly-fishing destinations in the world. The transboundary Flathead River is remarkable for its aquatic diversity, native fish, and high diversity of carnivore species.

11. The largest population of grizzly bears in the Lower 48 and one of the densest populations in the interior of Canada is found in the Crown. The region also hosts other North American predators, including wolverines, mountain lions, gray wolves, black bears, bobcats, Canadian lynxes, fishers, and martens.

12. Today the two most serious threats to the Crown are, first, the fragmentation of landscapes that connect the protected core areas and, second, climate change. As temperatures warm and habitat conditions shift, some wildlife species will be able to move farther north or to a higher elevation; however, some species already largely restricted to alpine areas may have nowhere else to go.

A red-necked grebe gently checks its eggs before settling down to incubate them.

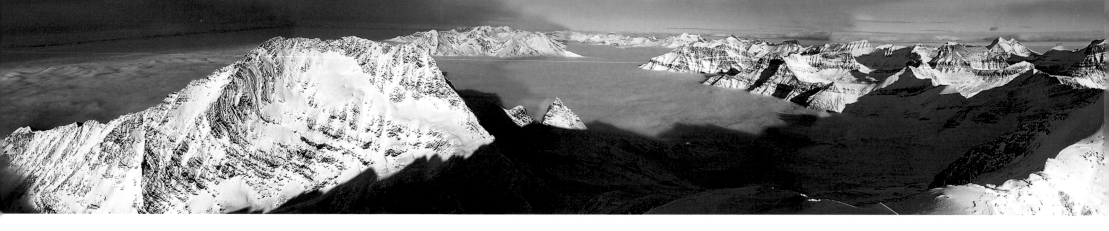

Acknowledgments

My thanks to:

My lover, friend, and wife, Aly—thank you for your unending support, which has enabled me to endure weeks alone photographing in the middle of winter, and for chastising me if I came back early. If this book doesn't sell, we can stack piles of extra copies around us to make ourselves a little home…

Doug Chadwick—this book would never have come to pass were it not for a conversation with you at the coffee shop. You saw these images in a bigger context. Thank you for your and Karen's friendship and wisdom in guiding these images to be part of a larger narrative, a larger landscape, and a web of connections.

Michael Jamison, for your friendship and collaboration on this project and for connecting me with the many people that were necessary to complete this work.

Dylan Boyle, for your work around the Crown and for collaborating on this project and always figuring out how we can spend more time on the water.

John Weaver, for lending your expertise and critique of our manuscript. We couldn't have had a better scientist's eye on this.

Jeff Kuhn, for reviewing the manuscript and lending your geologic expertise. Dave Hadden, Greg Chernoff, Ric Haurer, Cliff Muhlfeld, and Crown Management Partnership for providing the always-essential maps from which we could create the ones that are included in this book.

Karsten Heuer, for your tenacity and vision to walk from Yellowstone to Yukon so many years ago and for seeing the value of lands and their connections to wild spaces around them. I'm glad we got to meet, and thank you for writing the epilogue.

My sister Nicole and her husband, Zach Dowler, for your hospitality—allowing me to stay in your home while I did fieldwork, even when I brought wet, dirty gear back into your living room to dry.

Don and Linda Dimmitt, for your ongoing support of Aly and me. Thank you for investing in our lives and this project—I'm glad you got to see a few wolverines when you came out for a backpack in the Crown.

Nate and Bryna Closson, for your friendship and for turning your studio into a guest room and office. Coming back to your place felt like returning home after long trips in the mountains.

Rich and Bonnie Closson, for your wisdom and for allowing Aly and me to stay in your cabin during the first year of fieldwork for this project.

To the people who have supported me in many ways and have encouraged me to share these images with others: Jimmy Blair, Greg and Kelly Burfeind, Pete Mason, Evan Zeiger, T. J. Engstrom, Chris Caskey, Jesse Loether, and Dennis Brands for your friendship, for conversations that helped shape me, and for joining me on many of the days in the mountains; Sutton and Betsy Finch for letting me work on your land; Lonnie Collinsworth for honing my

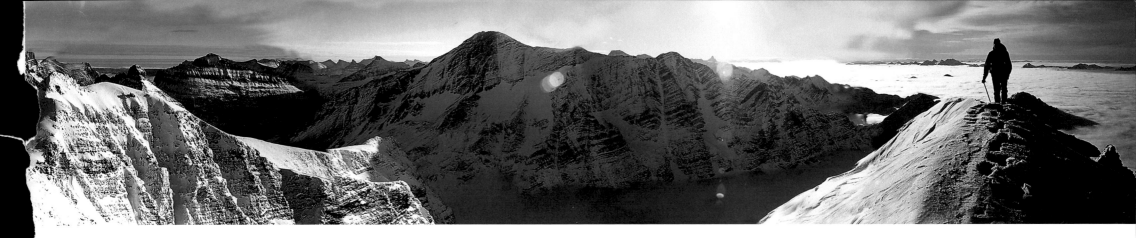

A self-portrait of Steven Gnam in Glacier National Park

eye and giving me time and space to create art in high school; Jim and Linda Bjork for too many things to list—thank you!; Ric and Dawn Blair for always encouraging me to photograph; Chris and Viktra Bumgarner for sharing your home while I lived in Polson and was first collecting images for this project; Scott Marskbury for keeping me up to date about photography and sharing your thoughts on spirituality; Gretchen Finch for conversations about art over tea; Scott and Pattie Strellnauer for support in the years after high school while I began to photograph images in this book; my uncle Rob Gnam for helping me purchase my first digital camera after I'd been shooting slides for almost ten years; and Clay Binford for seeing my potential and my need for a website long ago—thank you all.

And for those at Braided River, thank you:

To Helen Cherullo, I am honored to work with you and so thankful for your wisdom and patience to see such projects through.

To Laura Waltner for tying up all the loose ends throughout the project.

To Deb Easter for your gentle tenacity (can I pair those words?). You prodded the whole writing team along with just the right amount of whip cracks and well-placed sweets on the trail.

To Kerry Smith for your editorial deftness and for some extended deadlines . . .

To Jigsaw Jane Jeszeck for finding the flow for the images, to Ani Rucki for making maps, and to Kris Fulsaas for fine wordsmithing.

To the other members of the team at Braided River and Mountaineers Books for helping this book come together, including Margaret Sullivan and Emily White.

To Gary Hawkey, iocolor—and Artron Color Printing Company.

To all the organizations and funders that made this book and project possible, thank you!

Lastly to the Creator, the Giver of Life (known by many names and by many forms), for the beauty of the earth and for weaving our lives so closely with the lives of all humanity, with the plants, the animals, the water, and the soil of the earth. May we have the strength and knowledge to take care of the world and its inhabitants, choosing health over profits, meekness over greed. My deepest thanks and gratitude to You.

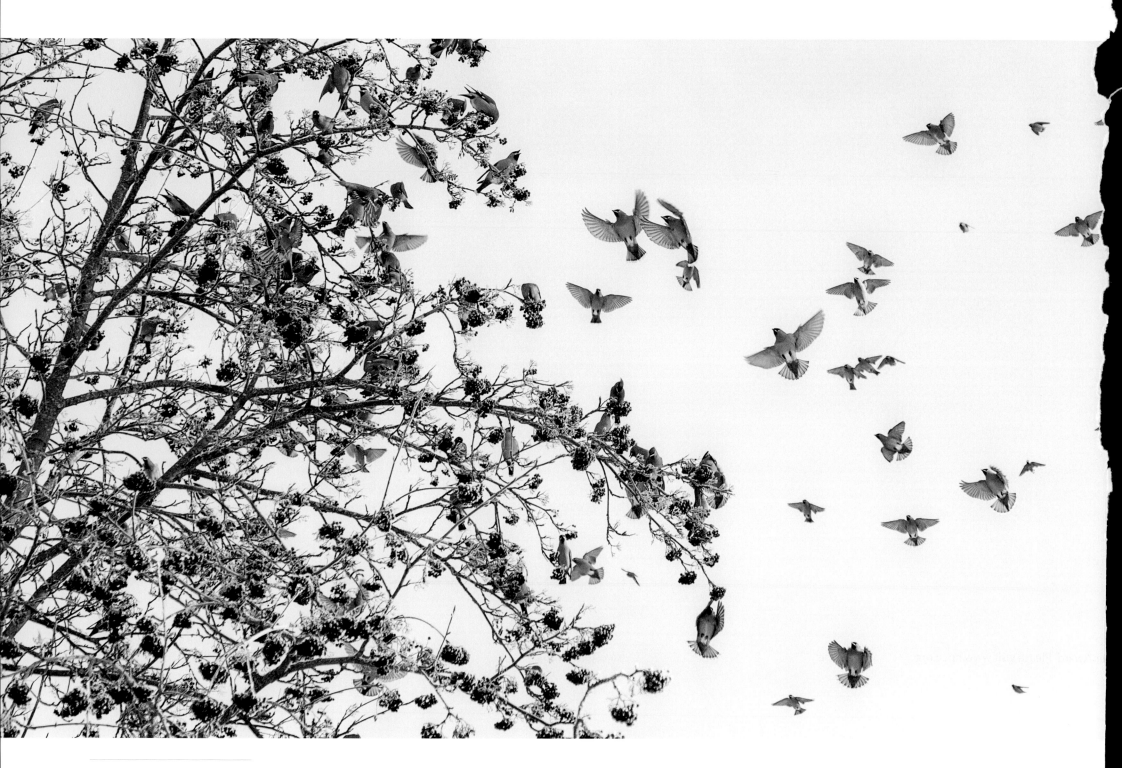

Flock of bohemian waxwings
descending on a mountain ash tree

About the Contributors

DOUGLAS H. CHADWICK has traveled the globe reporting on natural history and conservation, from Africa's Congo headwaters to Russian Siberia to Australia's Great Barrier Reef. A wildlife biologist with a master' degree and a regular contributor to *National Geographic* and other popular magazines, he is also the author of eleven books, including the critically acclaimed *The Fate of the Elephant* and *A Beast the Color of Winter*. His latest books are *Growing Up Grizzly* and *The Wolverine Way*. Having volunteered much of his free time to help with biology research projects in the Crown of the Continent over the years, Doug also assists a team in Mongolia trying to help save the last known Gobi bears. He is a founding board member of the nonprofit land trust Vital Ground, which protects wildlife habitat on private property through conservation easements. Doug and his wife, Karen Reeves, live in Whitefish, Montana. Please visit www.vitalground.org to learn more.

MICHAEL JAMISON joined the National Parks Conservation Association's (NPCA) Glacier Field Office as the Crown of the Continent program manager in 2010, following twenty years as a journalist. He operated the Missoulian newspaper's Flathead Valley Bureau, in the Glacier National Park region, providing an emphasis on natural resource policy and science reporting. Michael has also written for national magazines. In 2009 he was honored by the Forest History Society (Duke University) with the John M. Collier Award, recognizing his contribution to writing about environmental and conservation history and the interaction between people and landscapes. He contributed to the book *How the West Was Warmed: Responding to Climate Change in the Rockies*, which focuses on climate change in Glacier and other national parks and was a finalist for the 2010 Eric Hoffer Award. Please visit www.npca.org to learn more.

DYLAN BOYLE had the good fortune to be raised in Colorado and Hawaii before finding his permanent home in Montana. Growing up around the tourism industry, Dylan followed his passion for special places in his education, earning an undergraduate marketing degree with an emphasis in sustainable tourism, along with a master's degree in recreation management from the College of Forestry and Conservation at the University of Montana. He currently leads the *National Geographic* co-branded Crown of the Continent Geotourism Project, where he oversees day-to-day operations. He is also the founder of Geotravel Consulting, LLC, specializing in community education on responsible and authentic travel, based in the Crown of the Continent. In his spare time, Dylan can be found skiing, backpacking, or fly-fishing around the headwaters of the North American continent. Please visit www.crownofthecontinent.net to learn more.

KARSTEN HEUER has worked as a wildlife biologist and park warden in the Madikwe Game Reserve in South Africa, in Canada's Yukon Territory, and in Banff and Jasper National Parks in the Canadian Rockies. He is the recipient of the 2003 Wilburforce Foundation Conservation Leadership Award and the Sigurd Olson Nature Writing Award. In 2003 Karsten and his wife, Leanne Allison, followed the Porcupine caribou herd 1500 miles (2414 kilometers) as it migrated from its Yukon winter range to its calving grounds in the Arctic National Nation Refuge—and back—over five months. The adventure was documented in a book and film, both titled *Being Caribou*. Later, Karsten, Leanne, and their son retraced the epic journey of Canadian writer Farley Mowat, from Calgary to Nova Scotia, which was also documented in film. After Karsten walked the entire 2200 miles (3542 kilometers) from Yellowstone National Park to the Yukon, including the 250-mile (402-kilometer) spine of the Crown of the Continent, he authored *Walking the Big Wild: From Yellowstone to the Yukon on the Grizzly Bear's Trail*. He is president of the Yellowstone to Yukon Conservation Initiative. Please visit www.y2y.net to learn more.

About the Photographer

STEVEN GABRIEL GNAM is a professional photographer who has focused on the wildlands, wildlife, and peoples of the North American West. Steven runs, hikes, swims, climbs, and skis with camera in hand to cover stories and share the essence of wilderness. His work has been featured by clients including Patagonia, National Geographic Books, *Outside* magazine, Oprah, The Nature Conservancy, and the Trust for Public Land. Steven works closely with his wife, Alyson, a public interest attorney, on many projects because, besides providing excellent company, she tends to attract rare wildlife that have eluded Steven. Please visit www.stevengnamphotography.com to learn more.

Artist's Statement

I photograph to celebrate the beauty in nature, to reveal the heart of wilderness, and to show the relationships humans have with the earth.

For human life to be—for human life to thrive—there must be trees, there must be freshwater, there must be pure air. Every cell in our bodies, every breath, all the stored sunlight we consume for energy—comes from the earth. We depend on the earth's elements to build our bodies and on other organisms to purify the air. We are quite simply of the earth, all our cells made up from molecules of dust and water. When our bodies die, time weaves them back to the soil we were made from.

Most of us recognize that some amount of nature needs to be intact and functioning for human communities to flourish. But why do we need grizzly bears, wolves, wolverines, and large tracts of land with little or no human development? Not only can these creatures and spaces threaten us and our well-being and potentially our livelihoods, they threaten our egos, our sense that we are the top, the most important, the fastest, and the strongest. Grizzly bears, high mountains, and storms are no respecters of persons. They care not whether you have earned letters after your name or how much money is in your bank account. They care not if you sleep in a mansion or in your car. Wilderness and its creatures create a space wherein all humans are equal. For equality and for the sake of our own egos, we need to be reminded of our place in the universe. Wilderness helps us see ourselves and this truth clearly.

Wilderness is a sanctuary, a cathedral, a place where the anxieties of modern living fall away into a grounding perspective of what is necessary. Wilderness is an enigma. It is the wild roar of waterfalls, the sharp edge of the grizzly's claw, the impenetrable tangle of forest. It is the vast expanse of sky, glittering with stars unclouded by city light pollution. It is the morning mist covering a backcountry meadow; it is the deep forests reverberating with the chorus of frogs and birds. It is a place of exploration, adventure, solitude, and prayer.

Wilderness is all at once vast and intricate, wrapped up in the spiral on the back of a snail and lost in the arms of the Milky Way. It is beautiful and terrifying. It is real. In our modern societies, we need the balance that wilderness brings to our lives. We need to balance out our rushing about with the stillness and beauty found in the wild; we need to balance the way that modern living atrophies our senses with rich, sensuous experiences in nature. We need the balance of wild spaces—not only for the vital clean water and clean air that flow from them, but for the soul-stirring experiences that are possible only in the fold of wilderness. Balance also includes allowing wild creatures the freedom to roam, which is important for threatened species to survive, much as humans have the same need.

I take photographs to capture the essence of the natural world and the people who are entwined within it. Ultimately, I hope these photographs stir you to open your heart and mind to the beauty of the natural world—to celebrate its creation and glory and realize that we need to care for it.

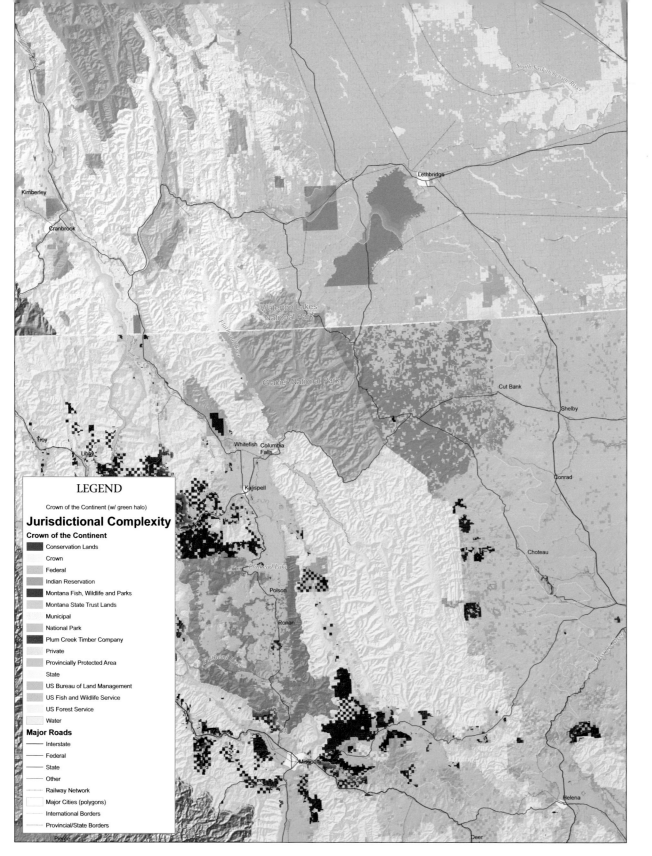

Land Ownership in the Crown

WHO OWNS THE CROWN?

As the map to the left shows, land ownership in the Crown is complex. Efforts to maintain natural corridors are taking place on lands owned by Native North Americans and private interests, from ranchers to timber companies. On both sides of the US-Canada border, every citizen has a say in the fate of state or provincial as well as federal public land use. Future decisions will continue to impact clean air, water, and soil—as well as the freedom for all living creatures to roam wild places.

Map courtesy of Crown Managers Partnership and Miistakis Institute, © 2013. Please visit www.rockies.ca for updates.

Partners and Resources

The Wildest Rockies is a visual media campaign celebrating one of the most biologically rich places on the planet—showcasing the Crown of the Continent through brilliant imagery and prose. Developed in partnership between Braided River and Steven Gnam, the campaign provides critically needed marketing and communication resources to grassroots organizations working to ensure the Crown's lasting protection.

Vision for the Wildest Rockies Campaign

- Celebrate wildlife, wild places, and local culture through art.
- Restore connections to the natural world through images and stories.
- Inspire stewardship of the natural world through art and education.
- Support people, communities, and organizations doing conservation work in the Crown.
- Encourage long-term sustainable choices for communities and the natural world.

Braided River gratefully acknowledges the financial and strategic support of the following organizations in the production of this book and corresponding outreach. Many of these groups also provide resources for learning more about the Crown of the Continent and getting involved in protecting the region.

Wilburforce Foundation

Protecting wildlife habitat in Western North America by actively supporting organizations and leaders advancing conservation solutions. *www.wilburforce.org*

Campion Foundation

Holding a strong belief that the wildest places in the western United States and Canada should be preserved forever. *www.campionfoundation.org*

Patagonia

Funding activists who take radical and strategic steps to protect habitat, oceans and waterways, wilderness, and biodiversity. Supporting people working on the frontlines of the environmental crisis. *www.patagonia.com*

Montana Office of Tourism

Striving to promote a quality experience to visitors while encouraging preservation of Montana's environment and quality of life. *www.travelmontana.org*

Crown of the Continent Conservation Initiative

Created to articulate and advance a long-term conservation vision for the Crown—a vision that will sustain the Crown's rich biodiversity far into the future. *www.crownconservation.net*

Crown of the Continent Geotourism Council

Celebrating the region's exceptional environment, culture, and heritage by providing opportunities for visitors and residents alike to learn, to experience, and to enjoy while contributing to the well-being of the region. *www.crownofthecontinent.net*

National Parks Conservation Association

An independent, nonpartisan voice working to protect and enhance America's National Park System for present and future generations. *www.npca.org*

Trust for Public Land

Conserving land for people to enjoy as parks, gardens, and other natural places, ensuring livable communities for generations to come. *www.tpl.org*

Vital Ground

Working with conservation-minded landowners to ensure the recovery and long-term survival of grizzly bears, together with the many native species that share their range, through the protection and restoration of core habitats and landscape linkages. *www.vitalground.org*

Wildsight

Working locally, regionally, and globally to protect biodiversity and encourage sustainable communities in Canada's Columbia and southern Rocky Mountain region. *www.wildsight.ca*

Yellowstone to Yukon Conservation Initiative

A joint Canadian-US not-for-profit organization that seeks to preserve and maintain the wildlife, native plants, wilderness, and natural processes of the mountainous region from Yellowstone National Park to the Yukon Territory. *www.y2y.net*

The following organizations offer more ways to get involved in experiencing and preserving the Crown of the Continent.

The Nature Conservancy, Montana *www.nature.org*
Swan Ecosystem Center *www.swanecosystemcenter.org*
Montana Wilderness Association *www.wildmontana.org*
University of Montana Crown of the Continent Initiative *http://crown-yellowstone.umt.edu*
Natural Resources Defense Council *www.nrdc.org*
Canadian Parks and Wilderness Society *www.cpaws southernalberta.org*

Please also visit www.wildestrockies.org for more information and updates on the book, Steven Gnam's events, outreach, exhibits, partners, and how you can learn more and get involved.

DEDICATION

To my parents, for teaching me appreciation for all the life around us and respect
for the neighbors, water, animals, and plants with which we share the earth.
Thank you for giving a young boy the freedom to explore the wildlands around home…
may the pages of this book honor you.

BRAIDED RIVER,™ the conservation imprint of **MOUNTAINEERS BOOKS**, combines photography and writing to bring a fresh perspective to key environmental issues facing western North America's wildest places. Our books reach beyond the printed page as we take these distinctive voices and vision to a wider audience through lectures, exhibits, and multimedia events. Our goal is to build public support for wilderness preservation campaigns, and inspire public action. This work is made possible through book sales and contributions made to Braided River, a 501(c)(3) nonprofit organization. Please visit BraidedRiver.org for more information on events, exhibits, speakers, and how to contribute to this work.

Braided River books may be purchased for corporate, educational, or other promotional sales. For special discounts and information, contact our sales department at (800) 553-4453 or mbooks@mountaineersbooks.org.

THE MOUNTAINEERS, founded in 1906, is a nonprofit outdoor activity and conservation organization, whose mission is "to explore, study, preserve, and enjoy the natural beauty of the outdoors. . . ." Mountaineers Books supports this mission by publishing travel and natural history guides, instructional texts, and works on conservation and history.

Our publications are made possible through the generosity of donors and through sales of more than 500 titles on outdoor recreation, sustainable lifestyle, and conservation. To donate, purchase books, or learn more, please contact:

Mountaineers Books
1001 SW Klickitat Way, Suite 201 | Seattle, WA 98134
(800) 553-4453
mbooks@mountaineersbooks.org | www.mountaineersbooks.org
Manufactured in China on FSC®-certified paper, using soy-based ink.

For more information, visit www.wildestrockies.org .

All photographs © Steven Gnam
All essays © by the authors
Publisher: Helen Cherullo
Project Manager: Kerry Smith
Acquisitions and Developmental Editor: Deb Easter
Copy Editor: Kris Fulsaas
Cover and Book Designer: Jane Jeszeck/Jigsaw, www.jigsawseattle.com
Cartographer: Ani Rucki
Scientific Advisor: John Weaver

Front cover: *Mountain goat in the high country of Glacier National Park* Back cover: *Bison in the National Bison Range on the Flathead Indian Reservation, with wallows in the foreground* Page 1: *Spawning Arctic grayling, a species that requires cold, clean water* Page 2: *Wildflowers along the Rocky Mountain Front* Page 4: *White-tailed deer in Montana's Mission Valley* Contents page: *Porcupine Ridge rises through the clouds in Waterton-Glacier International Peace Park.* Pages 6 and 7: *Patterns of rocks found on the edge of glacial moraines were formed by an ancient sea environment that opened and closed intermittently over many millions of years.* Page 191: *Black-billed magpie* Page 192: *A hoary marmot peers from beneath its boulder fortress.*

Library of Congress Cataloging-in-Publication Data
Gnam, Steven, photographer, writer of added text.
 [Photographs. Selections]
 Crown of the Continent : the wildest Rockies / Steven Gnam.
 pages cm
 Chiefly a book of photographs with complimentary text by the photographer and others.
 ISBN 978-1-59485-772-0 (hardcover)
1. Natural history—Rocky Mountains. 2. Rocky Mountains—History. 3. Mountain life—Rocky Mountains. 4. Rocky Mountains—Pictorial works.
QH104.5.R6F56 2014
 508.78—dc23 2013032519

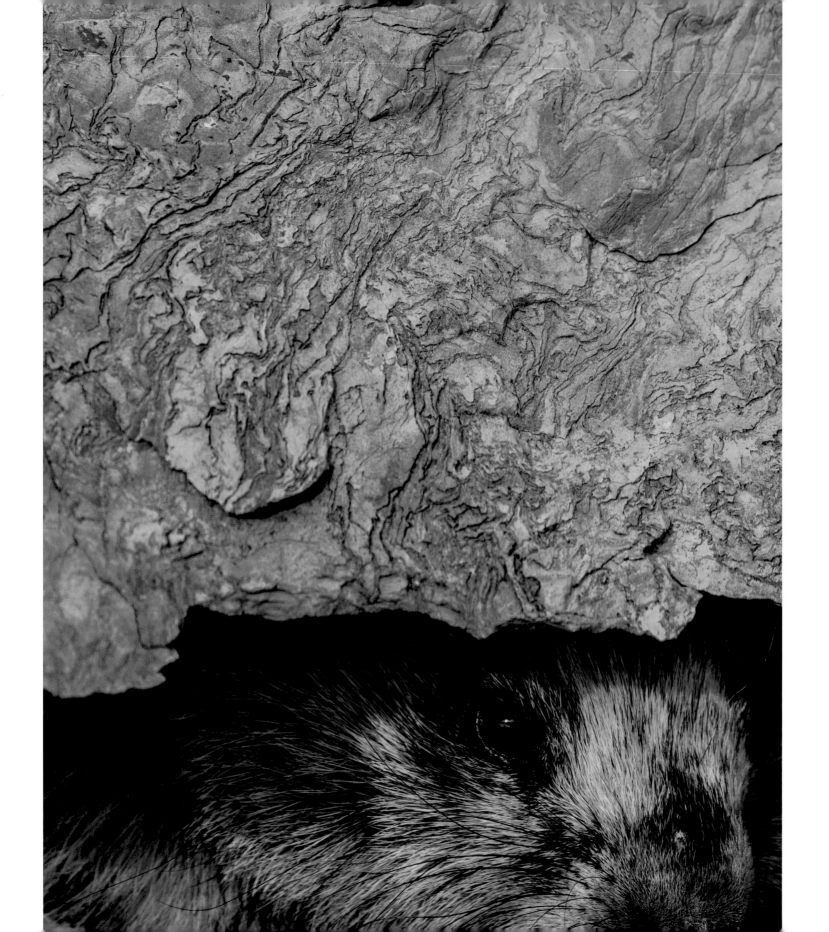